A GUIDE TO
HISTORIC HOLLYWOOD

A GUIDE TO HISTORIC HOLLYWOOD

A TOUR THROUGH PLACE AND TIME

JOAN MICKELSON

THE
History
PRESS

Published by The History Press
Charleston, SC 29403
www.historypress.net

Cover image: Hollywood beach in the 1940s. *Historic postcard courtesy of Bill Schaaf.*

First published 2005

Manufactured in the United States

ISBN 1.59629.049.8

Library of Congress Cataloging-in-Publication Data

Mickelson, Joan.
A guide to historic Hollywood : a tour through place and time / Joan
Mickelson.
p. cm.
Includes bibliographical references and index.
ISBN 1-59629-049-8 (alk. paper)
1. Hollywood (Fla.)--History--20th century. 2. Hollywood (Fla.)--Tours.
3. Historic buildings--Florida--Hollywood--Guidebooks. 4.
Streets--Florida--Hollywood--Guidebooks. I. Title.
F319.H7M53 2005
917.59'350464--dc22
2005022181

Notice: The information in this book is true and complete to the best of our knowledge. It is offered without guarantee on the part of the author or The History Press. The author and The History Press disclaim all liability in connection with the use of this book.

CONTENTS

Acknowledgements

I t is scarcely possible to thank the many people who assisted with this guide. If I have left someone out, I apologize, and I assure everyone that this material could not have come together without your generous and timely assistance. Any errors and omissions are mine. Thank you all for helping to produce this description of Hollywood and its people as many of us knew them fifty and more years ago. I hope readers will enjoy tracing the history of J.W. Young's city as they find it today.

With gratitude to Robert Arnan; Sean Atkinson; Cyndy Baker; Geri Bassett; Jeanne Connor Baxter; Anna Larsen Berry; Prudy Taylor Board; Merle Bowser; Tony Campos; Pauline Long Carmichael; John Causey; Lona Cochran Clark; Patti Clempson; Saul Cohn; Lois Cowan; Denyse Cunningham; Victor DeBianchi; Ellen Dilg; Harvey Driggers; Marla Dumas; Christopher Eck; Marion Fording; Linda Mann Gardner; Henry Geoffrey; Susan Gillis; Mel Greene; Jonathan Heller; Gail Humphrey; Ann Pell Hunter; Harry Hunter; Warren Hyres; Ralph Johnson, professor at Florida Atlantic University and his students at the Center for Urban Redevelopment and Education; Evelyn Long Jones; Elizabeth Kalkhurst; Katherine LaBelle*; Larry LaBelle; Lorna Lathrop LaBelle*; Robert LaFavre; Claudina Lopez; Justin Lukach; Judy Mann; Sandra Young Merrill; Andree Barthlemy Miller; Margarita Orta; Bill Owra; Joel Sachs; Bill Schaaf; Elaine Dresnick Schultz; Kitty Shay; Heidi Siegel; Pat Martin Smith; the staff of the *Hollywood Sun-Tattler*, October 1985; Sharon Stitely; Clive Taylor; Charles Watson TenEick Jr.; Pat Filson Van Noy; Richard and Michelle Vest; Patricia Wardrop; Jeanne Weyant; Bonnie Wilpon; Bill Young; Rodney Young*, and several sources who wished to remain anonymous.

*Deceased

INTRODUCTION

This book is intended as an interactive guide to the remarkable early history of Hollywood, Florida, which was a planned city from the start. Take the book along as you go up and down Hollywood's streets—from the beach to State Road 7—and see who lived here in Hollywood's formative years. In fact, you will read about when the streets themselves were laid. The book is in two parts. The first covers the years from 1920 to 1960, chronologically. The second, the street guide, will take you border to border and street by street from the beach to State Road 7, indicating a building, person or event that was part of Hollywood's early history.

Hollywood by-the-Sea, Florida, was the brainchild of one man, Joseph W. Young Jr., called J.W. by those who knew him. Born on the opposite side of the country, in Gig Harbor, Washington, Young began his career as a developer in Long Beach, California, at the beginning of the twentieth century, and in a number of ways, his ideas were formed in California. Young then spent a very productive half decade in Indianapolis, Indiana, developing suburbs, making millions and coming to know Carl Fisher (developer of Miami Beach) and other men of wealth and influence who supported him in his Florida venture. Virginia TenEick has summarized Young's biography in her detailed chronicle, *History of Hollywood (1920 to 1950)*. I have relied on her information, backing it up by also reading most of her sources. She was, by the way, my godmother. I chose to use my father, A.C. Tony Mickelson, as spokesperson for Hollywood's early development because he was present during that time and also because he left several valuable interviews. Fresh out of the navy, he met Young in Indianapolis in 1919, worked briefly as a land salesman and then was chosen by Young as

one of the first twelve men to begin the city. As head of surveying for Young's Hollywood Land and Water Company, he laid out the Central section, Little Ranches, Lakes section and the beach. After Young's death, my father worked for the city and served as city manager from 1947 to 1949. He and my mother were members of the Hollywood Pioneer Club and helped found the Hollywood Historical Society.

J.W. Young, whose vision and indomitable energy created Hollywood, stirred immense loyalty in those who knew him and worked for him. As Clarence Moody described it, "J. W. with his big eyes and supersalesmanship had me with his company in about ten minutes." Hollywood's pioneers were optimistic, and many were affluent. The women wore stylish crêpe de Chine flapper dresses and cloche hats, and the men wore plus fours, vests and caps. Young's vision was for a prosperous, well-appointed city, and he spent practically all that he earned on making the city beautiful. He provided bands and orchestras in the Country Club, the Tea Room (it was Prohibition) and band shells, and there were also several theaters. Young gave the city parks, and built the Broadwalk and Hollywood Beach Casino (not a gambling establishment). He also provided a variety of designs for the houses to be built in his "city of homes." A great many of the homes still exist, but sadly, most of the beautiful public structures Young had erected—and for the most part gave to Hollywood's citizens—have been torn down, even some in the designated historic districts.

But if development under the Hollywood Land and Water Company ended about 1927, building the city did not cease. The remaining members of the core group saw to it that building continued, and newcomers likewise built homes in the most up-to-date architectural style. There has not yet been an accounting of the splendid array of 1930s and 1940s Moderne houses that add to Hollywood's distinctive look. Most of these are on the beach, but a surprising number of these treasures can be found throughout the city. Some of these have been included as an incentive for others to study this era of Hollywood architecture. Tribute is also paid to the people of the generation who kept the struggling little city going in the difficult 1930s and wartime 1940s.

Others before me had considered publishing a street guide to Hollywood such as this. I would particularly like to mention the staff of the now-defunct *Hollywood Sun-Tattler*. In October 1985, staff members published an edition that included a number of the sites found in this guide.

Illustrations included herein are for the most part of buildings that no longer exist. My generous photo sources were the Broward County Historical Commission; Broward County Parks and Recreation Division; the City of Hollywood, Florida, Records and Archives Division; the Hollywood Historical Society; and private collections of Claudina Lopez, Bill Schaaf, Charles Watson

INTRODUCTION

TenEick, Jr. and my own. This is not intended as an exhaustive catalogue of Hollywood's historic sites. Instead, it is a broad survey of the city's early decades. To see the city's history firsthand, take a walk or a drive through Hollywood with this guide along. With its help, you may be able to identify other historical homes on your own. Please enjoy and treasure historic Hollywood, Florida.

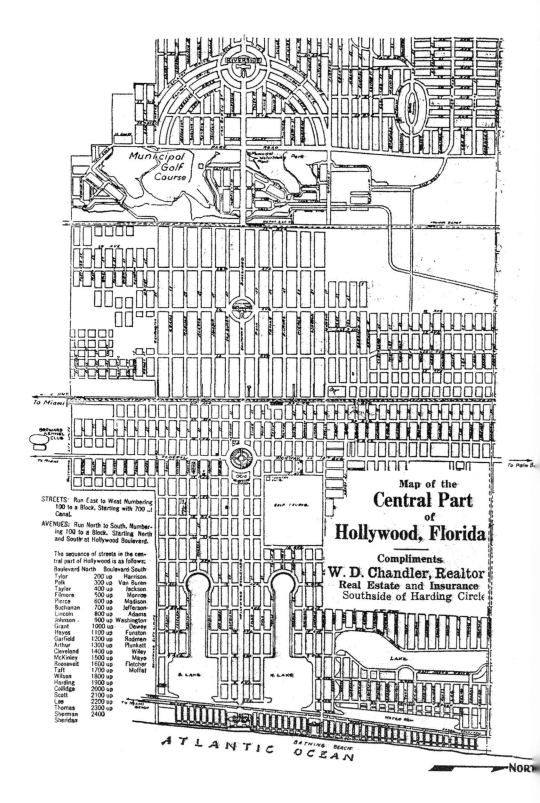

Map of the
Central Part
of
Hollywood, Florida

Compliments
W. D. Chandler, Realtor
Real Estate and Insurance
Southside of Harding Circle

STREETS: Run East to West Numbering 100 to a Block, Starting with 700 at Canal.

AVENUES: Run North to South, Numbering 100 to a Block. Starting North and South at Hollywood Boulevard.

The sequence of streets in the central part of Hollywood is as follows:

Boulevard North		Boulevard South
Tyler	200 up	Harrison
Polk	300 up	Van Buren
Taylor	400 up	Jackson
Filmore	500 up	Monroe
Pierce	600 up	Madison
Buchanan	700 up	Jefferson
Lincoln	800 up	Adams
Johnson	900 up	Washington
Grant	1000 up	Dewey
Hayes	1100 up	Funston
Garfield	1200 up	Rodman
Arthur	1300 up	Plunkett
Cleveland	1400 up	Wiley
McKinley	1500 up	Mayo
Roosevelt	1600 up	Fletcher
Taft	1700 up	Moffat
Wilson	1800 up	
Harding	1900 up	
Coolidge	2000 up	
Scott	2100 up	
Lee	2200 up	
Thomas	2300 up	
Sherman	2400	
Sheridan		

Municipal Golf Course

To Miami

To Miami

BROWARD KENNEL CLUB

To Miami

To Palm B.

GOLF COURSE

S. LAKE

N. LAKE

LAKE

To Miami Beach

ATLANTIC OCEAN

BATHING BEACH

NORTH

HIGHLIGHTS OF HOLLYWOOD HISTORY 1920–1960

Founder, Joseph W. Young Jr.

The founder of Hollywood, Florida, Joseph Wesley Young Jr., was born at the far opposite side of the continent, in Gig Harbor, Washington, on August 4, 1882. He began his career as a real-estate developer in Long Beach, California, where he had moved in 1903. That same year, he married Jessie Faye Cooke (1880–1955). Soon after that, Long Beach's boom era began when the trolley from Los Angeles started bringing city folk down to enjoy what was quite literally a long beach. From 1905 to about 1915, Young was buying, developing and selling parcels of land to investors and people looking for vacation property. A major flood brought that boom to a temporary halt, and Young began his move east. For a few years, he was in Arizona, then the Young family, now including three boys, settled in Indianapolis, Indiana, in 1917. Young—and others—believed Indianapolis was thriving due to the auto industry, although it was by then moving to Detroit, Michigan. Nevertheless, Indianapolis was a wealthy city. Young made the right connections and once again began developing and selling property, now in association with Edwin H. Whitson. By 1920, Young was a millionaire.

In 1920

Hollywood's founder, called J.W. by those who knew him, first set foot in his future city in July 1920. Hollywood, of course, did not yet exist. How did he get there, and what did he see? The two main north–south routes from Fort Lauderdale down to Miami through this beautiful landscape were the new Dixie Highway, completed

in 1915, and Henry Flagler's Florida East Coast Rail Road (FEC) tracks that reached Miami in 1912. Young had passed through the area by train the previous January, headed for Miami with Whitson to look at likely property there. What he saw north of Miami was palmetto scrub and slender jack pines on the high coral ridge, brackish water thick with mangroves to the east and grassy marshes to the west. Farmers, mostly from the city of Dania, owned the good ground where they grew pineapples on what would become City Hall Circle, groves of avocadoes and mangoes (along future Twenty-third Avenue), a citrus grove (Orange Brook Golf Course) and tomatoes (Johnson Street). East of about Fifteenth Avenue was tidal, and the beach was simply sand, grassy dunes and sea grape.

While Flagler was the impetus behind the development of southeast Florida, he and his railroad were not the first to arrive in what would become Hollywood. The Seminoles generally inhabited high ground well to the west but must have made their way through the area, hunting and fishing. Surely the soldiers in Fort Lauderdale and Fort Dallas in Miami in the 1830s occasionally rode between these encampments. Susan Gillis, in her history of Fort Lauderdale, lists trails to and from Miami, including a road constructed in the 1850s by Abner Doubleday from Arch Creek in North Miami to Fort Lauderdale, and the Bay Biscayne Stage Line route running from Lantana to Lemon City beginning in 1892. Proof that at least one of these trails went through the future Hollywood was an old signpost for a north–south route that still existed at Twenty-sixth Avenue and Johnson Street in the 1920s, according to Virginia TenEick in her *History of Hollywood (1920 to 1950)*. The water route passing the future city was the fledgling Intracoastal Waterway, and on the beach barrier islands, in the 1890s, it was possible to walk from Palm Beach to Miami in the company of the Barefoot Mailman.

Crisscrossed though it was by passers-by, the future city was barely inhabited in 1920. Young returned to Miami in July and headed up to the city of Dania, where he found someone to drive him over the farmland between Dania and Hallandale. His dream city must have taken shape in his mind as they bounced along, for he bought his initial land purchase at that time from Stephen Alsobrook. This was a square mile bounded by the present-day Dixie Highway on the west, Johnson Street on the north, Fourteenth Avenue on the east and Washington Street on the south. Several farmers had built homes on their property, notably the Alsobrooks, Bryans and Zirbs. Young acquired the Alsobrook house with his land purchase and made it the headquarters for his sales, engineering and survey crews. Fred and Albertina Zirbs remained in their 1910 home (now gone) until they died. The still-extant Bryan home, dated 1914, was far to the west of Young's Hollywood and probably more accessible to Dania and Davie. Another farmhouse, at the corner of Johnson Street and Twenty-fourth Avenue, was used initially as housing for black workers. A few barns and sheds are also documented.

Hollywood, Florida, in 1920. *Photographer unknown. Courtesy of the City of Hollywood, Florida, Records & Archives Division.*

First headquarters of Young's Company, purchased on the property from Stephen Alsobrook in 1920. The company added rooms, wings and gables and painted the building red in 1921, hence the nicknames "Red House" and "House of Seven Gables." In 1923 it was given the address 2044 Sheridan Street, then torn down in the fall of 1964 to widen the road. *Photographer unknown. Courtesy of the Broward County Historical Commission, Giles Collection.*

According to the Whitsons—Ed and his wife Edythe both worked with Young before 1920—Young had been thinking of creating a city for some time, and after his first visit to Florida, the idea had really taken form in his mind. During his July ramble over the undeveloped property he would buy, he made notes about plans for a city that he named Hollywood. It is not a unique name; there are at least seventeen Hollywoods in the United States, a few dating to the nineteenth century. Again according to the Whitsons, it was simply a name Young liked.

When Young returned to his offices in Indianapolis, he established the Hollywood Land and Water Company as the overall organization for his Florida property. He had numerous other organizations to handle aspects of the property, such as real-estate sales, construction materials, boats and dredges, and so on. Throughout the book, these will be addressed under the general heading of the Young Company.

In Indianapolis, he drew up more detailed city plans, first with his company draftsman/engineer George Schmidt, then with the Indianapolis architectural firm of Rubush & Hunter. This is a very elegant plan, an artwork in itself. What were its sources? To begin with, a classical geometric layout, based on straight lines and circles, with a wide boulevard flanked by identical circular lakes has

a source in Baron Georges Haussmann's nineteenth-century redesign for Paris, France. Haussmann made use of wide streets, open spaces and vistas—eye-catching structures on circles of land. Young had not been to Paris, but similar ideas had come to the United States via Pierre L'Enfant whose earlier plan for Washington, D.C., was developed in 1901. The wide boulevard interspersed with circle parks had then been brought to Indianapolis, and Young's office looked out on The Circle there, the hub of downtown Indianapolis. Paris and Indianapolis did not have paired lakes. To create these, Young planned to dredge and fill his waterfront and to build land and lakes. This concept would come directly from work done along the Long Beach shore. But surely the greatest influence on J.W. Young as he conceived his "dream city" was the City Beautiful movement inspired by Daniel Burnham of Chicago.

Daniel Burnham's influence in the early twentieth century was enormous. A man of great energy, he had designed the overall plan for the World's Columbian Exposition in Chicago in 1893, with his partner John Root. Root having died in 1891, Burnham carried out their plans that included creating the "White City" in south Chicago. Burnham was also on the Senate Park Commission in 1901 that oversaw the redesign of Washington according to L'Enfant's plans. Before his death in 1912, Burnham's ideas about city planning had reached architects

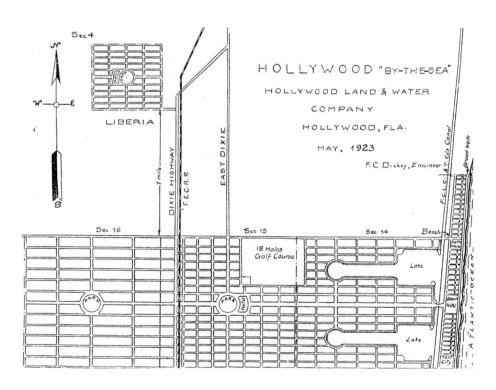

all over the United States. These ideas included not simply street layout, but every detail of making a city beautiful, healthy and enjoyable for all its citizens. Burnham once said, "Make no little plans…Make big plans; aim high in hope and work." This was J.W. Young's motto as well.

As the early map indicates, Young had plans to expand the city in all directions and did so.

The City Begins—1921

Stand in the middle of the pedestrian crossing on Hollywood Boulevard just to the east of the FEC tracks, and you are standing where Hollywood began. Wasting no time after drawing his city plans, in November 1920, Young sent twelve men to begin developing his new properties. One of these was my father, A.C. Tony Mickelson, age twenty-five, seen in the May 1921 photo. It took the first men eleven days to drive down the Dixie Highway from Indianapolis in three Ford touring cars. As there was no place to live in the palmetto under the jack pines, Schmidt moved into the Alsobrook place they called "The House of Seven Gables" where he drew working plans for the new city. Mickelson boarded at Bloom's Hotel in Dania. As head of the surveying party, he worked first under Schmidt, then under Frank Dickey, who replaced Schmidt in November 1921.

Land clearing of the first square mile, called Central Hollywood, began in June 1921. Road construction then began as Hollywood Boulevard was brought across the FEC tracks from the Dixie Highway. The boulevard was to be one hundred feet wide. Young intended to divert tourists heading south to Miami off the Dixie and eastward by means of this amazing roadway carved out of the wilderness. The vista in the distance would be a ten-acre circular park overlooked by Young's first grand hotel, Hollywood Hotel; the entire group of boulevard, park and hotel creating a vista too enticing to ignore.

Even before the first hotel was completed, Young's Hollywood Land and Water Company had a sales force operating in an open pavilion on the site of Harrison Street at Nineteenth Avenue. The first lot was sold at the Indiana State Fair in September 1921 to Orlando Forbes. As Wayne Guthrie, an Indianapolis reporter wrote, people from Indiana made up the majority of Hollywood's earliest inhabitants. His uncle Ira Guthrie was the Hollywood Land and Water Company's secretary-treasurer.

While the two existing routes through the future city, the Dixie and the railroad, ran north–south, Young's city plan ran east–west. From the start, he intended to have ocean property and made his first purchase in 1921, buying one mile of oceanfront and four hundred acres of uplands from Hallandale speculator Olof Zetterlund for $600 per acre. There were no roads on or leading to the beach at this time.

HIGHLIGHTS OF HOLLYWOOD HISTORY, 1920–1960

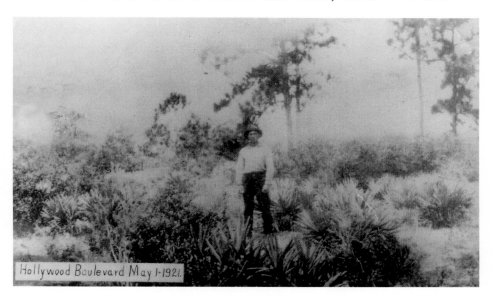

Hollywood Boulevard May 1-1921.

Surveyor A.C. Tony Mickelson, head of a surveying party for Hollywood Land and Water Company, at the spot where Hollywood Boulevard would begin. Photo published in the August 15, 1922 *Hollywood Reporter* with caption reading "Hollywood Boulevard May 1-1921." *Original photo from the J.W. Young family album. Courtesy of the estate of A.C. Tony Mickelson.*

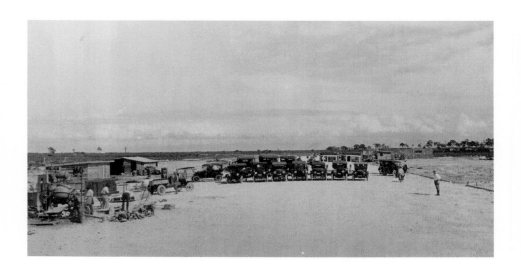

Hollywood Boulevard under construction in 1921. The photo was staged with seven cars abreast and room for more, to indicate how wide the road was—100 feet. No buildings had been completed yet. *Courtesy of the Broward County Historical Commission, gift of Harriet Ransom and Patricia Smith.*

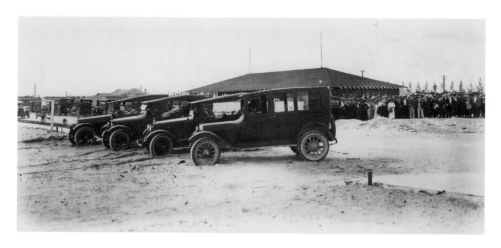

Prospective land buyers were brought by bus from near and far to hear a promotional lecture in this open pavilion and be served a sandwich, an apple, pie and coffee. Even before streets were laid out in the flat, bare, blindingly white terrain, sales were brisk in Central Hollywood. When the second sales pavilion was built, this served as Hollywood's school in 1924–25. Photo dated January 8, 1923. *Courtesy of the Broward County Historical Commission. From the Florida State Archives.*

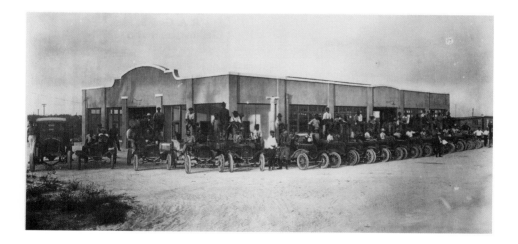

The first permanent building in Hollywood, designed by Rubush & Hunter in the California-mission style Young approved, this garage was at the first street corner, Hollywood Boulevard and 21st Avenue (north corner). Posing in this October 25, 1922 photo are some of the black workers who built Young's city. Note that the Boulevard in the foreground is simply crushed rock and sand. *Courtesy of the Broward County Historical Commission. From the Florida State Archives.*

With no other landowners as yet and roads to be built, Young's first building was the practical company garage, on the corner of his infant boulevard at Twenty-first Avenue. Trucks were kept busy running out to the rock pit opened at the future Thirty-fifth Avenue (now filled in for the tennis courts at David Park). Next built was a shed on the circle park to house workers, their housing being a chronic problem for Young.

1922

Not only were people buying lots almost before the lot lines were surveyed, they were also building homes. The first area to be laid out with sidewalks and rock-covered streets was between the Dixie Highway and about Eighteenth Avenue, and Washington Street to Johnson Street (naming the streets for presidents was apparently Young's idea as he first drew up a plan for the city). Young had contracted with the Indianapolis architectural firm of Rubush & Hunter to design buildings for his city, and most of what was built in Central Hollywood in 1922 was from those designs, including the company garage and the Hollywood Hotel. Sheets of drawings for twenty-four house designs by this firm are dated 1921; they were in a variety of styles, including bungalows, Cape Cod cottages and colonials, some with shingle roofs. Apparently lot owners could select a design and have it built. The Young Company—that is, the Hollywood Land and Water Company—did not build homes until 1924.

Much information about Hollywood's first four years can be gleaned from the *Hollywood Reporter*, a news magazine founded by J.W. Young as another means of advertising, and written and edited by O.E. Behymer. The first issue is dated February 1922. If previous houses were designed according to owner's choice, by April 1922 the *Reporter* announced that "[a]ll public buildings are to be in the Spanish type of architecture, presenting a uniform and striking appearance. Harmonious and artistic architectural designs add greatly to the beauty of any city."

The Indiana building contractor Harry K. Bastian built most of the first houses in Central Hollywood, starting several at once in 1922 (possibly late 1921). Some were built on spec for buyers who wanted their lot complete with a house. In February, the Bastian company hired John Brown to keep an eye on the fifteen houses already under construction. When Brown arrived in February, he found four families already living in the Hollywood area, including the original pioneer farmers Fred and Albertina Zirbs whose address became 1225 North Seventeenth Court. The Ben Joneses and the Ed Hensens were near the Dania/Hollywood city line at Sheridan Street and what eventually would become Eighteenth Avenue, and Walter and Lulu Altman lived just east of Eighteenth Avenue between McKinley and Cleveland Streets. Altman was water-pump

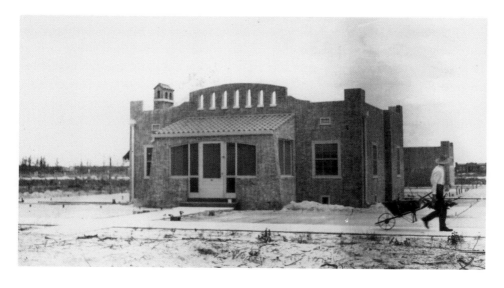

1901 Madison Street, seen here under construction, 1922, is considered the first residence purchased in Hollywood, by Charles and Emma Roden from Toronto, Canada. The Rubush & Hunter design, approved by Young, is a variation on the California adobe house. Torn down 1964. *Courtesy of the City of Hollywood, Florida, Records & Archives Division.*

engineer for the FEC steam engines, working the pump at about McKinley at the tracks. Still, these were the undeveloped outskirts, so in May 15, 1922, the *Reporter* announced that "Charles E. Roden and family [wife Emma] of Toronto, Canada, have the distinction of being the first residents of Hollywood. During the month of March they moved into their new home on the corner of Madison and Third [Nineteenth] Ave." Roden was a retired jeweler.

For the record, Hollywood's earliest avenues were numbered with East First Avenue and West First Avenue each beginning at the Dixie Highway. In 1925, the avenues were renumbered beginning with Seventh Avenue at the canal and going higher as streets were constructed to the west.

Houses similar to the Rodens' can still be spotted in this area that represents the heart of historic Hollywood. A notable example is at 1855–57 Monroe Street, the first Hollywood home of Clyde and Amy Elliott and their daughter Virginia, who would later write the history of Hollywood as Virginia TenEick. The Elliotts drove down, arriving in the fall of 1923 to settle in the house they called "Spanish Village," which had been begun in 1922. Virginia, with her reporter's eye, described her first impression of Hollywood as flat and glaring in the sun. The family enlarged the house before moving in; it is still extant. Apparently the bare ground made an impression on others as well, for the July

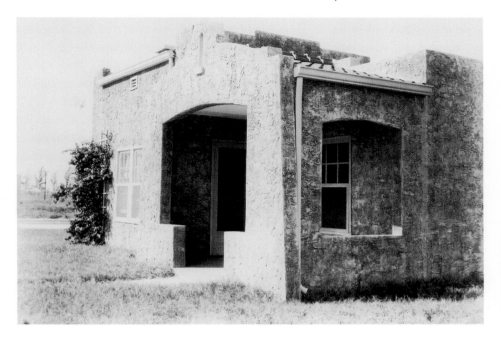

1855–57 Monroe Street in 1922, probably built by contractor Bastian from a design by Rubush & Hunter. California Spanish mission look includes thick stucco walls, roof tiles, irregular roof line (parapet) and niche over the entrance. It was bought by Clyde and Amy Elliott in 1923, who enlarged it. This important house still stands. *Courtesy of the Hollywood Historical Society.*

1923 *Reporter* said people asked why all the trees were cut down. The answer was that J.W. Young hated pine trees. To replace them, he was planting palms, pithecolobium, poinsettia, hibiscus, pepper tree, royal palms, cinnamon trees, ixora, bananas and more.

Other builders soon joined Bastian, including C. Carrolin of St. Louis, Missouri; Charles Schindler of Texas; W. Ward Kington of Kentucky; and Homer Masick [Messick] of Los Angeles, California. About Masick/Messick, the June 15, 1922 *Reporter* said he was an architect and builder who bought twelve lots between the future school and the playground. "He will build eight distinctive California bungalows of the most modern type this summer. Mr. Masick has made money building in California. He has caught the vision of Florida's promising future and will transfer his activities to our new resort city." So Young, who had lived in Long Beach, California, from 1905 to 1916 as it was being developed as a resort area for Los Angeles, was urging his designers toward the California-Spanish-mission-style and the Craftsman-type bungalow, another architectural

style developed in California. The Mission look was popularized by California architects in the years before World War I (when Young was living in Long Beach, California). Notable design elements are the shaped parapet, or roof line, arches, quatrefoil windows, bell niches, bell towers, arcaded entries, and tiled roofs. The Roden house was a variation on the California adobe, with sloping corner walls and a row of bell niches. The adobe style was derived from Spanish colonial rancher homes in California, often U-shaped around a courtyard, with wood rail balconies along the second floor. Craftsman bungalows were inspired by the work of the Greene brothers, also Californians. They are most quickly identified by a low-pitched roof often with a window in the second story, and a porch with short heavy columns set on massive, sloping piers. Examples of the owner's preference for the "California bungalow" are the 1922 home of D.C. Nevin and his wife at 1929 Van Buren Street (now gone); the Mark J. Tully home at 1917 Jackson Street, dated June 1922 (now gone); and the three nearly identical Monroe Street homes of Merrill H. Nevin, 1616 Monroe, Orlando Forbes, 1620 Monroe, and Edwin and Edythe Whitson, 1624 Monroe (all from April 1924 and still extant).

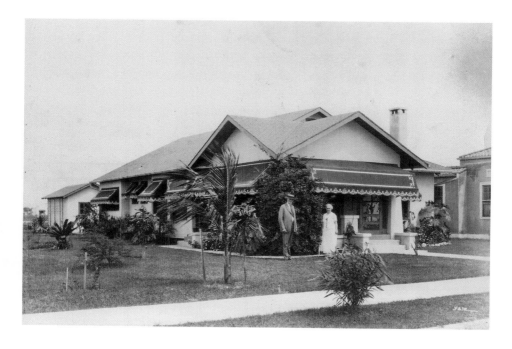

D.C. Nevin and his wife Florence at their home, 1929 Van Buren Street (now demolished). He was one of the Young Company's persuasive lecturers. Their comfortable home on two lots was in the California craftsman bungalow style. *Photo by Yale Studio. Courtesy of the Broward County Historical Commission, Mackay Collection.*

The July 15, 1922 *Reporter* compared Florida and California, saying both were ideal winter states with sunshine, flowers and beaches; California had had a tremendous vogue, but now the future was Florida's, being closer to the heavily populated—and wintry—Northeast through Midwest regions.

This same year, Young built several more civic buildings in order to serve his growing population. This new construction included the Hollywood Electric Light & Power at the corner of Buchanan Street and Twenty-first Avenue and the water plant between Taylor and Polk Streets on Eighteenth Avenue, both completed in February 1922. The May 15, 1922 *Reporter* noted that there would not be light or telephone poles on city streets. In the business section, the wires were underground, and elsewhere poles were placed in the alleys. Further describing Hollywood's alley system, the *Reporter* explained that at the rear of every lot was a fifteen-foot alley; garbage pickup would be in the alley. Furthermore garages were in the rear so there would be no "unsightly front driveways." It was also noted that Young's Hollywood Land and Water Company now controlled more than four thousand acres.

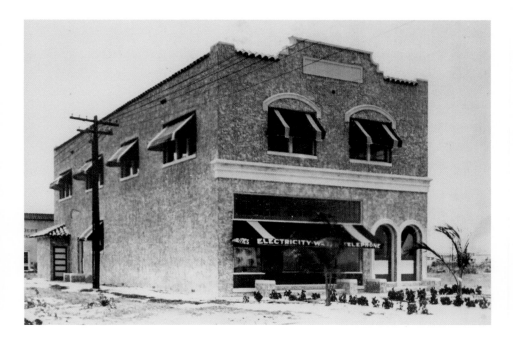

Initially the Young Company provided all water, electricity and phone service before the city was incorporated in 1925. The Hollywood Land and Water Company building was at 200 North 18th Avenue. *Courtesy of the Broward County Historical Commission, copied from an original lent by Bill Whitson.*

To manage the electric plant, water system and telephones, Young hired Florida native Clarence B. Moody from his position as engineer with Miami Electric Light and Power Company. His wife Lily Osment Moody, born in Cuba, was most likely the first Cuban to settle in Hollywood. The land Young purchased had an excellent supply of underground water. The April 1922 *Reporter* explained that the title Hollywood Land and Water Company referred to drinking water, as there were seven deep wells in block 43 alone. In fact, the *Reporter* went on, Hollywood's drinking water was so wholesome that the Hollywood Company contemplated bottling it for sale to Miami.

To facilitate the rapidly increasing building activity, Young was able to arrange with the FEC for a rail siding that began at Taft Street and ran south along Twenty-first Avenue for several blocks to Garfield Street, next to the company-owned Builders Supply Company. Completed in January 1922 and given to the Hollywood Company, the siding provided switching space for twelve to fifteen box cars. Rail delivery of construction materials was a great advantage to the new city. The siding is still operative.

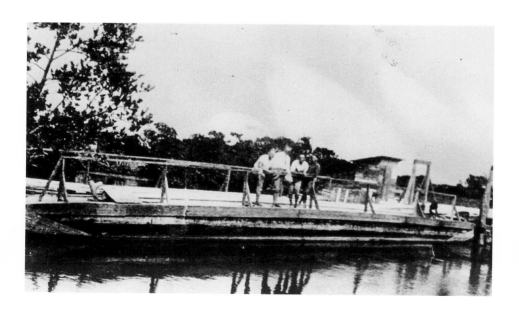

Pictured on the barge bridge at Johnson Street about 1922 are Connie Heath, Bill May, Tony Mickelson and Oliver Attaway. May was on the sales force; the others on the original survey crew. During the 1926 hurricane, the 70-foot barge was carried on floodwaters to 16th Avenue. *Courtesy of the Hollywood Historical Society, gift of A.C. Tony Mickelson.*

Young, typically, wanted everything done at once and was eager to open the beach. To reach the beach, it was no longer necessary to swim the canal after a seventy-foot barge bridge had been set up in February at the end of the track that would be Johnson Street, chosen as the first route to be extended through to the water. The grading and paving of Johnson from the Dixie to the Inland Waterway (later the Intracoastal Waterway) began in September. The barge bridge had a watchman to open it for yachts to pass through.

Development pushed west and east. Mickelson and his survey crew next laid out the half-acre lots in the Little Ranches section (Dixie Highway west to Twenty-sixth Avenue, and Jefferson to Johnson Streets). The first to purchase a lot in the Little Ranches were Riley and Nora Walters, at 2224 Pierce Street. (Riley worked for the water company.) Mickelson, who knew the lay of the land in Hollywood, soon followed, buying a double lot at 2301–07 Polk Street in August 1922. At fourteen feet above sea level, this is about the highest area in the city, dry and not prone to floods. Although he had no intention of farming, Mickelson was attracted to the avocado grove on the land, trees that produced superb fruit for the next fifty years. Some of these tall, ancient trees still survive in a line running north–south along what would be Twenty-third Avenue from about Fillmore to Jefferson Streets. That winter, Mickelson built a frame cottage on his land and moved from Dania. His house became the engineering cottage with six other young men bunking with him dorm style and a housekeeper/cook. Between them, the housemates had fine singers and banjo, mandolin and ukulele players; the engineers cottage must have been the best entertainment in town in the early years.

Settlers continued to pour into Central Hollywood, some bringing children. The November 1922 *Reporter* noted that until a school was erected in Hollywood, local children would attend school in Dania. At that time, eight of the students went to Dania by school bus. That fall, a school was established for the six younger children in a room in the house the California architect Homer Messick had just built at 1608 Madison Street, which was described at that time as a "double California bungalow." This landmark house still stands.

The Little Ranches with half-acre lots also filled rapidly; thirty families were living there by January 1923. Among those mentioned in the December *Reporter* were W. Ward and Minnie Kington who were building a two-story, concrete showplace on the Dixie Highway at Van Buren Street costing $10,000. Kington was a "retired coal and oil operator of extensive means" from Kentucky who had bought forty-one Hollywood lots to develop. He and his wife rapidly became leaders in various fledgling civic organizations, including the Woman's Club and the Chamber of Commerce. Not far from the Kingtons, on the boulevard at about Twenty-second Avenue, John Murray of New York had built a five-room

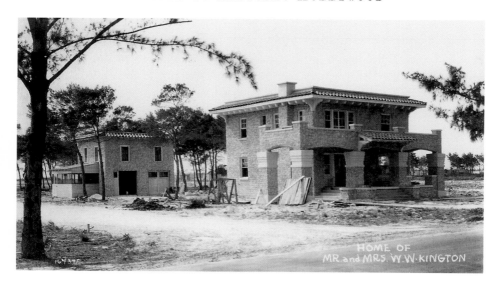

Kington mansion, built on the main road to attract tourists passing Hollywood. Under construction, 1923. In the distance are several houses on Hollywood Boulevard. Following the 1926 hurricane, it became a makeshift hospital. This Hollywood landmark was demolished 2005. *Courtesy of the Hollywood Historical Society.*

bungalow for his family and started a chicken farm beginning with forty chickens. The Gilmores had bought several lots on Polk Street, while several others had begun small farms on unspecified streets. Others provided their own food during "hunt season" in November, finding quail, rabbits and wild turkey not only in the Ranches but also on the golf course and all over the Central section. Even in the 1940s, bobwhite quail and wild rabbits rustled freely through underbrush in the empty lots in the Little Ranches.

To be ready for returning winter visitors at the end of 1922, Young saw to it that the Hollywood Hotel opened (with landscaping to follow). Built on its own island overlooking Circle Park, the American-plan hotel and dining room set the tone of upper-class comfort. Hollywood Boulevard was only paved from the Dixie Highway to the hotel, but almost immediately visitors were attracted and eager to see—and buy—land in the new city. The hotel, which could hold one hundred guests, was the first major building designed by Rubush & Hunter that Young would build. In general, it followed the California-Spanish-mission style adapted for resort hotels in that state just a decade or so earlier. In the May 1922 *Reporter*, it was described as "Spanish Renaissance" facing the Circle, with "Moorish effects" (probably including the dome) on the side toward the sea.

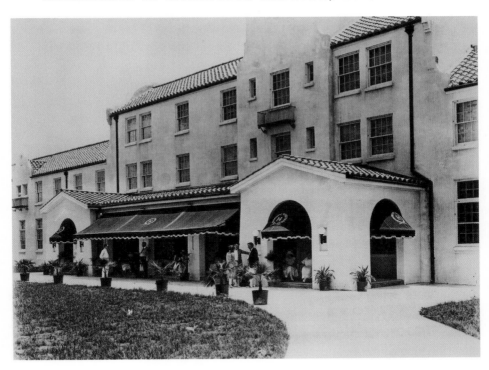

Entrance to the 1922 Hollywood Hotel, which faced Circle Park (now Young Circle). Young's first hotel, it was renamed the Park View Hotel. Photo dated June 21, 1923. This central location is now occupied by a grocery chain. *Courtesy of the Broward County Historical Commission, from Florida Photographic Collection, Florida State Archives.*

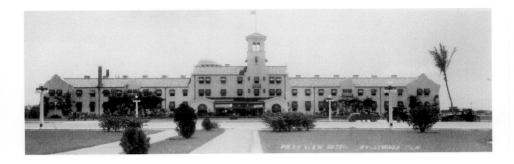

Decorative off-center towers became a trademark of 1920s Hollywood buildings. The Young family lived here in the Hollywood Hotel while they built their home. *Antique postcard published by Geo. L. Young. Courtesy of Claudina Lopez.*

At the same time, Young managed to open nine holes of his golf course to give his guests something to do. He bought the land that runs from Polk Street and Seventeenth Avenue to Johnson Street and Fourteenth Avenue from the former mayor of Dania, John Mullikin. Previously much of the land had been planted with tomatoes, like most of Dania. The golf course was designed by a friend of J.W. Young from Indianapolis, Ralph A. Young, and laid out and landscaped by Charles Olsen. The latter, a horticulturist from Rochester, New York, was responsible for the beautiful tropical landscaping of most of the city including the central Circle Park.

Johnson Street—having been chosen as the first route through to the beach (the seventy-foot barge bridge fit neatly there where the Inland Waterway was seventy feet wide)—was graded and paved by December. Meanwhile Mickelson's survey crew laid out lots in the beach section (called First Addition). The December *Reporter* announced that $200,000 worth of bare sand lots had already been sold. The *Reporter* also noted that "the work of leveling has begun." No one in Hollywood realized it then, but this was the beginning of disaster. Photos in the *Reporter* show big hoses blasting the natural sand dunes into the ocean. Years later, it was realized that this lowering of the beach by five or six feet to make it more beautiful, they thought, also removed the protective barrier against floods from storm surges.

At the end of 1922, the *Reporter* was pleased to note that the lights on the new Hollywood Hotel drew "autos from the Dixie Highway like a magnet," the

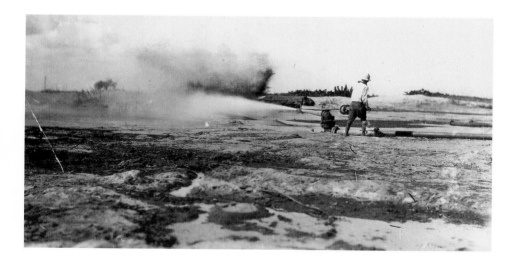

This photo from the 1922 *Reporter* shows hoses (such as fire hoses) blasting at the natural dunes, probably with water, and blowing the sand into the Atlantic Ocean. In recent years, some dunes have been replaced. *Courtesy of the Hollywood Historical Society.*

building boom was going strong in the Central section, with many Spanish- and Florida-style homes from Washington to Van Buren, Pierce and Lincoln Streets. And President J.W. Young was having plans made for a handsome home to be erected on Hollywood Boulevard, for about $30,000.

1923

Young and his wife Jessie and their sons, who had been living in Miami, moved into an apartment in the new Hollywood Hotel, on the second floor, south side, where Young could oversee his city's growth. The next phase of development eastward involved not just laying down streets but actually creating the land, in the area between Seventeenth Avenue and the Inland Waterway. As surveyor Mickelson explained later, the elevation of Eighteenth Avenue was ten feet, with a gradual downward slope that was tidal to Fourteenth Avenue. From about Fourteenth Avenue east to the Waterway the city-to-be was pretty much under water. This anomaly did not deter J.W. Young. In his original design, he had planned to dig and dredge out two keyhole-shaped lakes and use the bottom muck to fill the surrounding areas. This would create valuable waterfront lots and provide a causeway, the boulevard, leading to the prime beachfront property. Dredging began in the spring of 1923 and continued into 1925.

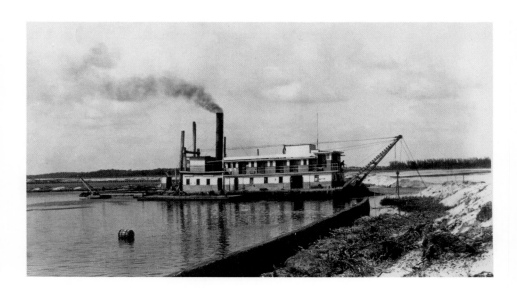

The East Marsh covered the future 7th through 12th Avenues in the Lakes section. Dredges created North and South Lakes from 1923 to 1925. *Courtesy of the Hollywood Historical Society, gift of J.F. Leonard.*

Money for the operations of the Hollywood Land and Water Company was flowing in, as not only individuals but developers purchased property. The January 15, 1923 *Reporter* lists a number of developers including Frank Thompson, "capitalist from Connecticut" and owner of twenty lots in the Central section and the beach who was building nine houses around Madison Street; builder R.M. Ducharme of New York, building on seventeen lots in the Central section at Adams Street between Seventeenth and Sixteenth Avenues; J.F. Martens [Martin] of Sandusky, Ohio, who was building bungalows on Madison Street and rental bungalows in the Little Ranches; builder George Young of Fort Wayne, Indiana; W.H. Fields of Kentucky who built an imposing eight-room, two-story home on Jackson Street with veranda and porte cochere; and Gilmore & Gilmore, contractors who planned to build on the five lots they owned.

An unexpected change in the city's overall design involved the Dixie Highway. Before the city was laid out, the only auto road south was the Dixie, which came through Dania east of the FEC railroad tracks, then made an angle turn west to cross the tracks to the north of Sheridan Street. So Young's wide boulevard was designed to lure drivers off the Dixie and into the city. However, after the Twenty-first through Seventeenth Avenues were installed between Dania and Hollywood Boulevard and laid with rock, drivers began to take the straight route to the Circle, which was Eighteenth Avenue, then head west on the boulevard, back to the original Dixie Highway. So the January 15, 1923 *Reporter* indicated that as this was probably inevitable, Eighteenth Avenue (still called Fourth Avenue then) would become the "East Dixie," a main road through the heart of the city. So it remained until the 1930s when it became a national route, U.S. Route 1 or the Federal Highway, as the locals call it.

With trucks now able to reach the beach island, the pink concrete Broadwalk was begun at Johnson Street in March. By winter it reached south for one mile; visitors could park at Johnson and walk along the pavement admiring the pristine beach and the Atlantic Ocean. Also in March, the Young Company began offering lots for sale in the future Lakes section (still mostly underwater). The name was derived from "the two artificial lakes that are now being excavated on either side of Hollywood Boulevard." (The boulevard did not as yet exist east of Sixteenth Avenue.) The lakes "will contain a total of one hundred and seventy acres...Around the lakes will be boulevard drives and beautiful parkways with ideal home sites where water privileges may be enjoyed...Every foot of this mile square contains rich marl soil where flowers and ornamental shrubbery can be grown in profusion." The article continued, "Building restrictions will range from $5,000 to $7,500, thus making this a very exclusive section." City maps and literature now begin calling the city "Hollywood by-the-Sea."

HIGHLIGHTS OF HOLLYWOOD HISTORY, 1920–1960

People already living in the Central and Little Ranches sections needed amenities. The first fire station was built at Polk Street and Nineteenth Avenue. Just big enough for one truck, the little building was in the approved Spanish-mission style. A post office was built at Harrison Street and Nineteenth Avenue. J.F. and E.S. Beebe built an ice plant at Twenty-first Avenue near Buchanan Street. Store blocks went up, such as the Curtis Block on the west side of the Dixie Highway at the boulevard, where James Breeding opened a drugstore, and the Kington Building just east across the tracks at the southeast corner of Twenty-first Avenue and the boulevard. A Rubush & Hunter design was employed, with stores at street level and large apartments on the second floor. The Bastian Building on the southeast corner of Twentieth Avenue housed Black's Drug Store. Farther east were the Central Arcade at 1936 Hollywood Boulevard and the Kagey Building at 1925–27 Hollywood Boulevard. The W.C. Kriekhaus building at 2012–25 Hollywood Boulevard with its oolite limestone rock-covered arcade was completed in August 1923 (now gone).

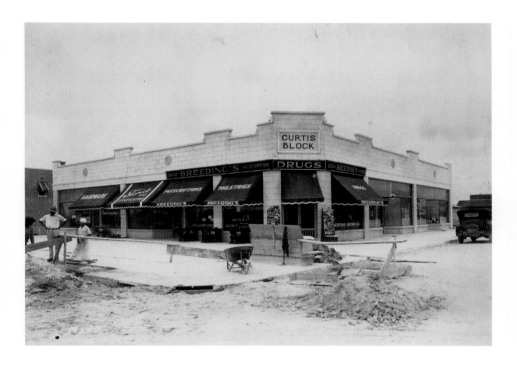

Curtis Block, built in 1923 on the west side of the Dixie Highway at Hollywood Boulevard and destroyed in the 1926 hurricane (which spared the Kington mansion just south). In the 1930s, Valhalla, a nightclub, was built here (demolished 2005). *Courtesy of the Broward County Historical Commission, gift of Mr. and Mrs. Joseph Mackay.*

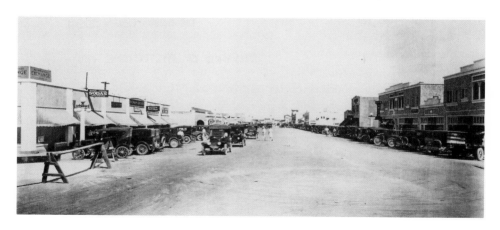

Hollywood Boulevard looking east from the FEC tracks, about 1924. On the right is the 1923 Kington Building. According to the *Reporter*, Kington personally oversaw its construction just across the tracks from his home. The Renaissance appearance may reflect Kington's preference. In 1933 the building became the Broward Building. Today it faces another landmark, the original Young Company garage (at left, behind sawhorse). *Courtesy of the Broward County Historical Commission.*

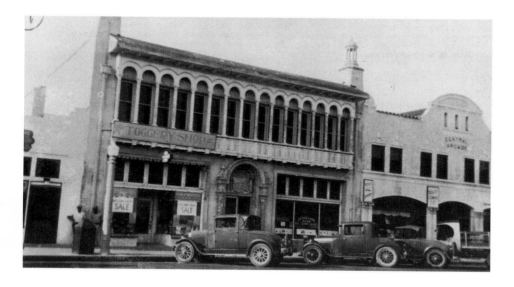

The 1923 Central Arcade on the right was designed in the prescribed California-mission style, with roof tiles, bell niches and curving parapet. Next to it is the 1926 *Hollywood News* building with its highly ornamented façade, probably by a different architect. The *News* building was grandly restored to resemble this photo by present owners Aron and Zahava Halpern. *Courtesy of the Broward County Historical Commission.*

Highlights of Hollywood History, 1920–1960

The Young Company built its first Administration Building on the southwest corner of Twentieth Avenue and the boulevard, and a second sales pavilion on the south side of the boulevard at Sixteenth Avenue. The company trucks and buses were removed from the downtown area to 2700 Van Buren Street out in the underbrush and the city's first building became the Ingram Arcade. Late in 1923, a large two-story building at 1911 Hollywood Boulevard became the Hollywood Furniture Company; one lot west, contractor Thomas McCarrell Sr. built the Hollywood Theatre. Before any churches were built, the Catholic and Presbyterian congregations held services in the Hollywood Theatre. In August, the boulevard was paved, with sidewalks, westward to what would be the second circle.

More 1923 homes that can be identified include that of H. Emerson and Alice Evans at Fifteenth Avenue and Tyler Street. Evans was a Young Company general sales manager for the Northeast. Doc and Della Aspy were at 1907 Grant Street (he worked for the city); Canadians James and Pearl Barton were also on Grant near Twentieth Avenue; William and Helen Eitler at 1724 Johnson Street; and two homes built by a brother and sister, the Adlers, at 1945 and 1949 Monroe Street. Phil Adler and his wife Minnie chose a bungalow, while sister Hattie Adler went for the Adobe-mission style. The Adlers owned the first women's wear shop on the boulevard, at number 1914. With their sister, Victoria Landman, the Adlers were important figures in the civic life of Hollywood. At age one hundred, Hattie Adler attended the author's wedding, with her younger sister Vic, and gave the bride a hand-crocheted blouse.

The second Young Company sales pavilion, or Hollywood Lecture Hall, where the Boulevard ended in 1923. Its second story provided an optimistic view to the ocean over the East Marsh as it was being drained. *Photo from the November 1923* Hollywood Reporter, *courtesy of Bill Schaaf.*

Young Company's second garage in 1923. On the left is one of Young's White buses, which brought people from all over the Northeast to visit his new city. This photo gives a good impression of the high, dry ground in the Little Ranches. The garage no longer exists. *Courtesy of the Broward County Historical Commission, gift of Mr. and Mrs. Joseph Mackay.*

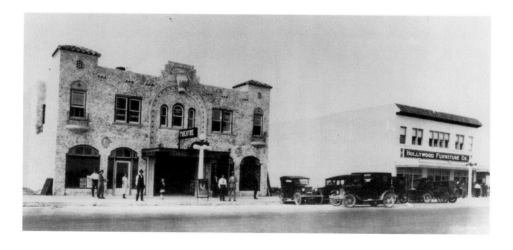

Hollywood Furniture Company, owned by J.E. Banks, 1923. To the left, number 1921 is the Hollywood Theatre. Young's photographer, Yale Studio, had offices on the second floor. Eventually the theater became the Ritz Theater, Banks moved elsewhere and the second floor of 1911 became a bowling alley. *Courtesy of the Broward County Historical Commission, gift of Katherine LaBelle.*

1945 and 1949 Monroe Street built in 1923 for Hattie Adler (on the left), and Phil Adler and his wife, in the California bungalow style. The family owned Adler's ladies wear store at 1914 Hollywood Boulevard. Pictured in the January 1924 *Reporter*, these homes still stand. *Photo by Yale Studio. Courtesy of the Hollywood Historical Society.*

Another new resident was William Mikel, born May 21, 1923, to Anna and Burpee Mikel, who lived on the boulevard at Twenty-fourth Avenue. William was considered to be the first baby born in Hollywood. However, it was later discovered that Altman Lee Aderholdt was born June 21, 1921, to Cora Belle and Alvin Lee Aderholt. Anna Mikel and Cora Aderholt were sisters, daughters of Walter Altman, who was the water-pump engineer for the FEC railroad, so the two "first babies" were cousins.

By 1923, Young must have realized that Florida's segregation laws were going to affect his black workers, not to mention likely black landowners. Therefore he bought more land on the high ground along the main routes, near Dania where there was already an established black settlement, and in August 1923, announced Liberia, a new town for African Americans. Frank Dickey's map, drawn in May 1923, shows forty square blocks around a circle park, with a half circle intended for a hotel, similar to Hollywood's Circle and Hollywood Hotel arrangement. The *Reporter* described Liberia as a town where residents controlled their own municipal affairs, where African Americans could share the prosperity that Hollywood had already brought to the east coast of Florida. Liberia was laid out in September, and when the land was opened, water and electricity were put in. The Young Company would donate land for schools, churches and parks, and had built four frame houses. Interest in Liberia was already being shown by affluent blacks, the *Reporter* noted.

Young also turned his attention back to his golf course, knowing that a fine golf course was a sure draw for visitors to Florida. Once again he called upon his

Young created an all-black city called Liberia after learning that segregation laws would prevent his black workers from living in Hollywood. The wide boulevard, begun 1923, was originally called Liberia Street (now Atlanta Street). As in the neighboring Little Ranches, the land was high and dry, and dotted with pines. Three workmen at the end of the road wait for another load of coral rock. *Courtesy of the City of Hollywood, Florida, Records & Archives Division.*

An early home in Liberia, 1923–1924, possibly that of Tom Hannibal and his wife. *Courtesy of the City of Hollywood, Florida, Records & Archives Division.*

friend Ralph Young to complete the eighteen holes and correct problems, such as bunkers that were put in wrong. Ralph and his wife Lena returned that summer and took a house at 1715 Buchanan Street.

Always in competition with George Merrick in Coral Gables, J.W. Young now hired the hot young Miami architect who had just designed a country club for Merrick, Martin L. Hampton. Hampton's design for the Hollywood Golf and Country Club appeared in several pages of the November 1923 *Reporter*. Located at the northeast corner of Seventeenth Avenue and Polk Street, the club would have a center tower and two wings. The December 1923 *Reporter* has a photo of the country club nearing completion and another of an extended railroad station also nearing completion. To convince the FEC to make a passenger stop at Hollywood, Young promised to build the station, which was completed in March 1924. This beautiful landmark, praised as the most imposing station south of Jacksonville, stretched between the FEC tracks and Twenty-first Avenue from Polk Street to Pierce Street. It had a central tower, tile roofs and arcaded wings, the epitome of the tropical Spanish look Young had selected. The architect's name has not been discovered; perhaps Hampton received this commission together with the country club. The contractor was Louis Bergeron of Miami.

There is no question that the four men who created new cities for south Florida in the early twentieth century knew each other and closely followed what each was doing. They were Carl Fisher, who developed Miami Beach, George Merrick who invented Coral Gables, Young who created Hollywood and Addison Mizner who

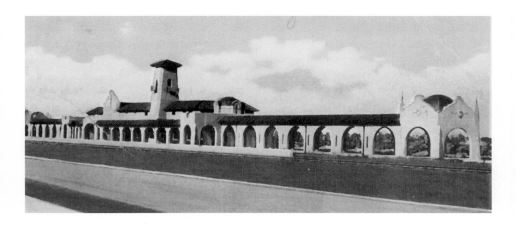

Florida East Coast Rail Road station, begun in 1923. The first passenger train, The Floridian, stopped here April 6, 1924. The beautiful station in Young's preferred California-mission style was demolished in the 1960s to straighten 21st Avenue. *1920s hand-colored postcard, courtesy of Bill Schaaf.*

designed Palm Beach and Boca Raton. Young had known Fisher in Indianapolis, and came to Miami following the impetus of Fisher's success there. It seems likely that Young also had known Addison Mizner's younger brother Wilson in California. There are no specific connections between Merrick and Young, but there are numerous references from other smaller developers about "seeing what Young was doing in Hollywood"; surely some of Merrick's team of designers did just that. A definite connection between all four was architect Martin Hampton.

Not only was Hampton working for Merrick, he had been hired for several buildings by Fisher. And at the beginning of his Florida career, Hampton had worked in Palm Beach with that most innovative architect, Addison Mizner. Mizner, a Californian who had been raised in Central America and studied in Spain, had already created the Palm Beach look, elaborate buildings vaguely based on Spanish palaces but with many quirky adjustments of his own. His multilevel interiors were even more elaborate, with odd stairways, fireplaces, balconies, sconces and overhead beams, all painted and gilded. Pulled together with the eye of a genius, the results were dazzling. In November 1923, Young's news magazine the *Reporter* noticed this, quoting from the *Indianapolis Star* under the heading "Homes of Old Spain Copied at Palm Beach." A "new type of architecture," the "architecture of the early Spanish centuries," is being developed in costly Palm Beach winter homes of Cosden, Satterwhite, Wood, Renfro, Wanamaker, Claffin, Vanderbilt and Replogle, the *Star* said. The architect of such homes was Addison Mizner. Seldom has an architect the opportunity to shape the dwelling places of a community in strict accordance with his one taste, but this is what has happened at Palm Beach, the article continued, where Mizner was the architect of all the houses that have been mentioned and many others. J.W. Young did not hire Mizner, but by bringing in Martin Hampton, Young had a direct connection to Mizner's work. For Hampton not only learned from Mizner, it is speculated that the younger architect did some of Mizner's interiors. If Hollywood buildings from about 1924 to 1927 became more elaborate and more Spanish, it is probably due to the influence of Martin Hampton and his experience working with Addison Mizner.

1924

The year opened with a grand extravaganza, the January 19 formal inauguration of the splendid Hollywood Golf and Country Club. Young had spared no expense to attract the posh crowd, and his efforts were rewarded. Crowds from Palm Beach to Miami came to dance on the open-air, glass-brick dance floor with its colored lighting, not just on that one evening but for many to come. By day, golfers were pampered with lounges in baronial Spanish style, from dark wood beams

overhead to tile flooring with handsome carpets. The open-air courtyard with its glass dance floor could be covered in rainy weather by means of a canvas roof on rollers, patterned after an Arabian tent, said the *Reporter*, no doubt thinking of Rudolph Valentino and *The Sheik*. Nothing quite like this elegant country club existed elsewhere; Hollywood was now a resort to be reckoned with. This was affirmed in the February 1924 *Reporter* in the article "Sol Meyer of Meyer-Kiser Bank Promises Great Things for Hollywood." The bank was in Indianapolis; Sol Meyer was a friend of Carl Fisher, who was developing Miami Beach (and inspiring Young and Merrick). Meyer stayed at the Hollywood Hotel and attended the opening of the golf and country clubhouse. He had seen Hollywood when it was "a veritable wilderness" and now praised Young for the "great work" he had done "creating wealth and opportunity for Florida."

With money flooding in, Hollywood needed its own bank. With the help of Miami financiers, in particular Ed Romfh, Young was able to open the Hollywood State Bank in February 1924 on the boulevard. There was also a need for another hotel downtown, so Young put Hampton to work again, designing the

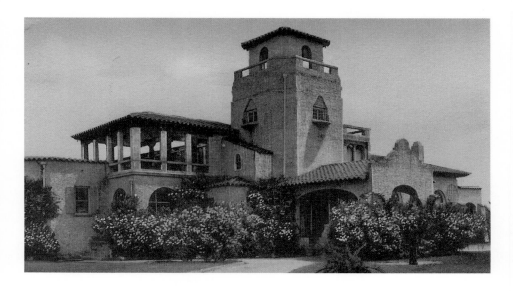

Hollywood Golf and Country Club, 1924, Olaf Owra, contractor. Sited at the northeast corner of 17th Avenue and Polk Street. Architect Hampton followed Young's wishes for a Spanish-eclectic design; elements such as the open second-story pergola at one side, also suggest Hampton's previous work with Addison Mizner. In the 1930s, the club was operated by Al Capone as a gambling establishment, then during World War II it was a popular entertainment facility for the armed forces. No longer extant. *Historic postcard courtesy of Bill Schaaf.*

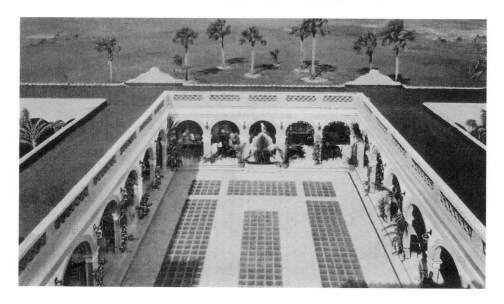

Hollywood Golf and Country Club 1924. Revelers danced on the famous open-air glass brick dance floor with its colored lighting. *Historic hand-colored postcard courtesy of Bill Schaaf.*

future Great Southern Hotel. Situated on the southwest quadrant of the great Circle, it was angled to catch motorists from both the "East" and "West" Dixies. Construction began in September. With one hundred rooms and a ballroom, the hotel cost Young more than half a million dollars. The three-story U-shaped building had a single-story enclosure across the arms of the U, facing Circle Park, leaving the upper stories open to the Trade Winds, an advantage in the years before air conditioning. This defining landmark of downtown Hollywood where J.W. Young carried out the business of building the city is endangered in 2005.

Farther west along the boulevard, Young had Hampton design more spacious quarters for his company. The result, called the Second Administration Building, was on the northeast corner of Twentieth Avenue. Other than the central element with balcony, crown and triple windows, the building is elegantly simple and classically balanced. Following the 1926 hurricane, it served as a morgue. In 1934 the Piggly Wiggly grocery chain moved its store here from Twentieth Avenue.

Quarters were continually needed for Young Company employees, so Young built a dormitory for hotel help on Twentieth Avenue and Polk Street, designed by Rubush & Hunter. Shortly this became the Casa Blanca Hotel for paying visitors to the city. In August, a dormitory for those working at the Beach Hotel was built at 2036 Van Buren; it became the Whitehall Hotel. For

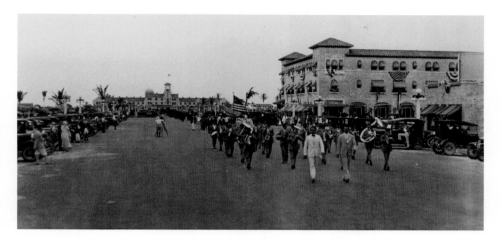

Parade passing the Great Southern Hotel, 1925, recorded by a movie camera. The Spanish-eclectic design, low towers, window surrounds and tiled roofline are combinations used by Hampton elsewhere. *Courtesy of the Broward County Historical Commission, gift of Max Sorolovitz.*

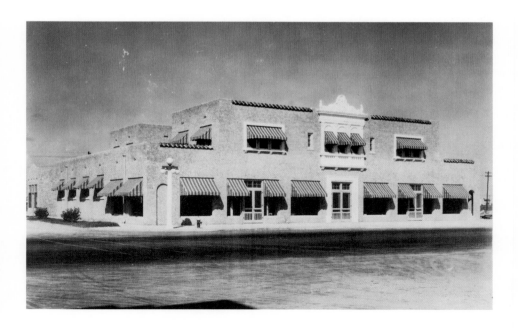

Young Company Second Administration Building, 1949 Hollywood Boulevard 1924, by Martin Hampton. J.W. Young had his office on the second floor behind the central triple windows. The site is now Anniversary Park. *Courtesy of the Broward County Historical Commission, gift of Mr. and Mrs. Joseph Mackay.*

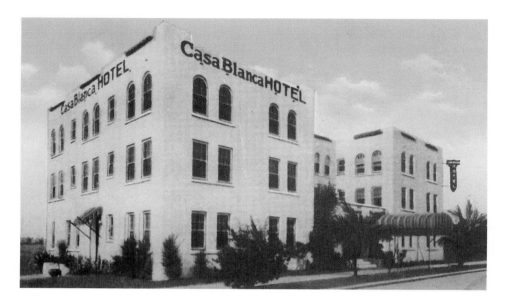

Built as a dormitory for hotel help on 20th Avenue and Polk Street in 1924, it soon became the Casa Blanca Hotel. Now used for different purposes, the building still looks much as it did in the 1920s. *Historic postcard courtesy of Bill Schaaf.*

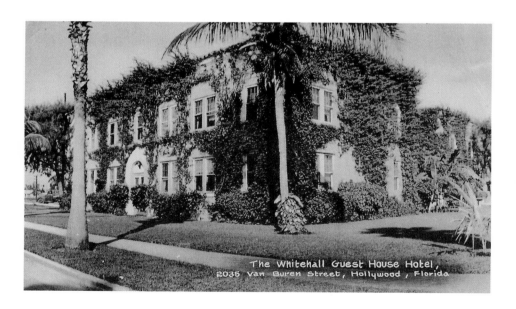

This building was begun in 1924 as a dormitory for Beach Hotel help, but was not completed until late in 1925, so it is not surprising that the 50-room building, not near the beach, became the Whitehall Hotel for paying guests. Still extant. *Historic postcard courtesy of Bill Schaaf.*

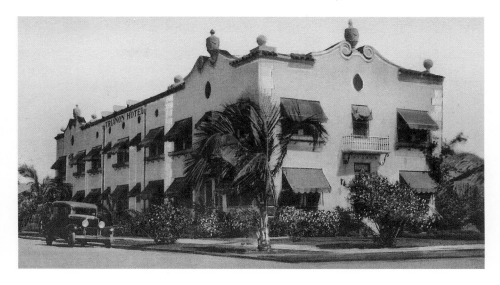

The elegant Trianon Hotel at 1957 Monroe Street was L shaped, with parapets borrowed from California missions. It was built in 1924 by the Whatley sisters from Chicago. *Historic postcard courtesy of Bill Schaaf.*

black workers, Young built a dormitory in Liberia that housed ninety-six men and was designed by his oldest son, Jack Young, according to the September *Reporter*. With visitors pouring in and housing scarce, others were also building apartment buildings around the city. Another designed by Rubush & Hunter for future Mayor Paul John was the Olive Apartments at 1800 Fillmore Street, while J.S. Matson commissioned architect Hampton to design the Flora Apartment Hotel at 1656 Polk Street, directly opposite the country club. It opened that May 1924, and is still in operation. Kitty-corner from the Flora on Seventeenth Avenue, Harry Hutchinson built the Hutchinson Hotel overlooking the country club with its elegant arcaded entrance. Also in 1924, the Whatley sisters from Chicago built the elegant Trianon Hotel at 1957 Monroe Street. The Whatleys would eventually become linked to the Youngs when Marion "Babe" Whatley married Billy Young in 1937. Catherine Fitzgerald, another Whatley sister, bought Fitzgerald Court, established in 1924 at 2201–07 Polk Street, consisting of six small frame houses. Tourist courts like this were springing up all over the city, particularly in the Little Ranches and along north Eighteenth and Nineteenth Avenues, the area closest to the city of Dania. West on the boulevard at 2450 was the Chandler Hotel, and still farther west was McCutcheon & Peck's Tourist Camp. West on Johnson Street at Thirty-fifth Avenue were the Hendrick Hudson apartments.

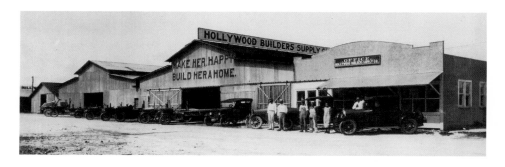

Southern Mill & Bungalow Company, also known as Hollywood Builders Supply, was both lumberyard and millworks, with its own rail siding. Later, James Mack bought the complex and renamed it Mack Lumber Company. Not extant. *Courtesy of the Broward County Historical Commission, gift of Mr. and Mrs. Joseph Mackay.*

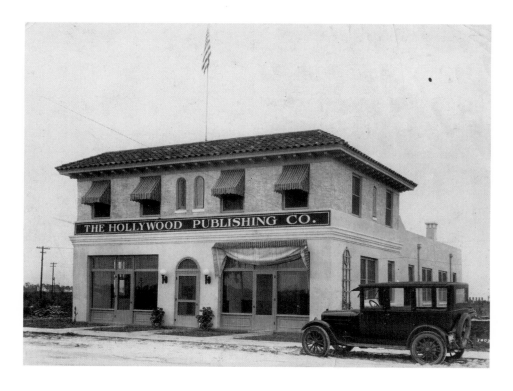

Hollywood Publishing Company, built 1924 but soon outgrown, when the company publishing enterprises moved to Hollywood Boulevard. When Hollywood became a city on November 28, 1925, this building, not occupied at that time, served as Hollywood's first City Hall. Note that 21st Avenue has a white rock surface but is not yet paved. *Courtesy of the Broward County Historical Commission, gift of Mr. and Mrs. Joseph Mackay.*

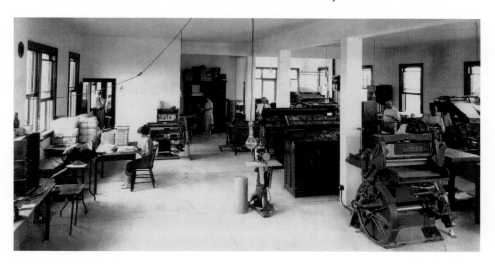

Hollywood Publishing Company, second floor, press room in 1924. Although expanded, the original structure remains and is recognized as a landmark. *Courtesy of the Broward County Historical Commission, gift of Mr. and Mrs. Joseph Mackay.*

Businesses supplying all this construction included Southern Mill & Bungalow Company, belonging to the Hollywood Land and Water Company, on Twenty-first Avenue stretching north from Garfield to about Taft Street. It was also known as Hollywood Builders Supply Company. Sand and gravel were now produced by Meekins Cement Block at 2027 Johnson Street. To generate news and publicity, the Young Company built its own printing plant, Hollywood Publishing Company, at 219 North Twenty-first Avenue. The architect for this handsome building, begun in July and described as "Italian Renaissance," has not been discovered and was probably either Hampton or Rubush & Hunter. The first department store on the boulevard at 2024 was opened by Louis Brown. Across the tracks, on the Dixie Highway was the Accurate Garage, Jane Short, proprietor.

Development of the beach First Addition had been continuing apace; Johnson Street there was lined with shops and the Hollywood Beach Casino pool complex, designed by Martin Hampton, was under construction. The Young Company had already built the Tangerine Tea Room on the north corner of Johnson Street and the Broadwalk. In 1924, the company built the Theatre Under the Stars band shell on the Broadwalk at the head of Johnson Street. The first two homes on the beach were built in February by the Franks from Buffalo, New York, and in March by the Russos. J.L. Frank's two-story stucco house was "three blocks south of the proposed Casino," a site not definitively identified but probably 325 Buchanan Street. The Daniel Russos' home at 324 Indiana Street, built

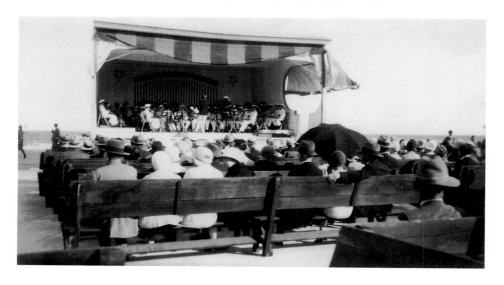

Theatre Under the Stars. Ever ready to entertain visitors, in 1924 the Young Company built a three-sided band shell on the Broadwalk at the head of Johnson Street and provided band concerts. *Photo by Valentine Martin. Courtesy of the Hollywood Historical Society, gift of Patricia Martin.*

1924, still stands, although modified. Here Dr. Harrison Walker established and operated Hollywood's first hospital, called Gulfstream Hospital, until the Depression caused him to close in 1929. A third recorded beach home from 1924 was designed by Hampton and built by a couple named Mr. and Mrs. W.B. Symmes from New York and Atlantic City at the Broadwalk and Harrison Street with apartments above and an arcade below. This handsome "Mexican" adobe stucco building did not survive the 1926 storm surge.

In July 1924, Ocean Drive, the first road on the beach, was begun at Johnson Street, heading south.

The East Marsh, where the two artificial lakes were being dredged, was sufficiently drained by March 1924 so Young could at last envision Hollywood Boulevard extending from Seventeenth Avenue east to the Inland Waterway. Road or no road, construction was now being readied for the first real bridge in Hollywood to cross to the beach at the boulevard and lead directly to the site of Young's anticipated magnum opus, the Hollywood Beach Hotel. From the first moment Young drew his plans for Hollywood by-the-Sea, he must have intended to have a major hotel at this very site, for it is due east, straight down the hundred-foot-wide boulevard, from the initial turnoff at the Dixie Highway. Young had waited four years for roads to reach it, but it would still be another

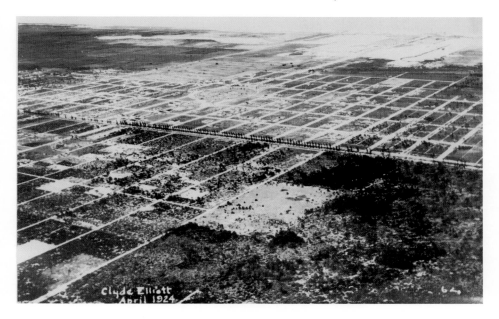

Aerial view of Hollywood in 1924 looking east over the FEC railroad, seen crossing the center of the photo, lined by Australian pines. Above is the Golf and Country Club. At top is the Atlantic Ocean, with North and South Lakes just below, right. The land surrounding them is not completely drained—the edges appear marshy and there is an island in North Lake. The large lake at left is West Lake. A tiny circle between West Lake and the ocean must be Duck Lake. *Photo by Clyde Elliott. Courtesy of the Hollywood Historical Society, gift of Mrs. A.C. (Lamora) Mickelson.*

year. The March *Reporter* quoted chief engineer Frank Dickey as saying it would take from six to eight months to complete the lakes. Then time would have to be allowed for the water to drain and the land to settle. "By this time next year," said Dickey, "it is hoped that Hollywood Boulevard will be paved through to the ocean and that building will be possible."

Few people other than Young were as important to the development and growth of Hollywood as Dickey. He oversaw the platting and surveying of the original lots, streets and lakes, and worked closely with Charles H. Windham to construct Port Everglades Harbor. Dickey served three terms as a Broward County commissioner, and from 1935 to the 1940s, he was Hollywood city manager. His home was at 1941 Jackson Street.

Frank Dickey's description of dredging North and South Lakes is interesting. He said, in the March 1924 *Reporter*, that all the soil in the lake basins would be removed down to the coral rock bottom, which varied from only a few feet to

Hollywood Land and Water Company Chief Engineer Frank Dickey wore bow ties. The other man in this undated photo is George B. Hills. *Courtesy of the Broward County Historical Commission, gift of Valentine Martin.*

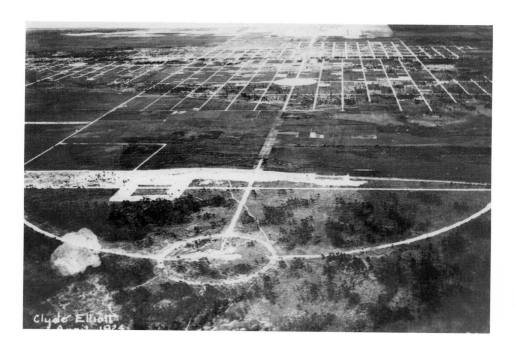

Aerial view from the third circle, site of a future "vista," the Hills Hotel. Only one crescent drive has been laid out. Farther east is the second circle at 26th Avenue. *Photo by Bobby Yale, signed by Clyde Elliott. Courtesy of the Broward County Historical Commission.*

nine or ten feet in places. Many tons of rock were being removed from the lake bottoms for paving streets nearby and on the beach. The soil now being removed, he said, was solid muck and marl of unsurpassed fertility, which he anticipated would lead to "a profusion of picturesque adornment of the parkways and walks bordering the lakes." The company would plant thousands of palms of all varieties, as well as flowers of all kinds.

The Youngs were still living in the Hollywood Hotel, also known as the Park View Hotel, but Young was ready to plan for an imposing family home. The September *Reporter* announced that architects (Rubush & Hunter) had drawn plans for the Young home on an entire block on the beach, one mile north of Johnson Street, on a large lake in the center of the block. This home was never built, and the natural lake, called Duck Lake, was gone with the wind in 1926, completely filled with sand. (See image on page 49.)

With beach development moving along, if slowly, Young continued to push west and south. A second ornamental circle was planned for the boulevard and Twenty-sixth Avenue. This was surveyed in 1924 by A. Louis Platt, who became Tony Mickelson's chief of party for the Little Ranches section of town. The third and final circle on Young's grand plan would be in the Hollywood Hills section. Engineer Sam Whitehead laid out the Hills with its several crescent drives beginning in January 1924. In 1924, Whitehead was living in the Lincoln Hotel, 2144 Lincoln Street, built in September 1923, the first hotel in the Little Ranches.

Young's news magazine, the *Reporter*, regularly describes beautiful "drives" for the auto-owning public. Working with a flat terrain that had few natural sights besides the ocean (which did not yet have roadways open to cars), Young created scenic drives such as the broad boulevard and wide Circle Park, planned drives around North and South Lakes, and crafted the several crescent streets curving around the third circle, which in time would hold a "vista," the Hollywood Hills Hotel.

In May 1924, the *Reporter* announced a movie being made for advertising purposes, called *The Building of a City*. The Kniffin-Coutant Photo Film Company of Hialeah Studios, Miami, filmed two reels of more than two thousand feet of views of Hollywood, with two days of filming. Everything under the sun in the new city was included, from the Broadwalk to the distant rock pit, the unfinished railroad station to an "aeroplane" landing on Hollywood Boulevard. No copies of this film are currently known, but movie photographers may be spotted in still photos of the city.

At about this time, Young acquired more land along the city's south border, and as the presidential street names began with Washington and moved north, names were needed for the new streets south of Washington in the South Hollywood Addition. The engineers suggested Dickey, Mickelson, Attaway, McCarrell and so

on, but Young demurred. Mickelson, a navy man from World War I, then suggested admirals, which is how the streets from Dewey to Moffat were named. (Another version of the story is that Young recommended the engineers' names, but in any case Mickelson chose the navy men.) Among those living in "the Admirals" were Jack Young who rented a place on Dewey Street in 1924 between Nineteenth and Eighteenth Avenues, and dredger R.H. Anderson who lived at 1708 Wiley Street.

Others were beginning to settle in new houses. Hollywood Land and Water Company top salesman J.M. Kagey and wife Eva built "a handsome home on Harrison, for $35,000 in the domestic Spanish style" (September 1924 *Reporter*) at 1650 Harrison, now the Hollywood Art and Culture Center. C.W. Sammons, general sales manager, Miami division, built his mansion at 909 Hollywood Boulevard by September 1924. Benjamine Adler is listed at 1300 Tyler Street, the Relda Hotel, which she and her husband Sol owned. Mark Tully, one of Hollywood's first independent realtors, at 1917 Jackson Street, was a neighbor of chief engineer Frank Dickey and wife Orpha at 1941 Jackson Street. William Cozens owned several properties including 719 South Seventeenth Avenue. James and Gertrude Newman lived in a cabin they had built at 1512 North Nineteenth Avenue. The Newmans gradually enlarged their home. James Newman was one of the lecturer-salesmen who gave inspiring speeches in the sales pavilions. June and William Pyne were at 1812–18 Madison Street—she was Hollywood's first policewoman. A neighbor on Madison Street was attorney L.O. Casey, general counsel for Hollywood Land and Water Company; he served on the city Charter Committee and with T.D. Ellis Jr. wrote the city charter. Ellis lived at 1643 Madison Street. Also on Madison at 1832 were C.C. and Sarah Freeman; he was on the city Charter Committee and later served on the Broward County Port Authority (Port Everglades). C.W. Zimmer built three houses on Adams Street, including a bungalow at number 1719; Zimmer was editor of the *American Poultry Journal*. The home of Louis and Sarah Sokolow Brown was at 1947 Adams Street. They also owned Brown's at 2024 Hollywood Boulevard. William Jennings and Ira Guthrie were both on Jefferson between Eighteenth and Nineteenth Avenues. Guthrie was secretary-treasurer of the Hollywood Land and Water Company; Jennings was director of the landscape department. George and Susan Young lived at 1912 Van Buren Street; George was also on the city Charter Committee. Margaret and Merrill H. Nevin were landscaping their new home on Jefferson Street (number not located) after selling their house at 1616 Monroe to Dr. James Hartley.

Frances McNicol, known as Fannie, and her husband were vacationing in Fort Lauderdale from St. Louis in 1924 when the Broward County school superintendent put out a search for a teacher to replace the present teacher, Miss Gertrude Brammer, who was finding herself unable to cope with the ever-growing

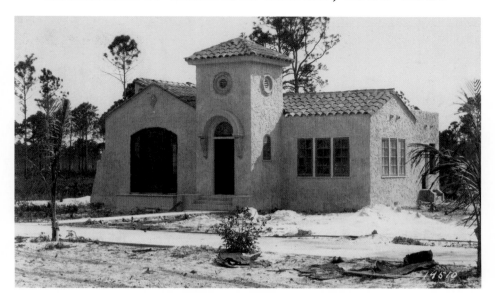

One of many homes built by the Meyer-Kiser company, 1924, with Spanish-eclectic attributes: cross-gabled tile roof, arch over the door, asymmetrical layout, focal window, stucco surface and tower. Exact location on Tyler Street unknown. *Courtesy of the Broward County Historical Commission, gift of Mr. and Mrs. Joseph Mackay.*

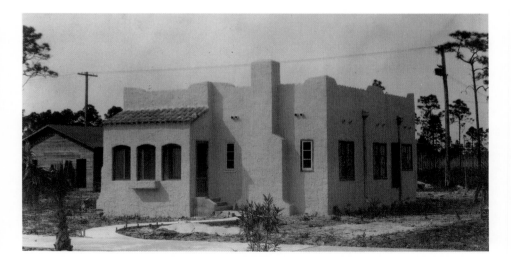

This Meyer-Kiser home is classic pueblo revival, lacking only projecting roof beams. Typical are the flat roof, stucco walls and irregular rounded edges of corners and parapet. Houses in this popular design may be found all over Hollywood. *Courtesy of the Broward County Historical Commission, gift of Mr. and Mrs. Joseph Mackay.*

influx of schoolchildren. The school had been moved from the Messick house to the Young Company's first sales pavilion at Nineteenth Avenue and Harrison Street, and was beginning to overflow with pupils from all over the United States as well as Cuba and South America. Mrs. McNicol accepted rather reluctantly and was put in charge of the "junior high school," forty pupils in the seventh and eighth grades alone. The entire enrollment was closer to one hundred students, all studying in an open pavilion. Apparently hardy pioneer stock like other Hollywood settlers, the McNicols moved to 1447–49 Madison Street. She continued to teach and her husband became postmaster, and years later McNicol Middle School at 1602 South Twenty-Seventh Avenue would be named in Fannie's honor.

The Meyer-Kiser Corporation built a number of homes in September 1924 on Tyler Street, from Seventeenth Avenue east as far as the land was drained. Meyer-Kiser commissioned Rubush & Hunter to design a variety of prestigious homes for the properties they owned there. The architects provided about twenty designs in tile, stucco and cast stone, often asymmetrical with a tower at one side, with moon gates, triple Palladian windows, balconies, urns and the like. Another builder, or perhaps working with Meyer-Kiser, was Sol Adler, whose Adler Construction Company had headquarters at Tyler Street and Thirteenth Avenue. The Young Company also went into the home-building business in September, starting thirty new homes to be sold with their lots (addresses not located).

Well to the west of Young's land, in what would only later become Hollywood, another developer, Robert L. Conlon purchased land along future State Road 7 and laid out streets. Conlon's property on the west side of what later became State Road 7 extended from Pembroke Road to Hollywood Boulevard; on the east side from Pembroke Road to Johnson Street. Conlon later described his subdivision as a "miniature Coral Gables," with a fountain as the centerpiece and streets named after Florida trees. In 1925-1926 homes were built there in the Spanish style. As with J.W. Young, Conlon's fortunes failed with the Depression and that area remained barely inhabited until after World War II. At least two of the homes he built in 1925 are still standing, at 6103 and 6131 Mayo Street.

In the Little Ranches, Sylvester and Laura Carpenter lived at 2317 Hollywood Boulevard; Enart Banks, who owned Hollywood Furniture Company, lived at 2412 Madison Street. On Polk Street, Bennett L. and Mildred David built a substantial CBS home (cement block and stucco) at 2115 where they would raise eight children, several of whom became prominent in the city. Next door to Tony Mickelson were William and Ida Swabey, who had a coral rock house that still stands. Bill was a World War I army veteran given to blowing taps on his bugle; the Swabeys raised chickens throughout World War II. It was a treat for the little girl next door to collect the eggs. Architect Jack Davidon, who designed the

Harry Pringle, Hollywood's third and fifth mayor, elected in the first municipal election in 1927 and again in 1931. His home was at 1708 Cleveland Street. *Courtesy of the Hollywood Historical Society.*

O'Sullivan rooming house at 2021 Pierce Street that spring, had property on Van Buren between 2600 and 2700, near future City Hall Circle.

Near the town center, future Mayor Clarence Moody, still head of utilities for Young, had a house at 1949 Taylor Street. Harry and Ida Pringle lived at 1708 Cleveland—Harry was Hollywood's third and fifth mayor. J. Rogers Gore was listed on Fillmore Street between Nineteenth and Twentieth Avenues, possibly the Alva Hotel. He was editor of the new *Hollywood News* that began in January 1924. The blocks between Eighteenth and Twentieth Avenues, particularly from Johnson Street north to Sheridan, were filled with cottage courts, for example, Navajo Court, 1933–35 McKinley, which had twelve cabins. Victor Court at 2314 Pierce Street and Everglade Court at 2240–46 Pierce are other groups of cabins shown on the 1926 Sanborn map. Sanborn city maps are published for municipalities, particularly the fire departments; they indicate every structure and are updated regularly. The 1926 Sanborn map is valuable for indicating the city's built environment before the 1926 hurricane.

Hollywood had become a settled community as well as a resort. As early as 1922, the Chamber of Commerce of Hollywood by-the-Sea, Florida, was begun, with W. Ward Kington named president. His wife Minnie helped found a Ladies Community Club, in December 1922. The group became the Hollywood Woman's Club in 1923, and Mrs. Kington was the president in 1924 and 1925. At this time, J.W. Young gave the club land at North Fourteenth Avenue, opposite and east of the golf course. There the women built a clubhouse, now listed on the National Register of Historic

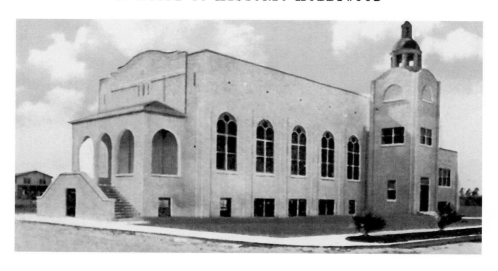

First Methodist Church, 1924. The original building, shown here, was the first church built in Hollywood, in 1924. Severely damaged in the 1926 hurricane, it was rebuilt by 1927 and still stands. *Historic postcard courtesy of Bill Schaaf.*

Places. It was designed by architect Frederic A. Eskridge as a frame cottage with a neoclassical entrance graced by a classical pediment and Corinthian columns. The first president was Orpha Dickey. A Junior Chamber of Commerce was organized in 1924, naming engineer John J. Gleason as president. This group published a detailed *Greater Hollywood City Directory* for Hollywood by-the-Sea, 1926.

Musician Philip Vitsky lived in the Waverly Apartments at 310 South Seventeenth Avenue in the 1920s. He operated the Western Union telegraph office; a former vaudeville performer, he wrote the song "Hollywood-by-the-Sea" in 1924. After the 1926 hurricane, Vitsky with other local entertainers helped keep up the morale of refugees and patients recovering from the storm.

The Methodists were the first religious group to form a congregation, as early as 1922. By March 1924, a "$30,000 Methodist church" was under construction, according to the *Reporter*, at Van Buren Street and Eighteenth Avenue, from Rubush & Hunter designs.

Up till now J.W. Young had been in a sense a benevolent despot as he owned all the public buildings and all land that had not been sold to others. It seemed time to incorporate as a city. In March 1924, the Charter Committee was formed. Members were James Boehm, L.O. Casey, Clyde B. Elliott, C.C. Freeman, Joe Gumberg, Frank Hosbein, Harry Hutchinson, Merrill E. Nevin, Ned Sawyer and George Young. Young Company attorney Larry Casey with

independent attorney T.D. Ellis, Jr. prepared the final charter, which was adopted November 28, 1925.

In March 1924, another community was established that would in time be connected to Hollywood. This was the Seminole Okalee Indian Village, 481 acres creating a reservation for the independent tribe on both sides of Stirling Road at State Road 7. Hollywood then ended at Sheridan Street and near future State Road 7; today Hollywood surrounds the Seminole reservation lands. Interestingly, the *Reporter* had a piece on the Seminoles in the December 1923 issue. The magazine stated that the tribe has high moral standards, and divorce and gambling were unknown.

At the end of 1924, J.W. Young took another momentous step, possibly even more far-reaching than creating a city. In the name of the Hollywood Harbor Development Company, he purchased 1,440 acres from John F. Warwick around Lake Mabel (or Bay Mabel). The land included submerged and mangrove-covered land, north of Dania and south of Fort Lauderdale. Here Young envisioned a deep-water harbor that would serve U.S. cities along the Atlantic coast, with shipping eventually reaching down to South America. In a great hurry, as usual, Young wanted the mangroves cleared and dredges put to work. John Gleason, whose Vermont family had logged

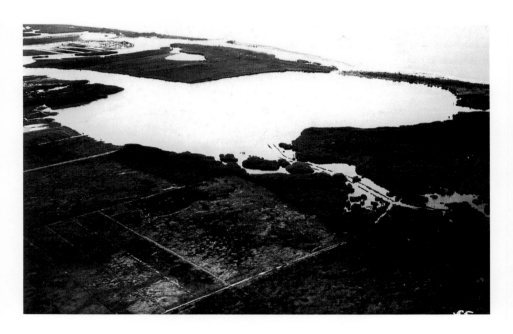

Pristine Bay Mabel purchased 1924 by Young's Harbor Development Company. This photo of the future Port Everglades was included in bound books of photos carried by salesmen for the Hollywood Land and Water Company. *Courtesy of the Hollywood Historical Society, gift of Raymond Thompson.*

their property for more than two centuries, decided to bring expert lumberjacks for this difficult job. Gleason went back to Woodford that winter, hired thirty-five French Canadian lumberjacks and brought them down by train and steamship. It took them only one month to clear the future Port Everglades, then most returned home.

Young was able to sail around his watery properties beginning that December, when his new yacht, the *Jessie Faye* was launched.

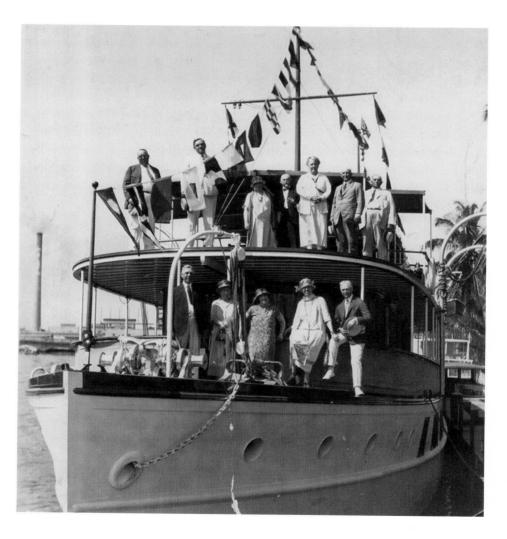

J.W. Young and friends on his yacht the *Jessie Faye*, 1925. J.W. is on the upper deck, far left. Others not identified. Embossed bottom left is "Yale Studio Hollywood, Fla." Bobby Yale was Young's official photographer. *Courtesy of the Broward County Historical Commission, gift of Mr. and Mrs. Joseph Mackay.*

1925

In just five years, Hollywood, Florida, had grown from undeveloped farmland supporting no more than five families to a thriving city of more than twenty thousand inhabitants. A brochure published by the Hollywood Land and Water Company in June 1925 described the city: the first city begun with a zoning system and with more than one thousand residences (all stucco with the Spanish-style predominating). Listed amenities included a railroad station, hotels (Park View, Great Southern and Lincoln), the Hollywood Golf and Country Club, a post office, a theater, a furniture house, a department store (Brown's), the new company Administration Building, Hollywood Publishing Company, an electric-light plant, waterworks and a fire station. Industries mentioned were the lumberyard, electric laundry, concrete block and tile mills and ice plant. There were also parks listed: Circle Park—a showplace of Florida, ten acres in the city center; a twenty-acre park being developed in new highly restricted residential section, Hollywood Hills; a block set aside for recreation (Jefferson); a water works park (Polk Street); five artificial lakes; and a five-and-a-half-mile cement walk on the beach nearing completion. Add to these a "jack knife" design bridge over the Inland Waterway and a school. Future developments noted in the brochure included a $3 million hotel on the ocean, booking for January 1926; bathhouse/casino nearing completion; and a tent city being constructed.

The electric-light plant that had been developed by Young's company at Twentieth Avenue and Pierce Street became the Florida Power & Light Power Station in 1925 and was enlarged. East of it was Hollywood Cold Storage. The Hollywood Electric Laundry was at Hayes Street and Twenty-first Avenue, and there are other laundries indicated on the June 1926 Sanborn map at 2409–15 Monroe Street and 2308 Taylor Street. The ice plant formerly owned by the Beebes had been bought by the Pure Ice Company, or Purity Ice & Cold Storage Corporation, in 1925 and moved to 2200–04 Jackson Street.

The impressive wide bridge over the Inland Waterway (still the Florida East Coast Canal) was completed in the spring of 1925 by engineers from Donnell-Zane, a New York bridge-building concern. The term "jackknife" probably described each of the two sides of the bridge, which opened upward in the shape of a jackknife to let boats pass, instead of swinging sideways over the water. Engineers were also working to bring what would be Ocean Drive south down from Johnson Street, thereby opening the beach to vehicle travel. Paths were thus gradually converging toward Young's magnum opus, a grand hotel on the Atlantic Ocean, at the east end of his broad boulevard.

Young's original city plan indicates that the boulevard with its central Circle Park has culminating vistas at either end. On the ocean, set off by the twin lakes

Boulevard Bridge, 1925, cost $110,000. During World War II, marine sentries guarded the bridge, allowing only those with proper credentials to pass to the beach. *Historic postcard courtesy of Bill Schaaf.*

across the canal, Young planned for a magnificent hotel. As early as 1922, this hotel was described in the *Reporter* as the mammoth beach hotel, modeled after the Virginia Hotel in Long Beach, California, one of the most deluxe hostelries on the Pacific coast; the Hollywood beach hotel would be second only to Henry Flagler's Royal Palm Hotel, a sprawling frame structure with 450 rooms (100 with private baths) built in Miami at the mouth of the Miami River in 1896 and still in 1925 the choice resort for the social crowd. Rubush & Hunter were commissioned to design the Hollywood Beach Hotel and had drawings made by February 1925. This grand resort had rooms for five hundred, a ballroom, an ornate dining room as well as sumptuous lobbies. Much of the design was the work of Philip A. Weisenburgh from Indiana, who, as the architectural firm's master of ornamentation, was responsible for office and design supervision of all Rubush & Hunter Florida commissions. To reach the proposed site of this focal point of his city, Young had swamps drained, land created, roads built over sand and a bridge installed, at a cost of millions. At last in the spring of 1925, construction vehicles and materials could reach the site and work began. Foundations for the huge structure on the sandy beach island were laid by Olaf Owra, a Norwegian who had been in Hollywood since 1922. Superintendent of construction was Clyde Reed from Reading, Pennsylvania. Work on the hotel

went on twenty-four hours a day for six months, under lights at night, in order to have the luxury hotel open by January 1926.

Meanwhile, at the other end of the beach, the Young Company was selling property north of Johnson Street and erected its last sales pavilion between Garfield and Connecticut Streets.

The Lakes section was sufficiently drained in 1925; lots had begun to appear all the way to the canal. F.O. Van Deren, vice president of the Young Companies, built an elaborate mansion at 1455 Harrison Street, best described as Spanish eclectic with its textured stucco walls, cross-gabled roof with variegated tiles and interesting details, such as the arched grill over the entrance. Another beautiful home on Harrison Street at 858 belonged to G.M. Stratton and was one of the showplaces of the newly created Lakes section. Stratton had sold Young the farmland he owned that was west of future Thirtieth Avenue. This would become the newest section of the city, which Young called Hollywood Hills. Contractor Eric Skoglund built himself a home at 1025 Tyler Street. The large house is no longer extant, but photos suggest it bore Moorish as well as mission details. Well ahead of the crowd, William Cozens built a handsome stucco home that stood in lonely splendor on the north side of brand-new North Lake. It was first numbered 818 Lincoln Street, then 815 North North Lake Drive, and lonely it remained for decades as North Lake failed to develop until midcentury.

In addition to the Meyer-Kiser company, other builders were at work erecting prestigious homes in the new Lakes section. Much of the new construction was considerably more elaborate than earlier homes. Young's *Hollywood Magazine*, successor to the *Reporter*, in the April 1925 issue said that the influence of Spain, the Moors' lost paradise, and sister Romance countries could be seen in Palm Beach, where Addison Mizner, more than any one other person, was responsible for the Spanish trend. This reference suggests that Mizner's influence was visible in Hollywood as well, although Mizner himself did not work in Hollywood.

In July 1925, Rubush & Hunter drew up plans for a baronial twenty-three-room Spanish-Moorish mansion for J.W. and Jessie Young and their sons, and construction began at 1055 Hollywood Boulevard. Weisenburgh was responsible for the design. The exterior of the house represents the more elaborate form that Hollywood architecture was developing, called Spanish eclectic, with designers borrowing freely from all periods of Spanish architecture and probably also from Mizner. The house, which is on several levels, has flat roofs and mission parapets, a tiled shed roof over the arcaded window and a Moorish archway surrounding the front door. The stucco surface is heavily patterned; balconies appear below slit windows. Inside there is much use of patterned colored tiles and iron grill work. Above the second floor, there is an open pergola where J.W. could look east

J.W. Young required his executives to live in the new city. F.O. Van Deren spared no expense when he built this elaborate Spanish-eclectic mansion in 1925. (Virginia TenEick in her book incorrectly identified this as the Sammons home.) *Courtesy of the Broward County Historical Commission, gift of Mr. and Mrs. Joseph Mackay.*

to the ocean and watch the Beach Hotel under construction, and from the other three directions, he could see his city rising.

Private homes of all kinds sprung up all over the city, most heavily in the areas between Twenty-sixth and Fourteenth Avenues on both sides of Hollywood Boulevard. Some of interest include 1612–14 Adams Street, home of the Reverend Thomas Sprague of the First Baptist Church; 2239 Atlanta Street, home of D. and Prudence Pratt and considered one of the earliest houses in Liberia; and 1637 Jackson Street, the home of Charles and Mary TenEick. Charles TenEick, who worked as an engineer for the city, later became postmaster. A good example of mid-1920s Hollywood Spanish-eclectic architecture, the house is notable for the arcaded wing wall (at the right side); the focal, arched triple window; the combination of one and two stories and cross-gabled roof; and the tiled roof.

Frank Burton had built a home at 1860 Jackson Street in June 1922. After the Youngs' oldest son Jack married Mickie (Mildred Albright) in February 1925, they lived here for a time and daughter Rene Ann was born here. This house is no longer extant. Dr. Bruce Butler moved to 1737 Jefferson Street in 1925. Charles

Charles and Mary TenEick home, 1925–26; she was a botanist. With relatives in 1930, they stand in front of their Jackson Street house, a good example of mid-1920s Hollywood Spanish-eclectic architecture. The house still stands, though modified. *Courtesy of Charles Watson TenEick Jr.*

and Mary Zinkil lived at 1740–42 Jefferson Street. Their son William would be mayor of Hollywood (1955–1957 and 1959–1966), then would be elected state representative and state senator. O.E. Behymer's home was on Madison between Eighteenth and Nineteenth Avenue (exact location uncertain). He was editor-author of the *Hollywood Reporter*. Thomas McCarrell, builder of the Hollywood Theatre, lived at 1841 Monroe Street. Well to the west, the Beerbowers built a bungalow at 2700 Plunkett Street.

Not all the homes advertised by the Young companies were ornate, or California-Spanish or stucco. A frame house marketed in the Young Company salesmen's books at Johnson Street between Sixteenth and Seventeenth Avenues is still extant. Literally hundreds more houses were built in 1925 and early 1926, as indicated on the June 1926 Sanborn map.

Several apartment-hotels must be mentioned, chief among them the elegant Villa Hermosa once at 1908–11 Jackson Street, built by J.W. Young's close friends Edythe and Edwin Whitson. Nearby between Madison and Monroe on Seventeenth Avenue was the amusingly named Vista del Colegio, or View of the School, that is, Hollywood Central. The building was a replica of a California

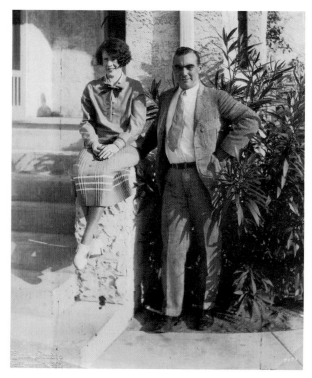

Jack and Mickie Young. In February 1925, J.W. and Jessie Young's oldest son John (Jack) married Mildred Albright (Mickie). *Courtesy of the Broward County Historical Commission, gift of Mr. and Mrs. Joseph Mackay.*

William Zinkil, Hollywood's mayor from 1955 to 1957 and again from 1959 to 1966. In the 1920s, his family lived in the mission-style home at 1740–42 Jefferson Street. Bill Zinkil was also a founder of the Hollywood Historical Society. *Courtesy of the Hollywood Historical Society.*

Homes to suit every pocket were marketed in the Young Company salesmen's books in 1925. Numerous others like this one are still extant. *Courtesy of the Broward County Historical Commission, gift of Mr. and Mrs. Joseph Mackay.*

adobe ranch. C.F. Brodbeck, manager of the deed, contract and abstract department for Hollywood Land and Water, lived here in 1925. The Wellinger Apartments at 1818 Jackson Street were the home of young marrieds Jimmy and Mary Mack and Virginia Elliott and Harold Lathrop. Jimmy Mack would buy the Hollywood Builders Supply at the close of the twenties and rename it Mack Lumber Company. Harold Lathrop arrived in Hollywood driving one of the Young Company's White buses.

Addresses of these and other Hollywood residents can be located thanks to the efforts of the Junior Chamber of Commerce. Under John Gleason, president, the JayCees published a substantial Greater Hollywood City Directory of Hollywood by-the-Sea in 1925 for 1926. Gleason's sister Lamora arrived by steamship on the Clyde Lines in August 1925. As John was living with Mickelson and other engineers, Lamora stayed at the Trianon Hotel.

The June 1926 Sanborn map indicates a profusion of cabins and cottage courts in the areas between Eighteenth and Twenty-fourth Avenues from Dania south to Taylor Street. These are variously named Adlers Court, 2113 Johnson Street (probably Sol Adler), and Whitehouse Gardens, 1930 McKinley Street (there are many unnamed houses on McKinley between 1707 and 1818). At the boulevard were Cree Court, 2209–15, Zimmer Court, 2224–30 and several

Villa Hermosa, the elegant Jackson Street apartment-hotel built by Edythe and Ed Whitson in 1925. After the 1926 hurricane, they housed 200 refugees and fed an additional 300 every day, including workers with the Red Cross and National Guard. Not extant. *Historic postcard courtesy of Bill Schaaf.*

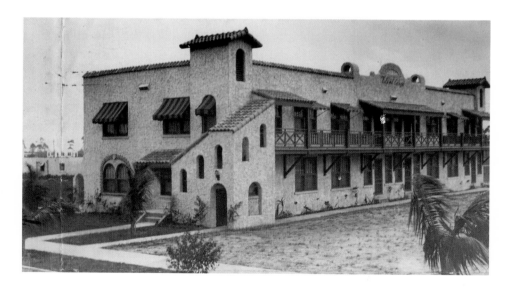

Vista del Colegio, between Madison and Monroe on 17th Avenue, with second-floor balcony suggesting a California-adobe ranch house. The 1925 photo was included in the Young Company's salesmen's books. *Higby Photo Co. Courtesy of the Broward County Historical Commission, gift of Mr. and Mrs. Joseph Mackay.*

more with unknown owner. At 1606–18 Harrison was a group of nine buildings. Jackson Street had Cherokee Court at 2145 and Seminole Place at 1724–40. Laura Place at 2233–39 Tyler Street had another row of cottages, and Crossley Court at 2317–23 Van Buren Street had thirteen.

Eager to bring visitors to stay on Hollywood's fine beach, Young had Tent City built at Surf Road and Washington Street in the fall of 1925. These were not exactly tents, but cabins with canvas roofs as well as floors, rooms, kitchens and baths that could house hundreds of campers. Provided were all amenities, including a communal lounge area, library and cafeteria. The July 15, 1922 *Reporter* says the Hollywood Land and Water Company will be introducing "tent cities," a new idea already popular on California beaches, including the Catalina Islands. The long description explains that a tent city was laid out in streets with stores, cafeterias and the like. Each tent was equipped with running water and electric lights. Individual tents varied from two to four rooms or more. Young planned to start with accommodations for one hundred families but expand to house several thousand people as a permanent feature. (The tents shown in some photos that are all canvas were the tent housing for the Beach Hotel workers.) Needless to say, all the tent housing was blown away in the 1926 hurricane, never to be rebuilt.

Hollywood Central School opened in March 1925, an elegant structure built to designs by Rubush & Hunter in the Spanish style on the city block between Madison and Monroe Streets and Eighteenth and Seventeenth Avenues. With its deeply sloping parapet, the design was closely related to the California-mission style. In the later 1920s the original building was enlarged. The yellow-ochre stucco building with red tile roof and tile floors had open porticos on the east and west, a cafeteria and an auditorium that was used for many civic events for

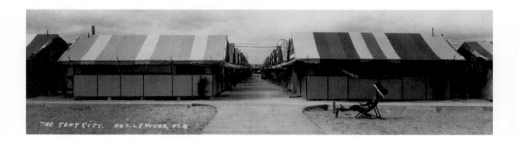

Tent City, Washington Street and Surf Road on the beach, based on similar canvas colonies on California beaches. Photo postcard collected by Jerry Lopez, then a young man from Spain working in the Beach Hotel kitchens. Lopez settled in Hollywood and eventually opened his own restaurant. *Courtesy of Claudina Lopez.*

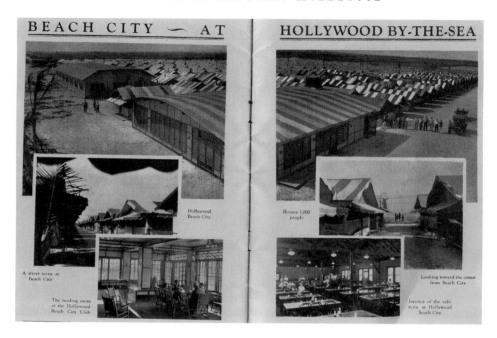

Tent City. Tourist housing providing all amenities, including a communal lounge area, library and cafeteria. Photo from a Young Company brochure describing the "Hollywood Beach City Club." Not surprisingly, Tent City was gone with the wind in a 1926 hurricane. *Courtesy of the Broward County Historical Commission.*

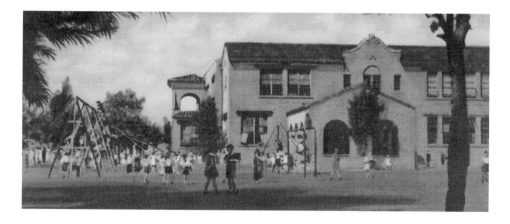

California-mission style Hollywood Central School with later addition. During recess, children roller-skated or played puss-in-the-corner in the shady tile-floored porticos or set up a record player and danced in the auditorium. Sad to say, the building suffered a fire and was demolished. *Historic postcard courtesy of Bill Schaaf.*

several decades. A school was also built in Liberia, at 3500 North Twenty-second Avenue, called the Dania-Liberia School. At that time, it served for all grades for the black schoolchildren.

More indication that Hollywood was settled with permanent residents in 1925 was the number of religious groups holding services. The largest denomination, the Methodists, had built the first church; at that time the Baptists were meeting in Central School, the Catholics and Presbyterians in the Hollywood Theatre, and the Lutherans in the Brandon's Hippodrome Theatre, a large theater on Eighteenth Avenue at Garfield Street. The second church built in Hollywood was St. John's Episcopal Church, in 1925 at 1700–02 Buchanan Street. The Catholics established the first Church of the Little Flower in a frame structure at Twentieth and Van Buren Street in 1926; the congregation later moved to the present structures on Pierce Street. A second Methodist congregation built the Temple Methodist Episcopal Church, an imposing structure in the classical style at 1350 Harrison Street. With the loss of population in the later twenties, the congregation joined the First Methodist church and this building remained vacant for some years. The Christian Scientists opened a Reading Room at 107 North Twentieth Avenue in 1925, before building their first church in 1932. The First Baptist Church, evidently from a Rubush & Hunter design with elaborate California-mission entrance, was erected at 1701 Monroe Street in 1925. The Masons and Eastern Star had a lodge on the second floor of the Tyler Building on the southeast corner of Twentieth Avenue and Tyler Street. The southwest corner was called the Florida Building. While there were a number of Jewish permanent residents in Hollywood, there apparently were not enough as yet to build a temple.

The "East Dixie," actually Eighteenth Avenue, had developed into a bustling commercial route, especially around Garfield and Buchanan Streets, with people staying in the numerous cabins, and shops to service travelers and probably Danians as well. The imposing Brandon's Hippodrome Theatre with its semicircular façade is known from post-hurricane photographs. The 1926 Sanborn map indicates that it held seventeen hundred. Less than a block away, there was the Garfield Theatre with capacity of seven hundred and fifty. Shops included a grocery, dry cleaner ("Walter Bono Cleans Hats"), the Yamato Inn at McKinley Street (Hollywood's first Asian restaurant?) and the Greenwood Inn at Sheridan Street. On Hayes Street just off Twentieth Avenue was Buttridge Lumber Co. There was even a "Hollywood Hospital" indicated on the Sanborn map on McKinley between Nineteenth and Twentieth Avenues. Oddly, there is no record that this building was used as a hospital. Perhaps it was not completed before the 1926 hurricane changed plans.

The original Dixie Highway, or "West Dixie," was not lacking in commercial development. At Polk Street was a cul-de-sac shown on the Sanborn map called

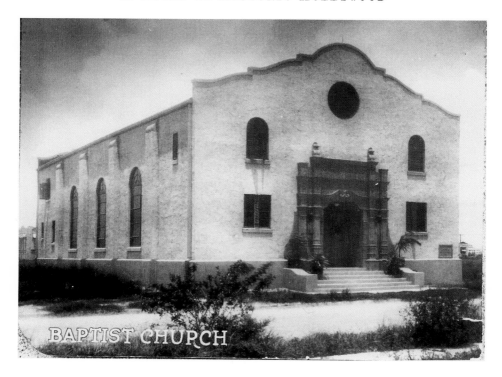

First Baptist Church, 1701 Monroe Street. The original sanctuary, built 1925, resembled an early Christian basilica with an elaborate, almost Mexican west portal as the only ornamentation. The original building has been changed and expanded. *Courtesy of the Hollywood Historical Society.*

Hollywood Place, opposite the splendid railroad station, with a garage for 120 cars, a dry cleaner and the Hotel Dixie. No record of any of this has been located. A few blocks north at Collins Court was the Accurate Garage auto repair shop of Jane Short and a filling station that offered "Vulcanizing" at 240 South Dixie. Across the tracks on Twenty-first Avenue was Young Company's Southern Mill and Bungalow. Dixie Sash and Door was at 2414 Johnson Street and the Green Light Inn was at 2201–09 Johnson Street. Another necessity, a septic-tank plant, was at 2540 Garfield Street. Almost all of these businesses have disappeared, while a small grocery store built in 1925 at 2404–10 Taylor Street in the heart of the Little Ranches has been in continuous operation ever since.

In November 1925, Hollywood was officially incorporated as a city. The first city officials were appointed by the Charter Committee. They were David C. Fessler, who was manager of Hollywood Land and Water purchasing department; Paul R. John, who owned the Olive Apartments; John M. Young (son of the

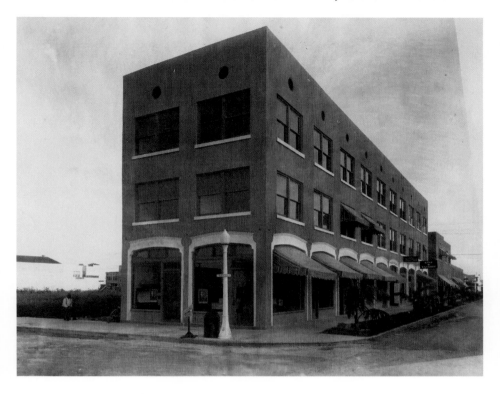

Tyler Building, southeast corner of 20th Avenue and Tyler Street, 1925. The Masons and Eastern Star had a lodge on the second floor. Later the top story was removed. *Courtesy of the Broward County Historical Commission, gift of Mr. and Mrs. Joseph Mackay.*

founder), who was managing some Young Company operations; Ralph A. Young (no relation), vice president of Hollywood Land and Water Company; and Joseph W. Young. J.W. was named mayor by his fellow officials. Charles H. Windham, J.W.'s friend from Long Beach, was appointed city manager, with Walter Hoff Seely, former personal assistant to Young, serving as temporary city manager until Windham could arrive from California. As City Hall Circle was still empty, and Young's publishing enterprises had moved to the boulevard, the empty Hollywood Publishing Company building at 219 North Twenty-first Avenue became Hollywood's first City Hall on December 24 and remains a landmark.

Young's Tropical Dredging & Construction Company had begun operations at Lake Mabel by May 1925. Initially Young, ever the promoter, had hired General George W. Goethals as consulting engineer following his world-renowned construction of the Panama Canal that was completed in 1914. However, the general did not suit, and in November, Young brought an old acquaintance from

J.W. Young, first mayor of Hollywood, 1925. He served two months, then resigned to concentrate on developing Hollywood Hills. *Courtesy of the Hollywood Historical Society.*

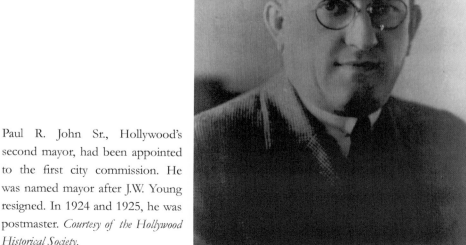

Paul R. John Sr., Hollywood's second mayor, had been appointed to the first city commission. He was named mayor after J.W. Young resigned. In 1924 and 1925, he was postmaster. *Courtesy of the Hollywood Historical Society.*

Long Beach, Colonel Charles H. Windham, to serve as city manager and oversee the development of Port Everglades Harbor, at a salary of $50,000 a year. Windham, then city manager of Long Beach, had been the visionary behind the development of the harbor of that city. Working closely with him would be Frank Dickey.

J.W. Young now had an astounding amount of major enterprises underway. On the beach, work continued round the clock to complete the Hollywood Beach Hotel in time for the beginning of the 1925–1926 winter season. Tent City had been started and continued to grow. Dredging was turning Lake Mabel into Port Everglades. Architect Martin Hampton had designed a bathing casino to replace a more primitive shower- and changing-room arrangement. The Hollywood Beach Casino occupied at least a city block, from the Broadwalk to Ocean Drive (Surf Road did not pass through). The U-shaped complex had the open side facing the Atlantic. One hundred cabanas, or changing rooms, occupied the two-story building. Within the arms were two wading pools and an Olympic-size saltwater pool. At the closed end was a three-level diving platform. Young and Hampton planned that the casino would be the site of swimming and diving competitions and exhibitions, together with other water games, so there were stands for spectators on either side of the pool. Furthermore, the casino was open to the public, for a small fee, and remained so until it was demolished in the 1960s. Although the casino was not completed until mid-1926, it opened in 1925 and drew crowds of spectators from the start.

Meanwhile in July, Rubush & Hunter had drawn plans for another major hotel at the opposite end of Hollywood Boulevard. This would be the Hollywood Hills Inn, built on the third circle at the west end of the city. (See image on page 50.) To get to the farmland purchased from G.M. Stratton, Young had to deal with the intervening problem of the West Marsh. Surveyor Mickelson described the west side of the city when surveying began: There was a fast slope from the FEC tracks to City Hall Circle, then from Twenty-eighth Avenue to the future Seaboard railroad tracks and beyond was all swamp, extending north from the present Orange Brook Golf Course to the Dania Cut-off Canal; sometimes this area was dry enough to grow tomatoes. L.B. Slater explained further that the area between the Little Ranches and the Hills, from about Twenty-eighth to Thirtieth Avenues, was a riverbed. Young bought the riverbed property from the Fahrquist family, then to build a golf course just west of Thirtieth, Young had a canal dug to drain the land, at his own expense, according to Mickelson. This is now the C-10 Canal. Maps indicate the golf course on the south side of Hollywood Boulevard, west of the canal, while on the north side of the boulevard is Park Road, west of the canal. Presumably Young intended that the marsh on that side of the boulevard would be a park.

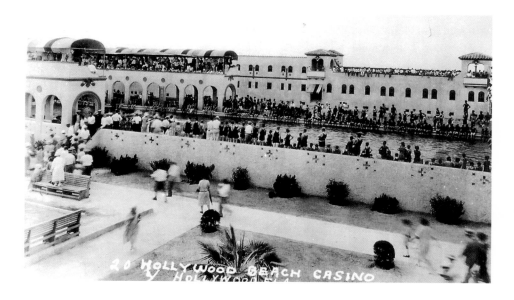

Hollywood Beach Casino, 1925–26, possibly inspired by one on Miami Beach. Water was piped directly from the Atlantic Ocean. The 1926 hurricane filled it with sand and caused half the cabanas to be removed, but this remained the place where Hollywood learned to swim. Not extant. *Historic postcard courtesy of Claudina Lopez.*

The Hollywood Hills section was now opened for sales. As engineering crews from the Young Company were stretched to the limit from the Little Ranches to the beach, the firm hired the Highway Construction Company of Cleveland, Ohio, to build streets and sidewalks in the area already platted by Young's engineers. Eventually this company, which changed names several times before becoming Hollywood, Inc., would acquire Hollywood Hills section but would not develop it until 1960.

J.W. Young resigned as mayor of Hollywood after two months to concentrate on developing Hollywood Hills.

1926

In January 1926, Hollywood residents must have believed they could expect another wonderful year. According to the Young Company's magazine, *South* (formerly the *Hollywood Magazine*), Hollywood's nickname was the "Miracle City." In 1926, the two neighboring towns decided to become part of the Hollywood miracle, Dania joining on January 4 and unincorporated Hallandale on January 15.

With the grand Hollywood Beach Hotel opened, rivaling the beach resorts built by Henry Flagler in the previous century, the beach was the place to be. At last it was possible to drive east down the boulevard, cross the canal on a fine bridge and enter the grounds—not yet landscaped—of a truly splendid hotel. Or one could turn left and drive north on Ocean Drive to Johnson Street, dine and dance at the Tangerine Tea Room managed by Mike Chrest, or swim in the Olympic-size saltwater pool of the casino (not a gambling establishment). Several smaller hotels had also been built on the beach, the Cavanaugh at 306–11 Arizona Street, the Southwinds at 322 Monroe Street, the Betty Bryan on Louisiana Street (no longer extant), the Hollywood Beach Apartments on Mississippi Street, Murrelle Apartments on Massachusetts Street, and the Neff Apartments at 312 Indiana Street.

At the far western end of the boulevard, the Hollywood Hills Inn was built on the third and culminating circle on Young's grand plan. Mirroring the Beach Hotel at the eastern end of the boulevard, the Hollywood Hills Inn created a pleasing vista to draw visitors west. Designed by Rubush & Hunter, the inn was grand and well appointed. The inn was intended to be the elite country version of the Beach Hotel, with golf, tennis, horse riding and the like, and would set the tone for the upscale homes Young envisioned in the Hills section. Completed in

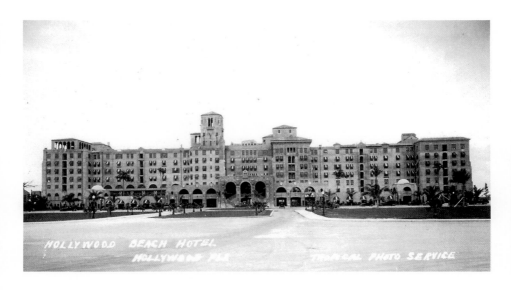

When Young planned his city he envisioned this magnificent resort on the east end of his boulevard, though he had to drain a marsh and build a bridge to reach it. Hollywood Beach Hotel was often the small city's chief industry through the 1950s. *Historic postcard courtesy of Bill Schaaf.*

Hollywood Beach Hotel dining room, 1925–26. Designed by Philip A. Weisenburgh, master of ornamentation for Rubush & Hunter. *Hand-colored historic postcard courtesy of Bill Schaaf.*

Hollywood Beach Hotel lounge and dance floor, 1925–26. *Hand-colored historic postcard courtesy of Bill Schaaf.*

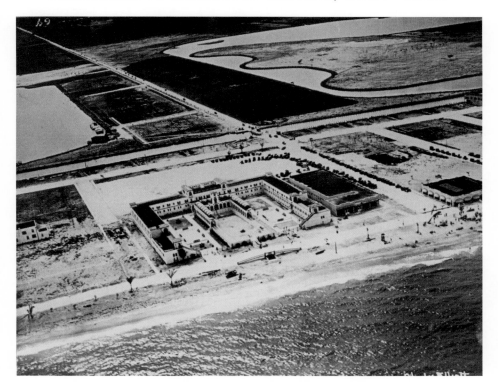

Aerial view of Johnson Street from the ocean looking west. Everyone could visit the shops, dance at the Tangerine Tea Room, swim in the casino pool or simply walk along the Broadwalk. (Dated 1924 but more likely 1925.) *Courtesy of the Broward County Historical Commission, gift of Katherine LaBelle.*

the summer of 1925, the site was occupied as the Hills Inn only for the 1925–1926 winter season.

As other steps toward maturity as a city, avenues were renumbered beginning at the canal and houses were given house numbers; these are indicated on the June 1926 Sanborn map. Young's fairly limited telephone system was sold to Southern Bell Telephone & Telegraph, and the water company to the new city.

There were warnings that trouble might lie ahead. A freight embargo in 1925 had held up delivery of sorely needed building materials. On January 10, 1926, in Miami, a wooden four-masted ship was having difficulty negotiating the quirky Biscayne Bay channel and keeled over at the harbor entrance. Sprawled there fully loaded, the *Prinz Valdemar* blocked any further shipping in Miami for twenty-five days. The boom was beginning to deflate, but in Hollywood (as elsewhere) people danced on. Dredging continued at Port Everglades; on September 4, Charles

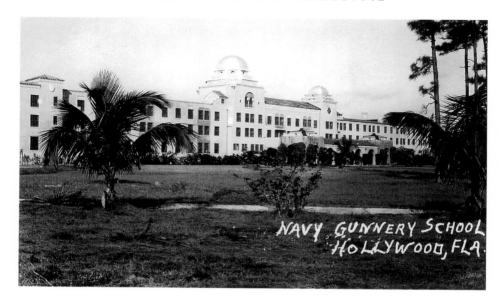

Hollywood Hills Inn, 1925, resembled the Park View Hotel with its Moorish domes. In 1931, it was purchased by Riverside Military Academy, which leased the building to the U.S. Navy during World War II for a training school. Not extant. *Historic postcard courtesy of Bill Schaaf.*

Windham resigned as city manager to become general manager of Young's Harbor Development Corporation. Frank Dickey continued to work with him. As if money would gush forever, Young commissioned Rubush & Hunter in June to design an elaborate bank building complete with penthouse. This would be the firm's last commission from Young. The elegant façade was another masterful design by Philip Weisenburgh. On the south and east façades, five round arches spring from intricately carved full-round Corinthian columns, which stand before two-story decorative balconies. Under the slightly overhanging tile roof is a central cartouche.

Others built homes, for example, another showplace home built for Anna Berner at 1504 Hollywood Boulevard, and one for Vincent Howard at 1116 Harrison Street. Blanche and Henry Mann, who came to Hollywood in 1925, built at 1811 Cleveland Street. In 1926, Blanche Mann was bookkeeper for J.W. Young; beginning 1933, she worked for the city in a career that spanned more than thirty years, serving as auditor, treasurer and city clerk. Henry Mann was owner-operator of the Arcade Cleaners, 2039 Hollywood Boulevard (later at 2025 Tyler Street for twenty years); he served as commander of Hollywood American Legion Post and president of local Kiwanis. Occupying a new position

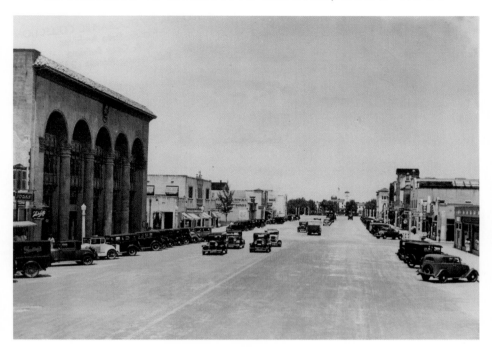

Hollywood State Bank, later First National Bank of Hollywood, 2001 Hollywood Boulevard. Following the 1926 hurricane, plans for a penthouse were eliminated and the impressive building remained as a fitting statement of strength and solidity for a bank that never closed during the Depression. *Historic postcard courtesy of Bill Schaaf.*

now that the boulevard bridge was operating was bridge tender Julian Eddy, who lived at 1940 Taft Street with his wife Ada.

In the evening of September 17, 1926, the wind off the Atlantic Ocean grew stronger than Hollywood residents were used to. Virginia TenEick describes how it became increasingly difficult to drive the car home to central Hollywood from an event at the beach. People began to realize they were in for a very bad storm, but no one in Hollywood was prepared for a Category 4 hurricane, because no one really knew what this was. Hurricanes were not named in those years, so this one has been called the 1926 hurricane. It hit Hollywood with everything in the hurricane repertoire, hundred-mile-an-hour wind, tornadoes within the big winds, storm surge and flooding, and the deceptive calm of the eye, luring people out to be slammed with the far side of the storm. Books have been written about the wind damage, but perhaps less has been documented about the flooding, when salt water from the Atlantic Ocean reached all the way west to the FEC railroad tracks. Tony Mickelson described it. He, John Gleason, Clarence Moody

Home of Vincent Howard under construction at 1116 Harrison Street in 1925. At right is a neat stack of roof tiles, clay forms shaped by being pressed on the thigh of the maker. *Courtesy of the Hollywood Historical Society, gift of Mrs. Willis.*

and Moody's brother-in-law Bill Osment sat out the first half of the storm in Moody's CBS house at 1949 Taylor Street, watching in dismay as most of the home disintegrated, leaving only the southeast wall for protection as the roof was also gone. During the lull, Mickelson went out, thinking to return to his house at 2307 Polk Street, and was astonished to find himself wading knee-deep in salt water, all the way to Twenty-first Avenue. It was later realized that removing the natural five-foot dunes on the beach had eliminated a substantial barrier, allowing the ocean to race straight across the now-flat sand island, through the ground floor of the Beach Hotel and up the flat, wide boulevard until halted by the elevation of the railroad tracks.

Three barges from the Inland Waterway were further evidence of the flood's reach. One was photographed at 1025 Tyler Street. The second, the Johnson Street barge bridge, was halted by buildings at Sixteenth Avenue between the boulevard and Tyler Street, and it was the wild ride on this barge that supposedly turned the hair of the city attorney, T.D. Ellis, white. Ellis was living in the Boulevard Apartments at Tenth Avenue. At the height of the storm, seawater in the storm surge had swept across the barrier island and up Hollywood Boulevard, reaching a depth of several feet in the apartments when

residents decided to evacuate. From the Johnson Street canal crossing (see images on pages 26 and 82) Ellis spotted the barge, now loose from its moorings and sailing west up the boulevard with people on it and others hanging onto ropes alongside. He and a Dr. and Mrs. McCormick, also from the apartments, grabbed the ropes and were towed west. A block later, the barge came to rest against a palm tree near the Young home at 1055 Hollywood Boulevard; some of the others dropped the rope and scrambled into the house (J.W. was out of town). Ellis and the McCormicks climbed the palm tree and got onto the barge, which soon broke free and continued sailing. They went below and closed the hatch. During the day, as the hurricane continued, the barge surged farther west on the flood. Those on board would occasionally lift the hatch to get their bearings, fearing they might be taken out to sea. When the storm abated, the barge was wedged between the house and garage on Sixteenth Avenue. Ellis made his way from there to the Park View Hotel and borrowed a dry bellhop's uniform to replace his soaked clothes. A third barge landed with the flood amid the extensive wind destruction at Eighteenth Avenue near Garfield Street.

Destruction in Hollywood was extensive, as were injuries, even deaths. The only hospital was at the beach, so temporary wards were set up in buildings that were undamaged: the Great Southern Hotel, Poinciana Hotel, the Maryland Apartments, the Villa Hermosa, and the Kington home on the Dixie Highway. The Young Company Administration Building was used as a morgue. Immediate outside aid came from the Salvation Army and the Red Cross, but it was days before the survivors were dry and fed or before the roads had been cleared so life could go on. Years later, many spoke with gratitude of Caesar LaMonaca and the Hollywood Band, who had only recently been hired by the city. As soon as they were dry, they set up to play and continued to do so for several days, lifting the spirits of the others as they dealt with disaster.

J.W. Young had gone to New York on business and when the hurricane hit Hollywood, he was in Philadelphia, Pennsylvania, at a Gene Tunney boxing match. He and others chartered a train to get back to south Florida (others said to be on that train included George Merrick, Carl Fisher and Miami financier Ed Romfh).

Young promised the citizens they would rebuild, and those who remained in Hollywood did their level best. But of the 20,000 inhabitants before the September hurricane, only about 2,500 stalwart individuals actually did stay. Properties were abandoned; payments were not made. Hollywood Hills School on Longfellow Circle at Thirty-sixth and Taft was completed in October 1926 for the children of Hills residents who did not materialize; the building stood empty for a time.

In 1926, tracks for the second railroad line to come through Hollywood were brought down from West Palm Beach. This was the Seaboard Air Line Railway,

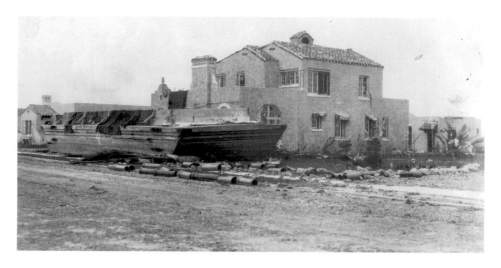

Home of stone contractor Eric Skoglund 1025 Tyler Street following the 1926 hurricane. During the storm, a barge from the Inland Waterway was carried by the deep water of the tidal surge to lodge against this house. *Courtesy of the Hollywood Historical Society.*

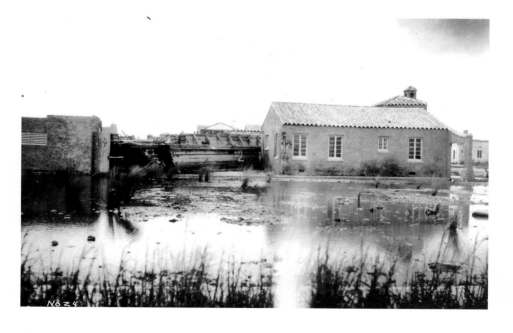

The Johnson Street barge bridge (see image on page 26) halted by buildings at 16th Avenue between the Boulevard and Tyler Street after being yanked from its moorings by the 10-foot deep tidal surge of 1926. T.D. Ellis rode out the hurricane on board. *Courtesy of the Hollywood Historical Society.*

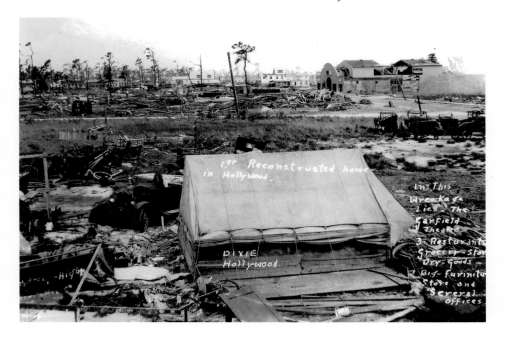

Garfield and 18th after the 1926 hurricane, fields littered with boards that were houses. Large building upper right was Brandon's Hippodrome Theatre, not rebuilt. Lettering on the tent reads, "1st reconstructed house in Hollywood." The other message says, "In this wreckage lies the Garfield theatre, 3 restaurants, grocery store, dry-goods, big furniture store and several offices." "Dixie" refers to 18th Avenue. *Higby Photo Co. Courtesy of the Hollywood Historical Society.*

Caesar LaMonaca and his Hollywood Band, c. 1926. LaMonaca stands at the center. *Courtesy of the Broward County Historical Commission.*

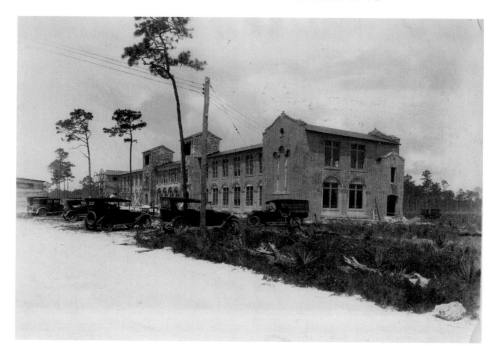

Hollywood Hills School under construction in the pine woods and palmetto. In spite of protests it was demolished December 26, 1974. *Courtesy of the Broward County Historical Commission, gift of Mr. and Mrs. Joseph Mackay.*

which ran through Hollywood paralleling a nonexistent Thirtieth Avenue (which was incorporated into the C-10 Canal). The Seaboard station house was designed by the architectural firm of Harvey and Clarke, which designed all the Seaboard stations from West Palm Beach to Homestead. The station was constructed in 1926 by the railway. When the first passenger train passed through Hollywood in January 1927, there was nothing much to see to the north or south but jack pines. There were a few houses and chicken farms at Twenty-eighth Avenue, and to the west down the boulevard at Fortieth Avenue stood the empty Hollywood Hills Hotel.

1920s Post-hurricane

Almost immediately Danians decided to separate from Hollywood, and Dania returned to city status. In January 1927, the people of Hallandale formed their own government, and they too left Hollywood. Young struggled on, but no one was buying the property he still owned on the beach and in the Hills section,

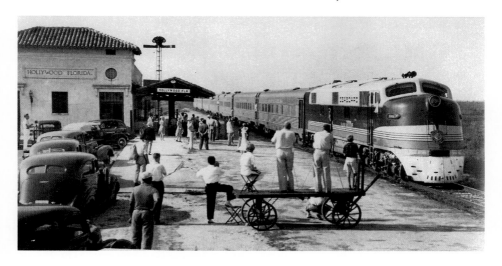

Hollywood Station of the Seaboard Air Line Railway, 1926. Placed on the National Register of Historic Places in 2005, it was dedicated as the Hollywood Railroad Station Museum, The Dorothy Walker Bush Museum. Still a working station. *Courtesy of the Dorothy Walker Bush Museum.*

and many were not completing payments on the rest. While Young was seeking other financial backing, Samuel Horvitz's Highway Construction Company which had been hired by Young to lay sidewalks and pave streets in the Hills, sued him. Forced to declare bankruptcy, his properties were sold at a sheriff's sale in 1928. Chief purchaser was the Highway Construction Company. In 1929–30, the latter merged with the Mercantile Investment Company of New York and became Hollywood, Inc., with offices in the Young Company's Second Administration Building. Hollywood, Inc., did not go forward with development of the Hollywood Hills property until 1959 or 1960. Children of the 1940s recall riding bicycles out there along sidewalks hidden under thick palmetto growth— there weren't any roads or houses, just sidewalks, as if civilization had come and gone in the area from Thirtieth to Sixtieth Avenues.

In the later 1920s, real estate was no longer lucrative. Two young couples who had come to Hollywood late in the game, 1925, sought a new business and made a lasting mark in the community. Floyd and Jane Wray, Vera and Clarence "Ham" Hammerstein, and Frank Stirling, a citrus grower from Davie, joined to found Flamingo Groves in January 1927. The citrus groves still operate as Flamingo Gardens. Floyd Wray was president, Stirling was vice president and groves manager, Ham Hammerstein was vice president in charge of advertising and sales, and Jane Wray was secretary. The Hammersteins moved from Miami

to the Fountain Court Apartments on Eighteenth Avenue and Tyler Street with Jane's parents Jacob and Mary Rust. The Wrays had been living in Hollywood at 1809 Jefferson Street. About 1926 or 1927, they acquired the house at 1615 Monroe Street, a site that is still beautifully maintained by the current owners.

Civilization continued in the city center, the Ranches, and the sections of the Lakes closest to Hollywood Boulevard. Clarence Moody, having lost his house in the hurricane, moved with his wife Lily to 1921 Van Buren Street. He was elected mayor for 1928–29. Attorney T.D. Ellis Jr. and his wife Marcella had a home at 1813 Madison Street. Ellis, known as Dave, was originally from Georgia, with undergraduate and law degrees from Emory University. The March 16, 1934 *Hollywood Herald* in a front-page profile of Ellis said he was brought to Hollywood by the law firm of McCune, Casey, Hiaasen & Fleming specifically to draw up the city's charter in 1925 with L.O. Casey. Ellis then became the city attorney. Dave and Marcella remained as important figures in the civic and social life of Hollywood until their deaths.

Dr. Byron Pell and wife Mildred lived at 1538 Polk Street. The sociable and civic-minded Pells came to Hollywood from Indiana in 1925, living first on Polk Street before moving to a 1924 California-bungalow-style home on Van Buren Street in 1935. A dentist, Dr. Pell had his office first in the Hollywood Bank building, then in the Hollywood Clinic on Seventeenth Avenue. Edwin Rosenthal, who now owned the Hollywood Beach Hotel and the Golf and Country Club, had an address at 316 Oregon Street on the beach.

City leaders who remained were determined to keep Hollywood going. Hollywood Central School was enlarged, as was its neighbor the Methodist Church. The Presbyterians built a small church on Hollywood Boulevard in 1926; the Christian Scientists built at 1532 Harrison Street in 1928. When the Christian Scientists built a larger church on the property, the original building became the Sunday school. Both buildings were designed in classic Greek revival style, with a triangular pediment over the entrance resting on Doric columns. Eventually the smaller building became the property of the Hollywood Garden Club, which moved the building to 3000 Hollywood Boulevard. It is now part of the Hollywood Railroad Station Museum—the Dorothy Walker Bush Museum.

The Rotary Club had quarters at 205–07 Twentieth Avenue. In March 1927, the Hollywood Garden Club was formed. The Woman's Club and the American Association of University Women established the Hollywood Public Library in May 1927 with a donation of 225 books. The library was housed in a space in the Morse Arcade. The Woman's Club completed its building at 501 North Fourteenth Avenue, dedicating it in August 1927. In 1928, City Hall was erected on City Hall Circle, 2600 Hollywood Boulevard. Clarence Moody was mayor that year, following Harry Pringle.

Clarence B. Moody, Hollywood's fourth mayor elected for the 1928–29 term. He and his wife Lily lived at 1921 Van Buren Street. *Courtesy of the Hollywood Historical Society.*

To the west of the city another north–west road was opened in 1927 at about Sixtieth Avenue, called State Road 7 (SR 7), now Route 441. That area was not part of Hollywood then nor did Hollywood's main roads (the boulevard, Johnson Street) quite reach SR 7, at least, not as paved roads. The chief use of State Road 7 at the time and for decades to come was as a sorely needed truck route. A bright spot for the future was the opening of Port Everglades on February 22, 1928. Costs of development were shared between Hollywood and Fort Lauderdale; the two cities still share the port.

Still, Hollywood continued to shrink in 1928. Young was not alone in seeing the city he developed go nearly bankrupt. Addison Mizner, who had been developing a section of Boca Raton, lost his properties. George Merrick in Coral Gables and Carl Fisher in Miami Beach were also impoverished as south Florida experienced an economic depression several years before the rest of the nation entered the Great Depression. Hollywood Hills School, designed by Thomas D. McLaughlin and brand new in 1926, closed in May 1928 for lack of pupils. Small businesses hung on, clustering around the boulevard between Circle Park, now called Harding Circle, and City Hall Circle. For example, on one block of North Twentieth Avenue, between the boulevard and Tyler, were the following shops: June Pyne Tea Room (number 116-20); Frank Petro, barber (number 117); Wells Watch & Clock Repair (number 117); Pauline Hobbs, dressmaker (number 121N); Enoch Johnson, shoe repair (number 122); Myron Cohn, tailor (number 123); Masonic Hall (number 125 upstairs); Washburn Florist (number 126); Jim's Bike Shop (number 128); and James Owens, radios (number 130). June Pyne

First Presbyterian Church, 1600 Hollywood Boulevard. The original building was erected in late 1926. *Historic postcard courtesy of Bill Schaaf.*

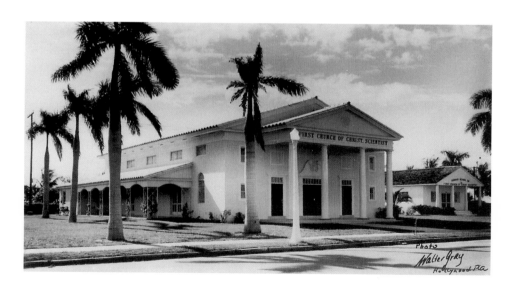

First Church of Christ Scientist. In this photo, the original church is the small building to the right, built in 1928, which became the Sunday school. *Historic postcard courtesy of Bill Schaaf.*

Morse Arcade, interior, from the third story, 1925. In the 1940s, the unoccupied third floor was in disrepair. Restored by the Ramada Inn Corporation, 2004 the arcade now closely resembles early photographs. *Higby Photo Co. Courtesy of the Broward County Historical Commission, gift of Mr. and Mrs. Joseph Mackay.*

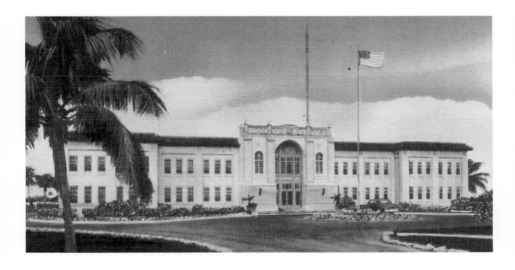

Hollywood City Hall, 2600 Hollywood Boulevard, built 1928. Pineapples were cultivated on the future City Hall Circle when J.W. Young purchased the land. This building has been replaced by present City Hall. *Historic postcard courtesy of Bill Schaaf.*

had several careers, including serving as Hollywood's first policewoman. Her tea room, decorated with fashionable black cutout silhouettes, continued through the 1930s. Jim Owens fixed bikes and radios, and his shop was frequented by kids who needed bikes to get to school or to the beach. Myron Cohn had been at work in Hollywood since at least 1924 when the *Reporter* noted that the "popular tailor" had returned for the season. He and his family now lived in an apartment in the Kington Building.

In 1929, the doctor who operated Hollywood's only hospital moved to Miami, leaving the city without a hospital from 1929 to 1937. Hollywood babies were born in Fort Lauderdale, in Miami or at home.

Also in 1929, Hollywood's links to organized crime began when the new owners of the Hollywood Golf and Country Club leased the elegant building to Al Capone's syndicate, their lease lasting until 1931. The new occupants installed a garish neon sign above the building, posed platinum-blond chorus girls on the lawn and turned the club into a gambling casino.

Early 1930s

The entire country was deep into the Depression. In 1930, the federal government took over operations at Port Everglades with its single slip. The East Dixie Highway or Eighteenth Avenue was made part of the national highway system and became U.S. Route 1, or the Federal, to locals. While it made road sense to head straight south from Dania along Eighteenth Avenue, this changed Young's intention. In his plan, driving around the circles was to provide excursions in that era of Sunday-sightseeing drives, while through north–south traffic was to continue straight along the original Dixie Highway. Of course, there was very little traffic of any kind in 1930 when it was decided to run U.S. Route 1 through downtown Hollywood and around the ten-acre circle. The work of widening and repaving Eighteenth Avenue down to the Dade County line continued through most of 1931. Possibly as a result of this changed traffic pattern, in October 1931, the Hollywood City Commission formally designated Harding Circle a park and banned all commercial enterprises there.

A white knight entered the city that year in the form of Colonel Sandy Beaver, operator of Riverside Military Academy in Gainesville, Georgia. Looking for a winter home for the cadets, Riverside officials purchased the unused Hollywood Hills Inn from the city, an ideal site for a boarding school with land for parade grounds. The cadets arrived that winter. Riverside also rented empty Hollywood Hills School for additional classrooms. Each winter, the academy brought 600 cadets and nearly 100 faculty members and their families to

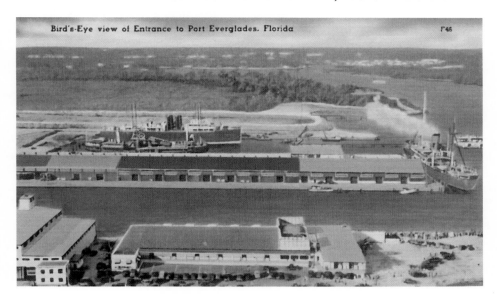

Bird's-Eye view of Entrance to Port Everglades. Florida F46

Port Everglades. In 1930, the federal government took over Port Everglades with its single slip. In this picture, a crowd is waiting for something, bottom right. It was common to go aboard and tour visiting ships. *Historic postcard courtesy of Bill Schaaf.*

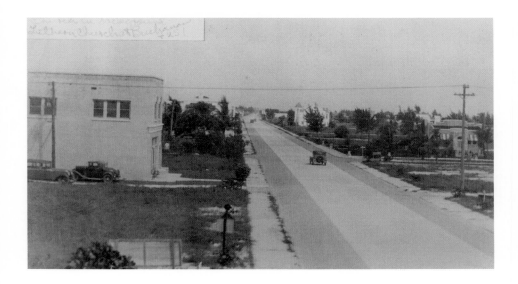

Heading north to Dania on U.S. 1, 1930s. 18th Avenue became "the Federal" to locals. At left is the original telephone company. In the distance, right, is St. John's Lutheran Church at Buchanan Street, built 1931. *Courtesy of the Broward County Historical Commission, gift of Harriet Ransom and Patricia Smith.*

Hollywood. The Youngs' youngest son, Billy, graduated from Riverside in June 1931. Clyde Elliott, father of future Hollywood historian, Virginia Lathrop TenEick, bought two adjoining houses on the southwest quadrant of Riverside circle and moved his family there. Elliott and his wife lived in one, and Virginia and her first husband, Harold Lathrop, lived in the other. Across the circle, on the northwest quadrant, were their only neighbors, Polly and C.H. Landefeld, also pioneers. C.H. Landefeld served as city attorney in the 1930s and was also on the city commission. Polly was a founder of Hollywood's Little Theater. Isolated or not, the Lathrops didn't have any trouble attracting guests to their parties. Virginia could get everyone singing when she played her accordion.

Mayor in the early 1930s was William "Big Bill" Adams, the former chief of police whose home was at 1628 Polk Street. Adams came to Hollywood in 1921 and joined J.W. Young's enterprises. From Pennsylvania, Adams had a degree from Boston College, after which he joined the army and took part in the Spanish-American War, the Boxer campaign and World War I. In 1911, he wrote a book, *Exploits of a Soldier Abroad and Afloat*, for which he received personal commendation from President Theodore Roosevelt. The city was so poor when he took office in 1931 that police were using their private cars; by 1932, Adams was able to buy one police car and a motorcycle.

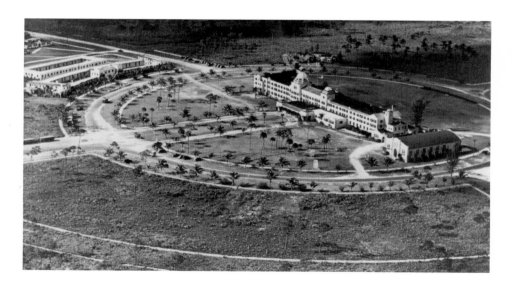

Aerial view of Riverside Military Academy, east façade. Blanton Hall, at right built in the later 1930s, designed by Bayard Lukens. Top center, behind the dome, are the Elliott family homes. Note that there are absolutely no other buildings nearby. *Courtesy of the City of Hollywood, Florida, Records & Archives Division.*

Posed here in front of the Elliott house are, *left to right*, Virginia Lathrop, Harold Lathrop, Reba LaFontaine, Earl LaFontaine, Amy Elliott, Clyde Elliott, Lamora Mickelson, Tony Mickelson and an unidentified woman. The dresses suggest the later 1920s. *Author's collection.*

As the Depression grew worse for most, Flamingo Groves began to thrive; its owners opened a fancy fruit shipping center at 1912 Hollywood Boulevard in 1931. Jack Dresnick opened Jack's in the ground floor of the Kington Building and lived in an apartment above. He also opened the Hollywood Furniture Company in a large building his father had owned on Harrison Street, still the only building on the block between Twentieth and Twenty-first Avenues. This building became the Holocaust Documentation and Education Center in 2005.

William Adams, mayor in the early 1930s, was the former chief of police whose home was at 1628 Polk Street. *Courtesy of the Hollywood Historical Society.*

(Before the 1926 hurricane, Enart Banks had owned a furniture store at 1911 Hollywood Boulevard called Hollywood Furniture Company. In 1940, Banks Furniture Co. is at 1946 Harrison Street.) The Dresnicks were not the first Jewish family to settle in Hollywood—the Phil Adlers, the Browns and the Cohns were there in the early 1920s. But there were not yet enough Jewish families to support a temple, so the Dresnicks and friends brought in a rabbi to celebrate the High Holy Days; these services were first held in an office in the arcade.

Prohibition was repealed December 5, 1933, and soon after, bars sprouted up. David's Place at 2009 Hollywood Boulevard began advertising beer for fifteen cents a bottle. On the beach, Mike Chrest, who had found himself out of work when the Tangerine Tea Room where he was manager blew down in 1926, opened Chrest's Bar at 203 North Ocean Drive.

Al Capone had left the Hollywood Golf and Country Club in 1931. Though gambling continued in Hollywood, the real action was in neighboring Hallandale. The Old Plantation club, operated by Julian "Potatoes" Kaufman, opened on Hallandale Boulevard even before Prohibition ended. In the later thirties, Kaufman lived at 1321 Tyler Street, an interesting house built by F.W. Thompson of New York, who designed the home himself and had it built by contractor Peter Brunner in 1933. Thompson drew his plans from memory of a California-Mexican Adobe ranch in San Diego that was said to have been described in *Ramona,* a late-nineteenth-century novel of life there. The house is U-shaped around an open courtyard and cost an initial $13,000.

Throughout the 1930s, a number of the shops in downtown Hollywood openly sported slot machines, racetrack wires, bolito, even roulette. For example, Jesse Wellons at 1930 Hollywood Boulevard was granted a license for slots in November 1935. Small children were generally kept out of the gambling areas, but as a teenager Marion Obenauf carried track information to her brother-in-law's haberdashery (with poker, roulette and a horse tote in the rear) and wrote it on the tote board. The city government didn't have any laws for or against gambling and for a time looked the other way.

Gambling was not putting much into the city's coffers, but poor as it was, Hollywood still had amenities such as Harding Circle and the beach. In January 1929, the first bandstand was put up in Harding Circle to provide free concerts. This was followed in 1934 by a more substantial band shell where performers included school bands and children from dancing schools. In May 1935, for example Reno Zaza's Hollywood Band performed together with a presentation of tableaux by the American Legion and Legion (Women's) Auxiliary. At the beach, the casino, which now belonged to the city, was leased to Arthur Paul McMann, and it was where local children learned to swim. The pink cement Broadwalk had been a victim of the hurricane, so the city laid a boardwalk

in its place. Another hurricane victim was the Young Company sales pavilion at Garfield Street on the beach, which was discovered floating in North Lake. Another shelter was built on the beach at Garfield, which is still referred to by old-timers as "the pavilions" or "the ovens," in reference to the 1930s-style cooking units provided there for picnics. In 1933, the city erected the paddleball courts at Garfield Street and Surf Road; the six courts plus three shuffleboard courts are now a city landmark.

By 1934, the worst of the Depression had passed. But on February 27, 1934, Hollywood's founder, Joseph W. Young Jr., died at his home at 1055 Hollywood Boulevard.

Young had not been living there for several years. Having lost all his Hollywood property except the house, he went to work on developing other properties in New York's Adirondack Mountains and in southern New Jersey. His two adult sons, Jack and Tonce, were working with him, as were Tony Mickelson, Pete Wells and several others from Hollywood. Young was hospitalized with influenza late in 1933, then returned to his Hollywood home in January 1934 to recuperate. Both the *Hollywood News* and the *Indianapolis Star* reported that, entrepreneur to the last, Young had been talking with Joe Kelly, publicity man for his organization, when his heart suddenly stopped. Young was fifty-one. Funeral services were conducted by Dr. Thomas Henry Sprague at the Young home, attended by the

Band shell, Harding Circle, 1934. Everyone performed here from the Riverside school band to children from dancing schools. *Historic postcard courtesy of Bill Schaaf.*

In the 1930s, the Broadwalk became a boardwalk. The pink cement Broadwalk had been a victim of the hurricane of 1926, so the city laid wood boards in its place. They were splintery. *Historic postcard courtesy of Bill Schaaf.*

city commissioners and Mayor James Lewis. Hollywood merchants closed their stores during the hour of the service, and the flag at Harding Circle was at half-mast. Young was then taken to Long Beach, California, and buried next to infant daughter Marion.

James A. Lewis, Hollywood's seventh mayor, had been in politics in Pennsylvania where he had been nominated for office by both parties. He had a mercantile business before retiring in 1922.

It was sad that Young did not live even a few years longer, for, beginning in 1934, prospects for his city were looking bright. Partly this was because of the receding Depression and partly because of the efforts of pioneering local residents and civic leaders, people who had been in Hollywood from the early twenties and were determined to keep it going. Men who ran for city commissioner were business and professional men, not career politicians; they served a few one-year terms and then returned to their work. For example, mayors in the 1930s (elected by their fellow commissioners) were Clarence Moody, business manager; William Adams, police chief; James Lewis, mercantile business; Arthur Kellner, dentist; and R.B. Springer, transportation. Of course, Hollywood was still a very small town where no one had much money, everyone knew everyone and no one locked their doors. Almost everyone was dependent on the tourist trade, but this

James A. Lewis was in office as mayor when J.W. Young died in 1934. He lived at 1951 Grant Street. *Courtesy of the Hollywood Historical Society.*

only lasted from December to April. Many stores closed for the entire summer and on Wednesdays at noon throughout the year. Entertainment was the radio, movies at the Ritz Theatre (formerly the Hollywood Theatre), and social events put on by the churches and at the Central School. Hollywood Little Theater was organized in 1933.

Tourists with money had some other options: they could play golf at the Hollywood Golf and Country Club (owned by the Hollywood Beach Hotel) and see Broadway-style revues there and elsewhere. In January 1934, for $4, there was dinner and a floor show with Sophie Tucker, self-named the "First and Last of the Red Hot Mamas." While in Hollywood, Tucker stayed at the Villa Hermosa. In March, comedian Eddie Cantor was at the Beach Hotel. To suggest that $4 was an expensive night out ($8 for two), consider two salaries listed in the *Hollywood Herald* that year. An associate chemist in the civil service with a college degree and experience in entomology (mosquitoes!) was offered $3,200. In September, Hollywood's police chief's salary was raised $15 to $135 per month, or $1,620 per year.

Hollywood residents realized they needed to attract more visitors, who would spend money around town and perhaps even buy an empty house or lot. (The 1940–1941 city directory lists numerous Lakes section addresses as either occupied by "Tourists" or "Vacant.") In 1933, the depths of the Depression, Earl Dowdy, who lived at 1940 Dewey Street, asked the city to help raise community spirits by creating a playing field on city property at Johnson Street and the Dixie Highway. He was manager of the Piggly-Wiggly grocery store at the time. The

city not only built the field, officials also named it for Dowdy. It soon became the home field for local teams, with a small grandstand for spectators.

In 1934, locals decided that the city should have a public golf course, since Hollywood Golf and Country Club was private for visitors to the Beach Hotel. The city was interested but didn't have funds to build a new course. However, Young had begun a golf course in 1926 in Hollywood Hills; the city now owned that land and would be willing to donate it, but funds for development would have to be raised. An unpaid Golf Commission was formed in August 1934, with Floyd Wray, C.C. Freeman, Dr. Kellner, R.B. Walker and C.R. Gilliland, who turned to Hollywood citizens and civic groups and began to raise money. As clearing began—the site having completely grown over after nine years—the original nine holes designed by Ralph Young were discovered by A.J. Ewing, golf-course architect, who thought 80 percent of the original course could be saved. Another

Dowdy Field, created 1933. The Baltimore Orioles held spring training here before World War II and from 1946 to 1948. South Broward High School teams also played here. The National Guard Armory, begun 1953 and still extant, is in the left corner of the field. *Historic postcard courtesy of Bill Schaaf.*

discovery was the remnants of an orange grove that Ewing hoped could bring in $500 per year when brought back to bearing condition. Through the efforts of these volunteers, the course and a temporary clubhouse opened with a flourish October 18, 1934, as the Municipal Golf Course, an immediate success. The *Herald* noted that like Dowdy Field, this had been a community project. Seventy-four hotel and apartment owners pledged more than $1,000 to support it. The opening day was a legal city holiday; there were speakers, a barbecue and entertainment by the local boys band. A handsome building by Bayard Lukens in the latest Moderne design, praised as "a very magnificent and modernistic building," soon replaced the temporary clubhouse. This is now the Orange Brook Golf Course.

Lukens was the first of the new wave of architects who would create a new look for Hollywood, working in the contemporary Moderne streamline, or international style (not to be confused with art deco, which is a similar but more elaborate look from the later 1920s). An ad in the March 23, 1934 *Herald* announced that Floridian Builders under Will Skoglund would build the "First Modern Homes Here," with "modernistic lines outside and in, which attracted attention at the Chicago World's Fair." Hollywood is a treasure trove of small, classic Moderne houses, fairly geometric, with flat roofs, trim applied sparingly as horizontal bands, wide windows, corners cut out for windows, off-center entrances, smooth stucco exteriors and use of glass brick. Many examples are found on Hollywood beach. Notable in town is 1727 Johnson Street.

Lukens's style incorporated a "Florida" look, with variegated tile roofs and a smooth curving wall at the front entrance. White stucco walls were set off by horizontal trim in another color. His interiors are beautifully detailed, with moldings, trim over and around doors as well as fireplaces with heatolators (vents with decorative metal screens along the sides of the fireplace surround). Examples of Lukens's houses are those of two of his friends in Kiwanis, back to back: Optometrist Roe and Ann Fulkerson's home at 1525 Tyler Street, and Ham and Vera Hammerstein's at 1520 Polk Street. Among his many public activities, Roe Fulkerson was a leader in Kiwanis and founder of *Kiwanis, International* magazine. In 1935, he was elected to the Florida House of Representatives and in the 1940s to the Hollywood City Commission. Anne, distinguished by wearing her thick blond hair in a crown of braids across her head, was a leader in war work in the 1940s.

Commissions to Lukens and other architects, including the so-far unidentified designers on the beach, indicate that better times were coming to Hollywood. New shops included Melina's children's wear at 2022 Hollywood Boulevard and Lillian's ladies' wear at 1902 Hollywood Boulevard. Lillian Stine and her husband Dave commissioned Cedric Start to design their home in 1940 at 1455 Tyler Street. As did Lukens, Start—a Vermonter who came to Hollywood in 1935—

brought the city the modern look called Tropical Modern or Florida Modern. Start's variation on the international Moderne vocabulary was his use of balanced geometric forms and spare linear trim. Architect D. Anderson Dickey designed an apartment building for Martin Wohl at 1612–17 Hollywood Boulevard; Wohl was a major developer in Hollywood in the 1940s and 1950s. Development around North and South Lakes had been stagnant in the early 1930s, but in November 1934, the Lakes section was to be "the cream of the crop" for the newest residences, according to the *Hollywood Herald*. One of the homes specifically mentioned was that of Mrs. Georgia Baldwin at 942 Hollywood Boulevard.

Many visitors brought children when they came for several months. Broward public schools charged tuition, $4 monthly for elementary and $5 monthly for high-school children in 1934; text books were furnished free. Local children grew accustomed to having out-of-towners in class for a few months. Some who returned annually were welcomed as friends, although what their parents did for work to allow them to spend three months at the beach remained a mystery. Some tourist children provided a source of revenue for enterprising teachers who offered to tutor them. Helen Hart established a tutoring school that continued for several decades, first at Twentieth Avenue and Harrison Street, then in her own building designed by Lukens at 1515 Hollywood Boulevard.

These were positive signs for Hollywood in the mid-1930s, but there were also negatives. Al Capone and his cronies were gone, but gambling continued and had begun to attract an undesirable element, games of chance, such as a perpetual auction, and carnival wheel right on Hollywood Boulevard. Licenses were available for $250; the city commission was asked to change this ordinance.

Mid-1930s

The gambling issue remained on the Hollywood City Commission's table right into the 1940s with arguments for and against. Slot machines were legal in 1935 but required licenses. Miami (in Dade County) had taken a firm stand against the machines. Hollywood (in Broward County) decided to license them, but carnival-style street gambling was halted. Even so, many citizens and some commissioners—including new Mayor Arthur Kellner—remained opposed.

Kellner and his wife Charlotte had their home at 1820 Rodman Street, and Dr. Kellner had his dental practice in the Central Arcade. They came to Hollywood in 1925 from Indiana, and he established his dental practice. Dr. Kellner was active in almost every phase of public life in Hollywood and served for many years on the Florida State Dental Board. He was one of those on the Golf Commission in 1934 who put up some of their own money and raised more to help the struggling city build the Municipal Golf Course (now the Orange

Brook Golf Course) to attract more visitors. As mayor of Hollywood during the later Depression, from 1935 to 1938, Kellner helped guide the city out of its worst years. After decades of public service, Dr. Kellner received the Chamber of Commerce Community Service Award. Charlotte Kellner was a talented artist. Their home is no longer extant.

By February 1935, Hollywood was building again, mostly private dwellings, but it was the best season since the boom, said the *Herald*. Every type of architecture was represented, from colonial cottages to the "newest of modern styled estates," from small cottages costing about $1,000 to the pretentious homes of $10,000 or more. An ad that month listed ten good reasons for building in Hollywood, the "city of homes." They were that the city owns its own:

> *Most modern water plant in Florida*
> *Salt Water Bathing Casino*
> *Nine Hole Golf Course*
> *Beautiful Parks and Parkways*
> *6 Miles of the Safest Bathing Beach in Florida*
> *Diamond Ball Field with Grandstand [Dowdy Field]*
> *Tennis and Handball courts*
> *Foot Ball Field*
> *Ample Boat Docking Space [on North Lake]*
> *5 Arteries of Travel—Boat, Plane, 2 Railroads, Auto*

Dr. Arthur Kellner, a dentist, served as mayor of Hollywood from 1935 to 1938 and helped guide the city out of its worst years. *Courtesy of the Hollywood Historical Society.*

Charlotte Kellner and Mary Mack, 1940s. Charlotte Kellner was a talented artist. She came to Hollywood in 1925 from Indiana with her husband. Mary Mack's husband Jimmy owned Mack's Lumber Company. *Courtesy of Broward County Historical Commission.*

Municipal Water Works Plant, Hollywood Boulevard at 35th Avenue. When the water plant moved from 18th Avenue to the former rock pit at 35th Avenue, the area around it was for the most part uninhabited. *Courtesy of the Broward County Historical Commission, gift of A.C. Tony Mickelson.*

Highlights of Hollywood History, 1920–1960

"Hollywood is financially sound," the ad continued. "Fine churches, schools, fraternal organizations. Winter home of Riverside Military Academy. You'll Live 10 Years Longer in Hollywood."

Another description of the "city of homes" is found in the 1939 *WPA Guide to Florida*, which describes Hollywood as a "tailor-made" city. Unlike some other boom-time cities, Hollywood withstood the violent strain of deflation and survived. It is a "city of hotels, apartment houses, attractive shops, pleasant houses, and beach cottages," a popular winter resort. The houses and buildings are white, buff and pink stucco with gray and red roofs. After summarizing the founding days, the two-page description mentions the bathing casino, Riverside Military Academy, the band shell and some parks.

As segregation was still in force, African Americans remained in the Liberia area. Homeowners there in the mid-1930s included William Walker, Matthew Hunt, Henry Newbold, Gus McCoy, Elizabeth Marshall, Frank Jackson, Wilfred Brown and Hence Cole, all on Greene Street; and Solomon Harrison, George Maddox, Henry Matthews, Turner Evans, Clarence Clayton, William Knowles and Lawrence Mann on Raleigh Street. On Simms Street were Joseph Evans, Ezekiel Edwards, Timothy Robinson, Ernest Saunders, Thomas Sawyer, Jesse Jackson and Samuel Rolle. Three churches were Mount Pleasant Methodist at 2245 Raleigh Street, AME Church at 2327 Raleigh Street and St. Andrews Episcopal at 2810 North Twenty-third Avenue.

New churches in Hollywood included the Hollywood Bible Chapel at 2300 Hollywood Boulevard. The Masonic Lodge began building a two-story center for Masons, Eastern Star, Rainbow Girls and DeMolay at the northeast corner of Nineteenth Avenue and McKinley Street (completed after World War II). Popular restaurants included the Rockery Tea Room at 110 North Eighteenth Avenue and Moy's Chinese Restaurant on the Circle at Eighteenth Avenue and Tyler Street. Valhalla at the southwest corner of the boulevard and the Dixie Highway was a nightclub and reputed to be a gambling establishment.

Building on the beach was active, providing Hollywood with "6 miles" of classic 1930s Moderne houses and small hotels. Some of these were the New Yorker Apartments at 320 New York Street, Carlson Apartments at 310 Arthur Street, homes at 300 and 314 Georgia Street, 315 Georgia Street, and 310 and 314 Harrison Street, the Surf Hotel at 201 Polk Street, Flamingo Court at 300 Van Buren Street and the Beach Crest Apartments at 330 Virginia Street.

Making a different design statement were the Log Cabins at 2301–02 North Ocean Drive. At the other end of the beach, the Beach Trailer Park, extending from the ocean to South Ocean Drive (number 1001) at Jefferson Street, was the 1930s replacement for Tent City.

Of particular interest is the Harry and Ruth Simms house at 712 South Broadwalk, designed by Henry Hohauser to resemble a grand yacht. Hohauser was a Miami architect notable for his inventiveness in designing streamline Moderne buildings in the 1930s. In a 1933 article about the Simms house, Hohauser offered to build others in Hollywood. Further study on Hohauser in Hollywood would be welcome.

Another house of special interest is number 320 Polk Street, built for Dr. and Mrs. Arthur Connor in 1933. Dr. Arthur Connor was an eye-ear-nose-throat specialist who signed up for one of J.W. Young's ten-day, all-expense excursions from Chicago to Hollywood in 1925, which he said became a $40,000 vacation (reflecting on the properties he had bought since). He and Mrs. Connor returned in 1926 and again in 1928. The Connors also owned the Ocean View Apartments (formerly the Murrelle in 1928). In 1929, they bought the Mayrose Apartments and the Boulevard Apartments in 1931, then built the tropical-modern Polk Street house in 1933. During World War II, Dr. Connor was called to Jackson Memorial Hospital to perform surgery to reconstruct faces of the men who were burned when the Germans attacked shipping in the Gulf Stream just offshore. Connor received a Presidential Commendation from President Franklin D. Roosevelt for this work.

In March 1935, President Roosevelt was the second president to visit Hollywood. (Warren Harding was the first; Circle Park became Harding Circle in his honor.) Roosevelt sailed into Port Everglades on a navy ship during a cruise of Florida waters.

Hollywood's population had almost doubled to 4,356 by June 1935, from 2,880 in 1930. Curiously, there was more traffic at that time along Twenty-fourth Avenue than in the Lakes section. Also, the unincorporated land to the west of State Road 7 was filling with dairy farms. Listed in the 1937 business directory are Biscayne Farms Dairy, E.A. Cowdery, proprietor; Farway Dairy, J.J. Woitesek and C.D. Rowe, proprietors; Goolsby's Dairy, R.G., E.W. and Cecil Goolsby, proprietors; Hollywood Hills Dairy, B. Gustafson, Peterson, proprietors; Johnson's Dairy, Ray Johnson, proprietor; McArthur Dairy, B.B. McArthur, proprietor; Perry Dairy, L. and H. Perry, proprietors; Wachtstetter's Dairy, Guy Wachtstetter, proprietor; and Waldrep's Dairy, W.P. Waldrep, proprietor. More than one hundred fifty workers at the several dairies began to populate the area on Hollywood's west border with their families. Locals who knew the dairymen were sometimes invited out to ride cow ponies over the empty cow pastures from Sheridan Street to Washington Street, in what is now the 6000 block.

Guy Wachtstetter spoke to the Kiwanis Club on July 20, 1934, about the advantages of dairy farming in the Everglades. There was abundant grass all year, he said, remarkable freedom from pests, such as deer ticks, and climatic

For a time, the welcoming sign on Young Circle read, "Hollywood by-the-Sea," an accurate description coined in the early 1920s. Seen at the far right is Moy's Chinese Restaurant at 18th Avenue and Tyler Street. *Historic postcard courtesy of Bill Schaaf.*

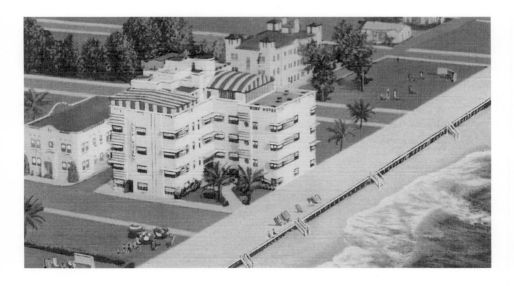

The Surf Hotel on the beach, 1930s. Ella Jo Stollberg, later Wilcox, Hollywood's first female attorney, lived there in 1940. The horizontal rows of balconies are a decided departure from the California-mission/Spanish-eclectic architecture of the 1920s. Hotel is no longer extant. *Historic postcard courtesy of Bill Schaaf.*

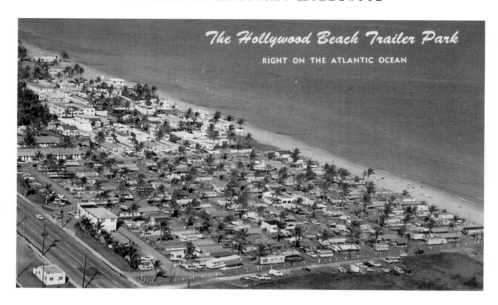

The Beach Trailer Park. The postcard brags that it is the only trailer park with ocean frontage in the Greater Miami area. *Historic postcard courtesy of Bill Schaaf.*

In March 1935, President Franklin D. Roosevelt sailed into Port Everglades on a navy ship. This pre-World War II postcard of the port shows an aircraft carrier at the dock. *Historic postcard courtesy of Bill Schaaf.*

conditions permitting the washing of cows before milking. The Wachtstetters lived in the Phyllis Apartments at 1849–53 Dewey Street, which they owned.

In 1934, the Hollywood City Commission, following a resolution by the Chamber of Commerce, named August 4 as Founder's Day in honor of Joseph W. Young, as this was his birthday. Furthermore, the circle park was re-dedicated as Joseph W. Young Park. Plans for Founder's Day developed apace, and by July, a gala program had been prepared with the entire Hollywood community expected to participate. Invitations were sent to all of Young's former associates. The day began with a golf tournament at the municipal course. Winner John Causey received the Joseph W. Young Cup. In the afternoon, there were water sports at the municipal casino arranged by Mollie Grimshaw, and a band concert at 4:45 p.m., led by Reno Zaza. Barbecues were

Guy Wachtstetter, dairy owner, also made deliveries. The First National Bank is behind him. Before World War II, milkmen, like ice men, delivered their products and most likely brought them into the house and put them in the ice box. *Photo by Valentine Martin. Courtesy of the Broward County Historical Commission.*

held at the ovens on the beach. At 8 p.m., there was a softball game at Dowdy Field. The climax was a dance at the Newport Inn. Those honored that day, in addition to Young, included the Charles Rodens, recognized for having lived in Hollywood the longest, since 1922, at 1901 Madison Street. (Actually the Zirbs had been in Hollywood since 1910, but perhaps they had not registered to be recognized.) Runner-up was Frank Dickey, who also came in 1922, followed by Charles Emerson and John Murray, builder of one of the first houses in the Little Ranches.

Hollywood's small local community came together once again when a Category 5 hurricane smashed into the Keys. Hollywood's damage was light, for example the wood boardwalk was ripped up, to be replaced once again with a black-topped Broadwalk. This, however, was the 1935 storm that took the workers building Flagler's railroad in the Keys by surprise and killed so many as they had nowhere for escape. Hollywood's American Legion Post took in forty-two survivors, helping to house them in the cabanas at the beach casino. The Veterans of Foreign Wars supplied cots, clothing and food, with assistance from the Salvation Army (the latter organization had been of major assistance after the 1926 hurricane, as well). Then on November 8, another hurricane blew in, not as strong but closer to Hollywood; Hollywood's loss totaled at least half a million dollars. Worst hit was Liberia where fifty-five homes were destroyed, while twenty-seven "white" homes were also lost. This time, the evacuation of people in insecure buildings had been planned in advance, preventing possible deaths. Once again, the American Legion stepped in under Commander Henry Mann. The post set up a kitchen in Liberia and, with the Red Cross, led the way for home rebuilding. Frank Dickey, now Hollywood's first paid city manager, was still removing sand from beach streets in December.

A community event begun in 1935 by the Chamber of Commerce would continue for many years to come. This was the Fiesta Tropicale, "a week of play, entertainment, and neighborliness to welcome winter visitors." Although held in December, it was described as "Mardi Gras with Spanish costumes." Chairwoman of the event was Miss Ella Jo Stollberg, Broward County's first female attorney, who was then living in the Surf Hotel. Other committee members were Sol Adler, Clyde Elliott, Sam Frost, Roe Fulkerson, Arthur Meska, Dr. Byron M. Pell and G.C. Sanders. For the parade, the boulevard was closed from Nineteenth to Twenty-first Avenues. To entertain the winter visitors, the parade consisted of bands, floats and pretty much anyone who wanted to take part, dressed in costume and marching along. Most Hollywood girls and young women recall riding on at least one float during the fiesta's early years. The fiesta was not held during World War II, 1943–1945, then was reinstated in 1946.

Late-1930s through 1941

Despite all the efforts of the locals, Hollywood was still struggling financially from 1937 to 1938 and had to declare bankruptcy. Transport company owner Ralph B. Springer was elected mayor and had to deal with gambling difficulties and unpaid property taxes. But these difficulties did not cause people to abandon Hollywood as they had after the storm of 1926. Hollywood was now home to about five thousand settled inhabitants with businesses to run. In 1937, Hollywood Hospital opened, at Nineteenth Avenue and Van Buren Street, the first new hospital since 1929. This was followed in 1939 by the Hollywood Clinic, at 139 North Seventeenth Avenue, just east of the Park View Hotel. The clinic was built by Dr. Elbert McLaury and Dr. Robert R. Harriss. Dr. Byron Pell had his dental office there.

The Hollywood Theatre was refurbished and renamed the Ritz Theatre, but now had a state-of-the-art rival in the glamorous Florida Theatre at 2016 Hollywood Boulevard, with its plush seats, subdued lighting, the latest in Moderne neon and air-conditioning—nearly the only one in town. Children younger than age twelve could go for twelve cents, stay all afternoon and come blinking out into the hot bright sun at five o'clock. Admission for adults was twenty-five cents. Theater manager Paul Robinson also held amateur variety shows on stage in the years before World War II.

Ralph B. Springer became mayor in 1938.
Courtesy of the Hollywood Historical Society.

Hollywood Hospital opened, in 1937, as the first new hospital since 1929. Once again Hollywood babies could be born in a local hospital; in the interim, many Hollywood natives were born in Fort Lauderdale or Miami Beach. *Historic postcard courtesy of Bill Schaaf.*

Florida Theatre built in 1939 showed all the first-run movies. Moreover it was air conditioned, unlike almost anywhere else in the county. Now a parking lot. *Historic postcard courtesy of Bill Schaaf.*

HIGHLIGHTS OF HOLLYWOOD HISTORY, 1920–1960

In 1939, the city created in-town shuffleboard courts, more elaborate than those at the beach (at Garfield Street), and the Shuffleboard Club was very active at 1845 Polk Street for years. Providing visitors with an evening activity, two rival art gallery/auction houses opened practically next door to each other, Jimmy Mann's Hollywood Art Gallery at 1900 Hollywood Boulevard and the Half Moon Art Gallery at 1908. Across the boulevard at 1907–09, the Rainbo Grill erected its distinctive façade and opened for business.

Hollywood Central School remained the only public school. Classes began with the first grade for children age six and older. As there wasn't a nursery school or kindergarten in town, two women with young children decided to open one. Lamora Gleason had married Tony Mickelson, and they had built a home on the east side of Tony's one-acre lot at 2301–07 Polk Street. With land to spare, in 1938, they built a three-sided row of classrooms on the west half of the lot and named it the Outdoor School. The south side was wide open, while the north side had half walls; both sides could be closed by awnings when the wind or rain blew, but generally classrooms were open. Local children flocked to the kindergarten, and almost immediately, it was decided to add first grade. Katherine LaBelle, a neighbor recently arrived from Chicago, Illinois, was the first-grade teacher. Later Katherine LaBelle entered the public school system,

Shuffleboard courts, 1845 Polk Street, 1939. This was another attraction built by the city to entertain visitors. The building in the center distance is the fire station. *Historic postcard courtesy of Bill Schaaf.*

teaching math at Hollywood Central and eventually becoming principal of Nova Elementary when it was established in the 1960s. Lamora Mickelson became headmistress of the Outdoor School, which continued to expand grade by grade through middle school, with high school courses offered mostly to children of visitors, as the school was accredited by the State of Florida. After Kay LaBelle left, Lamora Mickelson convinced her mother Evelyn Gleason to teach first grade, which she did for several decades. The school closed in the mid-1970s, after educating hundreds of local and visiting children for more than three decades.

The LaBelles lived at 2432 Taylor Street where they ran the LaBelle Villas, handsome cubist structures designed by Leo LaBelle's father, an architect. Housing ran in the family, as Katherine LaBelle's aunt owned the Trianon Hotel and her mother—Catherine Fitzgerald, another of the Whatley sisters who had been in Hollywood from the early 1920s—owned Fitzgerald Court at 2201–07 Polk Street. They became linked to J.W. Young's family in 1937 when Marion "Babe" Whatley (whose mother Helen owned the Trianon) married William Young on May 15 at the Young home, 1055 Hollywood Boulevard, where Jessie Young still lived. Bill Young was the only one of the founder's sons to remain in Hollywood and marry a Hollywood girl. He and Babe built a home at 1500 Adams Street. For many years, Babe was the nurse at the Hollywood Clinic. Bill served in World War II, then was elected a justice of the peace upon his return.

Before World War II, there was still a vast amount of undeveloped land in Hollywood. Bill Owra recalled his father cutting a wild pine for a Christmas tree by going "west" from their home on Rodman Street to the undeveloped acreage just the other side of the Dixie Highway. Farmers planted tomatoes in empty lots east of the Federal Highway from the Dania border to the Hallandale border (and those cities also planted tomatoes). On the west side of town, a number of people raised chickens and other domestic animals. The Wardrop family kept a cow at 1110 South Twenty-eighth Avenue until the war ended; Mr. Wardrop having been a dairyman in Cuba before coming to Hollywood. Farther west, except for the Lathrops, Landefelds and Riverside Military Academy, Hollywood Hills section was nearly uninhabited—and the cadets were only in residence from December to spring.

An unusual Depression-era business was raising frogs for consumption, in frog ponds at Twentieth Avenue near McKinley (behind the Larsens at 2022 Wilson Street).

But, people still had faith in their city, even if it was small. The Chamber of Commerce built a handsome new home at 330 North Eighteenth Avenue. The Catholic Church of the Little Flower also built a handsome new home nearby, on Pierce Street between Eighteenth and Nineteenth Avenues, in 1941. And in the

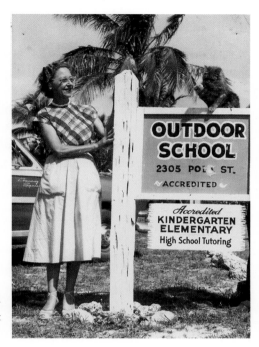

Lamora Mickelson, founder and headmistress of the Outdoor School at 2303–05 Polk Street. *Author's collection.*

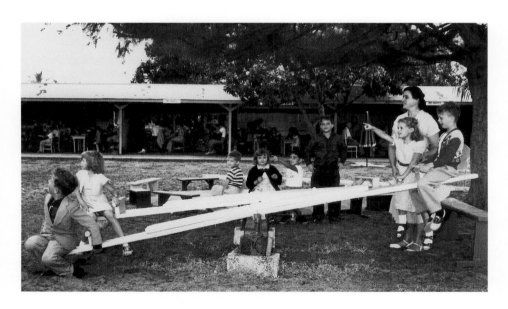

Outdoor School, founded in 1938. State accredited, the school taught all grades and offered ballet, tap, acrobatic and ballroom dancing, conversational French, art, music and music appreciation. At its peak, the school had 100 pupils and 10 teachers annually. *Author's collection.*

same area, the Hollywood Public Library, which had been operating in makeshift quarters, was given a beautiful building at 1824 Polk Street, designed similarly to the Chamber of Commerce of white stucco in a gracious classical style. It was completed in 1942. Clarence Williams was mayor.

In July 1941, a group of local citizens called the Pioneer Pilots arranged for an airfield in undeveloped land along the south Dixie Highway from Moffat Street to Washington Street. Initially named Hollywood Airport, it was promptly renamed MacArthur Field after the attack on Pearl Harbor, Hawaii. Throughout the war, it was one of a tiny number of airfields open to private aircraft. After the war, in 1945, the new owners renamed it Hollywood Airpark, and it remained active until July 1952.

1940s War Years

On December 7, 1941, the Japanese attacked Pearl Harbor, Hawaii, and the United States went to war. As did all of the coast of Florida, Hollywood became, in effect, a war zone. German submarines, called U-boats (*untersee boots*), found tankers and other cargo ships easy targets in the narrow, crowded shipping lanes

Hollywood Chamber of Commerce founded 1922, built its first home in 1941 on land given by the city; citizens raised about $8,000 to build it. When the city took back the land the chamber moved farther north on the Federal Highway. *Historic postcard courtesy of Bill Schaaf.*

Clarence Williams was mayor of Hollywood in 1941. *Courtesy of the Hollywood Historical Society.*

Private aircraft were allowed to use Hollywood Airport, later Hollywood Airpark, during World War II. *Historic postcard courtesy of Bill Schaaf.*

along the Gulf Stream clearly visible just off shore. No attempt was made to attack the United States on shore, but ships were torpedoed in broad daylight, exploding and burning before the horrified eyes of helpless beachgoers. According to Eliot Kleinberg in "The War Offshore," expert reports indicated that one of every twelve ships sunk worldwide in 1942 went down in Florida waters. One ship, the *Sama*, was sunk east of Hollywood on May 4, 1942. However, at least one U-boat did not make it back to home port. In 1942 or 1943, the author and others distinctly recall seeing a small black empty submarine beached near the ovens around Arthur Street. Police would not let anyone near it, and the navy or coast guard speedily removed it, without comment.

By night, Florida's brightly lighted cities had to be dimmed. People in buildings even well inland pulled down blackout curtains and shades, and auto headlights and streetlights were half covered with black paint. Men and women who were not in the armed forces were called into action on the home front. Some became plane spotters stationed in high places. In Hollywood, these included the open towers of the Beach Hotel, Hollywood Hills School and Riverside Military Academy, previously inhabited by bats and owls. Robert LaFavre as a boy accompanied his father to one of these towers where they spent the night watching the skies and reporting anything at all to the coast guard. Another group patrolled the shore at night on foot. Yet others sailed into the Atlantic to patrol for U-boats or rescue survivors; these trips were made on any available seaworthy craft, from yachts to charter fishing boats. Lee LaBelle was one of those from Hollywood who was a member of this Coast Guard Reserve Auxiliary, also called the Picket Patrol.

On August 4, 1942, the U.S. Navy came to Hollywood. The first contingent was part of the Naval Air Gunners Training School, which was established at Riverside Military Academy. On a postcard of Riverside Military Academy and cadets, a recent recruit wrote to a friend stationed in Alabama about his experience:

> *March 7, 1943, Dear John, Hi soldier. What do you know for the good of the country? I finished at Memphis last wk. & have just arrived at Hollywood. Will be going to school here at this Military Academy for 6 wks at least. It's nice. A bath in every room just like a hotel. Florida is beautiful—Palm trees everywhere. Went swimming in the Atlantic yesterday. I've been pinching myself to see if I'm still in the Navy—ha! I'm only 13 mi. from Miami. Best wishes, Paul* [Deich].

In December 1942, the navy occupied the other side of town when an Officer Indoctrination and Training School was established at the Hollywood Beach

D. H. 21 – Sun and Surf Bathers,
Hollywood. Florida

Hollywood beach in the 1940s where astonished young navy recruits found themselves at the beginning of World War II. If idyllic by day as this postcard suggests, by night it was patrolled by coast guard and civilians on horseback. *Historic postcard courtesy of Bill Schaaf.*

Hotel. The navy also occupied little Fogg Field (now Fort Lauderdale-Hollywood International Airport). Meantime, local men were joining up, including the current mayor of Hollywood, Theodore Raper, who resigned to enter the armed services. He was followed by Joe T. Hall as mayor. For the next two or three years, there were signs on shops all over Hollywood reading, "Closed for the Duration," as local men gave up their businesses in order to serve in the armed forces. Many of the remaining businesses were run by women.

Other home-front activities included a canning kitchen set up in Firemen's Hall on Polk Street, where local women learned to can homegrown produce, chiefly tomatoes and grapefruit. Vera Hammerstein was chairwoman of the Victory Canning Center. Years later, many local residents had unlabeled cans in their pantries that were probably tomatoes—unless they were grapefruit. Dinner therefore could be a surprise. Small adjustments to the war included taking in the widowed neighbor's dog so that he could leave and join the Seabees knowing that Pooch was in good hands. Highly successful War Bond and War Stamp drives were held under the leadership of S.S. Holland (for whom Holland Park was named). Children took part, too, using allowances to buy ten- or twenty-five-cent

Hollywood Beach Hotel goes to war. Marine guards stood at duty at the hotel entrance. Civilian plane spotters worked out of the hotel's tall tower; burning torpedoed tankers were easily visible from the beach. Other civilians helped patrol the Gulf Stream for German U-boats. *Historic postcard courtesy of Bill Schaaf.*

Joe T. Hall was mayor in 1942 and 1943 when the Officer Indoctrination and Training School was installed at the Hollywood Beach Hotel. In business, he dealt in real estate and insurance, and served on the city commission many years. *Courtesy of the Hollywood Historical Society.*

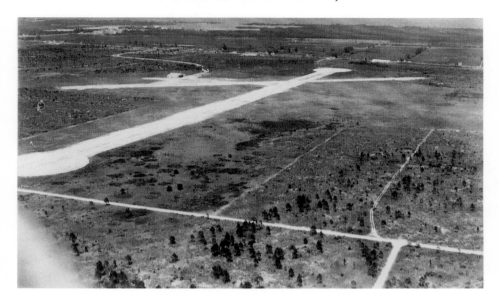

Fogg Field, where the navy trained pilots, deactivated October 1946. Seen here are the original runway, the rudimentary cross runway and the tiny hangar. The inlet top left leads from the Atlantic into Port Everglades and a small tank farm, showing how vulnerable the coast was during World War II. *Courtesy of the Broward County Historical Commission.*

Theodore Raper, mayor of Hollywood who resigned to enter the armed services in September 1943. *Courtesy of the Hollywood Historical Society.*

stamps toward a bond. Selling a certain number of stamps entitled a child to a ride on the local fire engine.

Another example of community effort was the Hollywood Servicemen's Club, which developed under the auspices of the USO, the city, the Chamber of Commerce and numerous other service and religious organizations in Hollywood. The privately owned Golf and Country Club on Polk Street was offered for a time as an entertainment facility for the men and women in the armed forces. The combined committees invited all army, air force, navy and coast guard personnel from Key West to West Palm Beach to visit for dances and other events. As Virginia TenEick wrote: "They came and never stopped coming until the war was over," an average of 1,500 servicemen per week.

Another gathering place, especially for navy men stationed at the Beach Hotel, was Chrest's Bar on Ocean Drive, right nearby, where young men wrote their names and messages all over the walls. Mike Chrest kept these often-poignant messages on the walls for years after the war.

1940s Postwar

When the war ended, the population of Hollywood had grown to 7,500. From mid-1942 through 1943, there wasn't any new construction as building materials went to the war effort, but after the war, construction resumed. Home development began to move west in the Little Ranches as far as Twenty-eighth Avenue. Two ads for houses in the *Hollywood Sun-Tattler* in 1949 were: "House for sale, high and dry, no land crabs, at 2501 Pierce Street," and at Twentieth and Wiley, "Home of the Future Today. Ranch Type-ultra modern. Scientific air-flow ventilation." The latter did not mean air-conditioning, which did not become universal for decades.

In July 1947, residents who had been in Hollywood from the 1920s formed the Hollywood Pioneer Club, which met in various local restaurants. The Elks formed lodge 1732 in 1947 and built a new lodge at Eighteenth Avenue (the Federal) and Funston Street in 1949. The Moose also built a new lodge in 1949, at 2233 Hollywood Boulevard.

In 1944, the city began a recreation center for local teenagers. Called "The Rec," it began in the Great Southern Hotel dining room while Firemen's Hall at 1855 Polk Street was being adapted, having just served as the Victory Canning Center and other war effort purposes. For the rest of the 1940s and the 1950s, high school students had a club of their own, with tables and chairs, ping-pong tables, a dance floor, a juke box and a soft drink machine. The Rec was open afternoons and weekend evenings, with a manager-hostess at the door. All school dances were held there, including the very popular Sadie Hawkins Day dance

when teens in the conservative postwar years could break loose and dress like characters from the *L'il Abner* comic strip. But mostly it was where teens could just go and meet their friends. While white kids of all social levels were welcome, unfortunately because of state segregation laws, black children (who did not attend the same schools) were not seen at The Rec.

Before Hollywood bus service reached out west as far as State Road 7, residents there—such as dairymen and their families—and those who ran the businesses along that road did not find it easy to get into downtown Hollywood or the beach without a car. Harvey Driggers, who was a boy in the 1940s, recalled that at State Road 7 and Grant Street, benches were set up along the sidewalk and movies were shown on an outdoor screen on weekend evenings. He also recalled that he, his brothers and others hunted bear and panthers at that time in the area around State Road 7 and Johnson Street. Wild animals might have been even closer to downtown at that time, as the Hollywood Hills from about Thirtieth to Fifty-sixth Avenues remained undeveloped.

The playground at Lincoln Street was begun in 1948. Earlier in the 1940s, children had developed playgrounds of their own, not always approved by parents and other authorities. Boys and some girls snuck into various rock pits where white stone had been quarried until the pit filled with clear spring water. These were very tempting—and very dangerous—swimming holes. One is now Topeekeegee Yugnee Park. Another girls' activity was to enter abandoned buildings to poke around in the "ruins," with their peeling walls, plaster-strewn floors and spooky echoes. Two favorite haunts were the empty third floor of Morse Arcade on Hollywood Boulevard and the abandoned church on Harrison

The Rec, 1855 Polk Street, adapted by the city as a recreation center for local teenagers in 1944. *Courtesy of the Hollywood Historical Society.*

Street. At that time, Floridians could drive at age fourteen if there was a fully licensed sixteen-year-old driver in the car. Hollywood teens put fifty cents worth of gas in Dad's car and drove far and wide. A tempting racetrack for the boys was the landing strip at the future Fort Lauderdale-Hollywood International Airport, left fairly empty after the navy moved out at war's end.

Postwar south Florida returned to normal in another way from 1947 to 1949, when the Hollywood area was hit by a series of hurricanes. On September 17, 1947, a Category 4 hurricane tore up the beach with thirty-foot waves and 118-mile-per-hour winds. A second, very wet hurricane hit on October 11, 1947, causing widespread flooding, which led to the state's biggest flood up to that time. Some 7.5 million acres were under water, in places for months afterward. Broward County was most affected. In Hollywood, the northwest section—Johnson Street to Sheridan Street and farther west—was under standing water for so long that schoolchildren were given various inoculations to prevent disease. Mayor at this time was former police Sergeant Robert L. Haymaker, who hired Tony Mickelson as city manager. Mickelson, who had seen the east side of the city flooded in 1926, now had to dry out the west side. The floods began to subside only when an opening was made at Dania Inlet so that water could drain into the ocean via the Cut-off Canal. Then in 1949, another Category 3 hurricane hit the Hollywood area, causing flooding once again to the north and west. By then Lester C. Boggs was mayor.

In 1945, the State Road Department wanted to run U.S. 1 right through the middle of Harding Circle. This was flatly rejected by the Hollywood City Commission, which in 1948 voted (again) to change the name to Young Circle. In 1947 and 1948, parking down the center of Hollywood Boulevard in the downtown was eliminated, and parking meters were installed. The author, a teen driving her mother, promptly pulled too far into a parking place and unintentionally pushed over one of the city's new meters.

Harry Truman was the next president to come to Hollywood, in 1946 and 1947. Or at least, pass through, as he was driven in a motorcade of black limousines down U.S. Route 1 on his way to the Little White House in Key West.

In January 1949, J.W. Young's first granddaughter, Rene Ann (child of his son Jack), became engaged to Craig McNair. At the time, she was living with her grandmother Jessie in the Villa-Arms Apartments at 1956 Adams Street. Jessie had sold the home at 1055 Hollywood Boulevard after the war.

Two schools were under construction in 1949, reflecting the growing population. At 2701 Plunkett Street, Colbert Elementary School was constructed and named for Paul F. Colbert, well-liked former principal of Hollywood Central School. Colbert, who lived at 1521 Adams Street, was also principal of West Hollywood, Hallandale and Dania Elementary Schools, and South Broward

Former police Sergeant Robert L. Haymaker was mayor of Hollywood from 1947 to 1949 when the Hollywood area was hit by a series of hurricanes, causing widespread flooding. *Courtesy of the Hollywood Historical Society.*

Lester C. Boggs, 2301 Lee Street, Hollywood mayor, also served on the city commission. Boggs Field was named for him. *Courtesy of the Hollywood Historical Society.*

DH-32—South Broward High School, Hollywood, Fla.

South Broward High School, built 1948–49. Architect Lukens included postwar trends such as projecting concrete canopies, the second story ribbon band of narrow windows, and open, covered walkways between buildings protecting students from the blazing sun. The school has since been enlarged. *Historic postcard courtesy of Bill Schaaf.*

Pauline Watkins taught history and social studies at Hollywood Central School and South Broward High School in the 1940s and 1950s. Pauline Watkins Elementary School in Pembroke Park was named for this very popular Hollywood teacher. *Courtesy of the Broward County Historical Commission.*

and Hollywood Hills High Schools. Continuing his extraordinary service to the children and teachers of the county, Colbert—a gentle, kindly man—went on to become assistant superintendent and then associate superintendent for the Broward County School District before retiring in 1970.

That same year Hollywood built its first high school, located at 1901 North Federal Highway between Harding and Shenandoah Streets, surrounded by tomato fields. South Broward High School educated white, public-high-school students from Hallandale, Hollywood, Dania and Davie. Previously, the school was in Dania, but after outgrowing that site, it was moved to the much larger acreage in Hollywood. Black children continued to attend Attucks, and Seminole children had schools on the reservation. Occasionally, a Seminole went to South Broward. The building was designed by Bayard Lukens and constructed in 1948–1949. The auditorium and a few classrooms were air-conditioned, a most welcome upgrade for the students.

Other schools named for individuals were McNicol Middle School, 1602 South Twenty-seventh Avenue, named for Hollywood's first junior high teacher, Frances McNicol. Pauline Watkins Elementary School, in Pembroke Park, was named for one of Hollywood's most beloved and best-known figures from the 1940s and 1950s. Pauline Watkins, a teacher who also led the Camp Fire Girls,. lived with her husband Earl at 1505 Monroe Street in a 1925 California-mission-style house originally belonging to William Cozens, who probably built it. A witty and engaging speaker, she also gave book reviews and did travelogues for adult groups.

The Mary M. Bethune Elementary School, at 2400 Meade Street, was named for the founder of the Daytona Normal and Industrial Institute for Negro Girls, later Bethune-Cookman College. McArthur High School, 6501 Hollywood Boulevard, opened in 1956 using portable buildings on land donated by James Neville McArthur, of the McArthur Dairy family. In 1958, McArthur donated another ten acres and a permanent structure was built for $1.2 million. Seminole Indians from the reservation began to join Hollywood children in this school. The original buildings were replaced in 2005 by the present handsome campus, for $27 million.

As the war ended, members of the Hollywood City Commission, prodded by attorney William L. Flacks, decided that allowing blatant—and covert—gambling was not creating a desirable image of Hollywood. Slot machines were no longer allowed in every other storefront; bookmaking and horse wires were closed down. But, this did not mean that Hollywood was free of racketeers, for among those who settled in the "city of homes" in the 1940s were Jake Lansky, at 1146 Harrison Street, by 1946 and Vincent "Jimmy Blue Eyes" Alo, at 1248 Monroe Street. Jake's brother Meyer Lansky never owned a home in Hollywood, but did rent houses in the Lakes section. Legend has it that

where the mob lived and raised their families was off-limits to their business activities, and in fact the Lanskys were more active in Hallandale, Miami Beach and Havana with various gambling casinos, but not in Hollywood, where their children went to school.

1950s

In 1950, the population of Hollywood was 14,351. A second hospital was built at Johnson Street and Thirty-fifth Street in 1952. Memorial Hospital was designed by architect Cedric Start. The band shell in Young Circle was replaced with a handsome large amphitheater designed by architect Kenneth Spry. Spry also designed the Hollywood Playhouse, at 2640 Washington Street, in 1953, and a group of homes on Johnson Street in the 2400 and 2500 blocks. These homes may be identified by the distinct midcentury design, the two sides of the slanted roof not meeting but joined by a clerestory window under the higher side. (Technically, this is called a shed roof.) On the wall surfaces, Spry also used new textures, including native oolite limestone on a house on Grant Street. A further study of Spry's work would be welcome.

Throughout World War II, Hollywood's Veterans of Foreign Wars and other civic organizations had maintained an Honor Roll of those who were serving in the war. The other organizations that took part were the American Legion, Kiwanis, Lions, Rotary Club, the Jewish Community Center and B'nai B'rith. As names were continually added, the Honor Roll was a fairly temporary structure. Following the war, when the amphitheater on Young Circle was under construction, it was agreed that its southeast façade would be a fitting site for a permanent war memorial. On November 11, 1951, the All-Wars Memorial and perpetual flame honoring the veterans of all U.S. wars was dedicated. In 2004, when the amphitheater was demolished, the All-Wars Memorial and perpetual flame were also demolished without ceremony.

Hollywood's Italian Americans built their first Civic Club at 700 South Dixie Highway in 1950. The first Jewish house of worship was Temple Beth Sholem, at Eighteenth Avenue and Van Buren Street, built in 1951 and 1952. Previously, the congregation had met in the Jewish Community Center (eventually called Temple Sinai) on Polk Street.

New recreation centers included the nine-hole Sunset Golf Course, at 2727 Johnson Street, which opened in 1952. In May 1953, Palumbo's Golf Course on Stirling Road opened, exclusively for Negroes. Hollywood Yacht Basin in North Lake, one of J.W. Young's many planned amenities for Hollywood, finally began to be developed at 700 Polk Street, although never to the extent that he had hoped. North Lake is simply too shallow for later-twentieth-century yachts. And with the opening of South Broward High School in Hollywood, Scott's Drive-In

In 1950, the city replaced the band shell in Young Circle with a large modern amphitheater designed by architect Kenneth Spry. It was demolished in 2004. *Historic postcard courtesy of Bill Schaaf.*

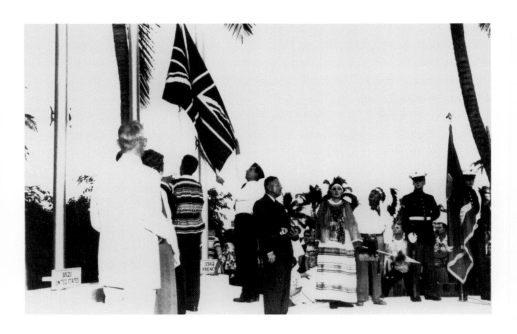

The All-Wars Memorial and perpetual flame honoring the veterans of all U.S. wars on the amphitheater in Young Circle was dedicated November 11, 1951. *Courtesy of the City of Hollywood, Florida, Records & Archives Division.*

Temple Beth Sholem, at 18th Avenue and Van Buren Street, built 1951–52. There were 300 at the first seder held there in April 1953. *Historic postcard courtesy of Bill Schaaf.*

became the favored hangout, at 1800 North Eighteenth Avenue. A true 1950s drive-in, Scott's provided waitresses who came to the car and attached a tray to the driver's-side door. The chief advantage Scott's had over The Rec for teens was that it served food.

The comforts of small, quiet Hollywood continued to attract the gangster element. Frank Costello never lived in the city but did own undeveloped land at Hollywood Boulevard and Eleventh Avenue. Liens were placed on his property in April 1953 while Costello was in federal prison. John Herchick, living at 1621 Van Buren Street, had not paid attention when the city cracked down on bookies, and in April 1953 was on trial for illegal bookmaking. Phil "The Stick" Kovolick apparently ran up against his own bosses and ended up in a rock pit with cement boots, or so the story goes. His beautiful home is still at 1311 Jefferson Street. Two other Hollywoodians who were also listed on the Florida sheriff's list of the one hundred top gangsters in Florida in 1959 with the Lanskys and Kovolick were Charles Frederick Teemer at 1011 Tyler Street and Frank Carbo at 2637 Taft Street. Meyer Lansky, who lived in Miami Beach, often met his friends at the Tuscany Motel at 3800 South Ocean Drive.

Hollywood continued to reach farther west, as the boulevard was extended from State Road 7 to U.S. Route 27 in May 1953. Land to the south and west of

Tuscany Motel where racketeer Meyer Lansky came over the county line from Miami Beach to meet his colleagues. *Historic postcard courtesy of Bill Schaaf.*

State Route 7, used as a gunnery range by the navy during World War II, was now ripe for development.

In the 1950s, Hollywood had been a city for more than twenty-five years. Older longtime residents were becoming recognized as pioneers. In May 1953, two women were honored as Pioneer Mothers by the Apartment & Hotel Association. They were Jessie Faye Young and Mildred David. Jessie, widow of the city's founder, then living at 2034 Dewey Street, was mother of Jack, Tonce and Bill. After moving to Bill's home at 1500 Adams Street, then to a convalescent home, Jessie Faye Young died November 24, 1955. John (Jack) had died August 29, 1942. Bill died soon after his mother, June 18, 1956. Tonce (Joseph W. Young III) died September 13, 1964. They were survived by John's children John Jr., Rodney and Rene Ann; Bill's daughter Patsy; and grandchildren.

Fellow honoree Mildred David, 2115 Polk Street, widow of B.L. David, was the mother of speaker-designate of the State House of Representatives, Ted David, and City Commissioner B.L. David Jr. Her other six children were Sam, Bob, Claude, Bill, Shirley and Sarah.

The 1950s saw yet another war begin, in that belligerent twentieth century, this one in Korea. Hollywood's National Guard Armory for Company C, 211th Infantry was begun in 1953 on a corner of Dowdy Field at Johnson Street and

the Dixie Highway. Supervising architects were Start & Moeller. The first troops from here went off to the Korean War.

A "porch house," designed by architect Igor Boris Polevitzky, was built at 1519 Harrison Street in the 1950s. At that time, Polevitzky was famous for his Birdcage House of 1950, constructed chiefly of screened-in extensions that integrated the outdoors with the interior and allowed for breezes in the era before air-conditioning. Hollywood's single-story "porch house" has his updated version of the front porch, with walls tilting outward, a model of midcentury modern architecture, a further development of 1930s streamline Moderne with more exaggerated horizontals, fin walls, cheese-hole masonry and clerestory windows. Interestingly, Polevitzky designed the Habana Riviera Hotel in Havana for Meyer Lansky. And for the Arthur Murray Dance Studio in Miami Beach, Polevitzky designed a retractable roof that opened to the stars. Perhaps he had been to Martin Hampton's Hollywood Golf and Country Club.

The original Diplomat Hotel at 3515 South Ocean Drive was designed by Norman M. Giller and opened in 1958. By today's standards, it would seem small, but then, ten stories was taller even than the Hollywood Beach Hotel. In a sense, it was the northern outpost of Miami Beach resort hotels that had sprung up on the beach since World War II. Giller particularly liked the building, with its hyperparabolic porte cochère.

At the end of 1959, Hollywood, Inc., finally began to complete the development of Hollywood Hills. The first section was opened for sales in April 1959; six hundred homesites were sold. In December 1960, the second section of three square miles was planned for six thousand homes. Warren Hyres, helping with the land surveys at the time, discovered that the sidewalks laid long ago had turned red after more than two decades under the palmettos.

1960 and Later

Only a few landmarks and highlights of the later twentieth century will be added.

With more permanent residents and with the beginning of the baby boom, Hollywood needed more high schools. Hollywood Hills High School opened at 5400 Stirling Road. A member of the first graduating class in 1960 was Bonnie Wilpon, who was named the first "Top Teen." In 1999, she published *The Postcard History of Hollywood Florida*. Chaminade High School for Boys, at 500 East Chaminade Drive, was under construction in December 1960. It was named for Blessed William Joseph Chaminade of Bordeaux, France. In 1988, it combined with Madonna School for Girls, founded in 1960 by the Sisters of Notre Dame.

The Hollywood Mall at 3251 Hollywood Boulevard was the first enclosed shopping center in Hollywood, built in about 1960 when the concept of the

Diplomat Hotel, designed by Norman M. Giller and opened in 1958. It was recently demolished and replaced by a much larger resort complex. *Historic postcard courtesy of Bill Schaaf.*

covered, climate-controlled mall was new. Shoppers greatly enjoyed strolling with their children, free from automobile traffic, where they could walk or sit down while avoiding blistering sun and sudden downpours. Sadly, this sense of safety was shaken when seven-year-old Adam Walsh, son of *America's Most Wanted* host John Walsh, was kidnapped from here and killed in 1981.

In 1965, the city of Hollywood could look back on forty eventful years. To celebrate the pioneers who had created the city—and carried it forward—Virginia Elliott Lathrop TenEick sat down and wrote its history. Not only was she an insider who had known nearly everyone she wrote about, she was a talented news reporter, working for the *Miami Herald*. Her invaluable book, *History of Hollywood 1920 to 1950*, was first published in 1966. It is still available in paperback.

In 1974, when Hollywood was about to celebrate its fiftieth anniversary, many original pioneers were still living in the city. Several of them decided it was time to collect and preserve historical documents and personal papers and photographs for future residents of Hollywood, and they founded the Hollywood Historical Society. The first officers were Lee Aderholdt, president; Katherine LaBelle, vice president; Irma Cauley, secretary; Norcott Henriquez, treasurer; Caroline Thompson, historian; Patricia Smith, membership; Ralph Walters, artifact

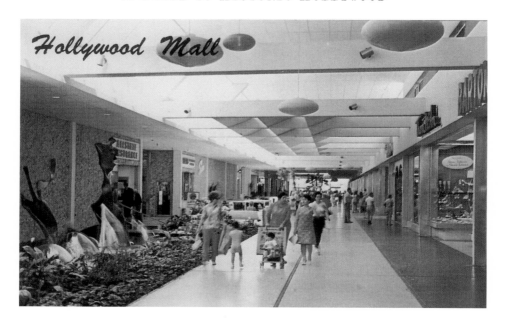

The Hollywood Mall, 3251 Hollywood Boulevard, was the first enclosed shopping center in Hollywood. *Historic postcard courtesy of Bill Schaaf.*

collection; Senator William Zinkil, bylaws. To date, the Hollywood Historical Society, a nonprofit independent organization, has collected more than eighteen thousand photographs, maps, papers, documents and other Hollywood items, and is still actively collecting.

In 1976, Hollywood was again sliced through by a federal road, Interstate 95. This highway followed a reasonable route, paralleling the Seaboard Air Line Railway rather than dividing the heart of downtown. And two future landmarks in the new century should be mentioned. The gleaming white towers of the Seminole Hard Rock Casino and Resort built in 2004 on State Route 7 off Stirling Road cannot be missed from a long way off. It is part of the wonderfully beautified Hollywood Seminole Reservation. Now under development in one of Hollywood's oldest buildings at 2031 Harrison Street is the Holocaust Documentation and Education Center.

Pioneers helped install a bronze bust of the founder, Joseph W. Young Jr., on the west side of Young Circle facing Hollywood Boulevard downtown, the area Young had first developed in 1921. The bronze sculpture was made by Hollywood sculptor Joseph Baumgarten and erected by the city commission in 1951.

Since 1953, Hollywood has expanded by annexing areas to the north and west, more than doubling the land area that was J.W. Young's Hollywood in the 1920s.

In this picture of Interstate 95 under construction, 1976, the now-defunct Howard Johnson's Inn is in the foreground. A small white building upper left is Stratford's Bar. Dating from 1944, it is one of the oldest bar/restaurants in Hollywood still operating. *Historic postcard courtesy of Bill Schaaf.*

The Hills section is neatly lined with attractive homes, the former dairy lands have been subdivided and populated. A marshy area in the extreme southeast corner of mainland Hollywood became prime residential property after dry land was created by means of the dredge-and-fill technique. Great patches of empty lots that existed right through the 1950s are a memory. It would seem that every corner of Young's city is now occupied by people and buildings, but this is not the case. Hollywood beach, far longer now than the original six miles, is open to the public for its entire length. Except at the extreme south, buildings are relegated to the west side of the Broadwalk, and the Broadwalk, the sand and the ocean are there for everyone's enjoyment. This happy situation was foreseen by the founder, as the *Reporter* noted in 1924: "Pre-empting the ocean. In some resort cities the wealthy have bought the shore property—how unfortunate! Hollywood by-the-Sea will have a different story to tell. Here there will be no riparian rights along the ocean frontage to exclude the public. For a distance of [then] five miles one of the most beautiful beaches in Florida will be forever dedicated to the people, never to be privately owned or built upon."

Young understood the value of an open beach, but very few in his era considered the value of wetlands. In the nineteenth century Governor Napoleon

HIS VISION AND COURAGE CREATED THIS CITY

Bust of Joseph W. Young, 1882–1934, founder of Hollywood, by Joseph Baumgarten, sculptor. Bronze cast by Modern Art Foundry, New York. Young faces west down Hollywood Boulevard, where his city began. Text on the marble wall reads, "His Vision and Courage Created This City." *Historic postcard courtesy of Bill Schaaf.*

Bonaparte Broward wanted to drain the entire Everglades. By the middle of the twentieth century, however, our understanding of ecological systems was much greater, and preserving them became important to the general public. And it was through the efforts of a broad-based state and national public effort, over a ten-year period, that an astonishing 1,500 acres of coastal wetlands, mangrove forest and a natural lake—all once owned by J.W. Young—were preserved.

Young bought the land around West Lake as he was buying land around Dania and up to his holdings at Lake Mabel (now Port Everglades). On maps, the shores of this natural lake were platted but not developed by Hollywood Land and Water Company. By 1930, the area had been acquired by Hollywood, Inc., but that company made no effort to develop it before 1960. By then ecologists realized that this unique area of untouched coastal property in south Florida was akin to a national treasure. Within its boundaries are approximately 123 bird species, including 20 that are rare or endangered; 10 animal species; 80 forms of plant life; and 86 species of fish. Many of the fish start their lives in West Lake mangroves before swimming out into the Atlantic. Thus the mangrove ecosystem of West Lake contributes directly to the aquatic health of Broward's coast. Nevertheless, the owners had every right to develop and build on the

West Lake, a natural body of water with access to the ocean, was part of J.W. Young's original purchase, but never truly developed. In 1985 it became a Broward County park with entrances at Sheridan Street. *Courtesy of the Broward County Parks and Recreation Division.*

property. But activists in the 1970s spoke out. Friends of West Lake was formed; its members were joined by community leaders; environmentalists; naturalists, including Marjorie Stoneman Douglas; and determined legislators from the City of Hollywood and Broward County in the effort to purchase and preserve this property. By 1985, a total of $20 million had been raised and the property was purchased from Hollywood, Inc., and became a Broward County park.

Hollywood's first settlers enjoyed their homes and their city, but they also loved the surrounding natural beauty. West Lake Park, preserved for the future, is a peaceful and eloquent reminder of where it began.

STREET GUIDE

O n the pages that follow are historically interesting locations. Listed first are the north–south routes, with avenues first then named roads in alphabetical order. These are followed by the east–west streets, listed in alphabetical order.

Key:
- 26 san. indicates building shown on 1926 Sanborn map.
- Street numbers used are the earliest found; numbers were often changed slightly.

PLEASE NOTE: **Private homes are not open to the public.** With the exception of the Hammerstein house at 1520 Polk Street, these are private homes. **Please respect the owners' privacy**.

North and South Routes and Landmarks

Addresses are numbered either north or south, beginning at Hollywood Boulevard.

A1A
See Ocean Drive.

Canal
Now the Intracoastal Waterway, this canal runs north–south between the beach barrier island and the mainland.

In 1920, it was privately owned by the Florida East Coast Canal Company. It was much narrower than it is today with shoals. The banks were mostly natural; in Hollywood, they were tidal mangrove habitats.

It is often called the Inland Waterway and is part of a national canal system that runs from Florida to New York.

7th Avenue
This is the road closest to the Intracoastal Waterway on its west bank; it runs parallel to the canal and was laid about 1925.

13th Avenue
13th Avenue extends to city limits north to south.

711 South 13th Avenue.

House designed by architect Claus Moberg in 1951. With Kenneth Spry, Moberg exemplified in Hollywood the architectural style now called midcentury modern, a further development of 1930s streamline Moderne with more exaggerated horizontals, fin walls, cheese-hole masonry and clerestory windows. Moberg's other buildings around Hollywood are yet to be documented.

14th Avenue
This was originally 8th Avenue. It extends to city limits north to south. This represents the east boundary of J.W. Young's land purchase for his future city. The other boundaries of the square mile were the present-day Dixie Highway on the west, Johnson Street on the north and Washington Street on the south. At that time 14th Avenue was merely a line on a surveyor's map. The next phase of development involved laying in streets, beginning in 1922. According to surveyor Tony Mickelson, a reason the line that became 14th Avenue was chosen as the east boundary was because from there east, the area was called the East Marsh and was pretty much under water, right over to the barrier island.

14th Avenue is the east edge of the Hollywood Golf and Country Club golf course.

14th Avenue and Hollywood Boulevard.

The Meyer-Kiser Corporation, which built and sold houses, had offices here in 1925 after the Lakes section was drained.

501 North 14th Avenue.

Hollywood Woman's Club; listed on the National Register of Historic Places. The club was built on land donated in April 1924 by Joseph W. Young. The frame Cape Cod cottage with its neoclassical entry flanked by two Corinthian columns was designed by Hollywood architect Frederic A. Eskridge; construction by C.E. Payne. The Woman's Club is the second oldest civic association in Hollywood (following the Chamber of Commerce). Minnie Kington helped found a Ladies Community Club in December 1922. The group became the Hollywood Woman's Club in 1923 and received its affiliation charter in the county and state federations of woman's clubs that year. The first president was Orpha Dickey. She was followed by Nora Walters, then Minnie Kington and Mae Behymer. The building was completed and dedicated in August 1927. Mrs. Behymer was then president. From the beginning, the club focused on the well-being of local children. With the AAUW, the Woman's Club founded the Hollywood Public Library in 1927. The club continues to attract new members and remains active to this day in its landmark building.

15th Avenue

15th Avenue was originally 7th Avenue. It extends to city limits north to south.

122 North 15th Avenue.

Home of H. Emerson and Alice Evans, 1925. He was general manager of sales, Northern division, for Hollywood Land and Water Company in 1924–25. Young required his top salesmen to build showplace homes in the city they were promoting. Evans did his bit—this house was said to have cost $80,000 to build in 1925. It is probably a Rubush & Hunter design, carried out by Meyer-Kiser (see Fourteenth Avenue), an impressive two-story Spanish-eclectic design no doubt influenced by Addison Mizner in Palm Beach. The house, still extant, faces 15th Avenue but also has the address 1500 Tyler Street.

17th Avenue

17th Avenue originally was 5th Avenue. It extends to city limits north to south.

As surveyor Tony Mickelson explained later, the elevation of 18th Avenue was ten feet, with a gradual downward slope to 14th Avenue. The marshy area from about 16th Avenue to 14th Avenue was tidal in many areas. Hollywood Boulevard

(and most of the other streets with the exception of Johnson Street) ended at 17th Avenue until about March 1924 when the dredge-and-fill operation in the Lakes section had begun to drain the land east of 17th Avenue.

17th Avenue, Polk to Johnson Streets.

West boundary of the Hollywood Golf and Country Club. The first nine holes opened at the end of 1922 on land previously planted to tomatoes by Dania farmers. The golf course was designed by Ralph Young (no relation to J.W.), and laid out and landscaped by Charles Olsen, a horticulturist from Rochester, New York. In 1924, Young built the country club. See Polk Street.

Between 17th and 16th Avenues on Adams Street.

In 1923, builder R.M. Ducharme of New York was building on seventeen lots there. Not specifically identified.

310 South 17th Avenue.

Waverly Apartments; home of Philip Vitsky in the 1920s. He operated the Western Union telegraph office; a former vaudeville performer he wrote the song "Hollywood-by-the-Sea" in 1924. Following the 1926 hurricane, Vitsky with other local entertainers helped keep up the morale of refugees and patients recovering from the storm. The building still stands.

719 South 17th Avenue.

William Cozens owned several properties there in 1924.

139 North 17th Avenue.

Hollywood Clinic, 1939, just east of the Park View Hotel. Founded by Dr. Elbert McLaury and Dr. Robert R. Harriss. Dr. Byron Pell had his dental office there. Marion "Babe" Young was the nurse for years. No longer a clinic, the building still stands.

404 North 17th Avenue.

Hutchinson Hotel, a Spanish-eclectic design with its entrance of columns and arches. The hotel has fifty rooms built in 1924 by Harry Hutchinson from Philadelphia, Pennsylvania. Also called the Golf View Hotel. Hutchinson was on the nine-man Charter Committee formed in March 1924 to develop a charter for the city. The final city charter was adopted November 28, 1925. The well-maintained hotel still stands.

516 North 17th Avenue.

Home of Reno Zaza by 1929. Zaza came to Hollywood in the mid-1920s as a musician with Caesar LaMonaca, whose band was hired first by Young and then by the

city. Finally the city could no longer afford a band in the early 1930s and LaMonaca moved to Miami, but Zaza stayed on. He directed the Hollywood Boys Band, then was hired as bandmaster at Riverside Military Academy where he remained until his retirement. Building not extant.

17th Court

In 1940, 17th Court extended from Johnson Street north to Arthur Street. In the 1920s, this area was called St. James Park.

1204 North 17th Court.

Home of James E. Jones, who founded Hollywood Hardware Company. The two-story frame house is a variation on the basic colonial-revival model with its double row of three wide windows on the front. Still extant.

1209 North 17th Court.

Home of Walter H. Wakelyn Jr., who built it in 1924. Wakelyn owned the Wakelyn Mill Works. The house is still extant.

1215 North 17th Court.

Home of Fred and Albertina Zirbs. By 1910, the Zirbses were farming in what would become Hollywood. They were long recognized as Hollywood's first residents and original pioneers. The house no longer stands.

18th Avenue

Originally, 18th Avenue was 4th Avenue. It has also been called the East Dixie, U.S. 1 and the Federal Highway. It extends to city limits north to south. The elevation of the land at 18th Avenue was ten feet. In 1922, the first area to be laid out with sidewalks and rock-covered streets in Young's proposed new city was between the Dixie Highway and about 18th Avenue, and from Washington Street to Johnson Street. Before this, only the Dixie Highway and a cart track at Johnson Street existed.

18th Avenue from Johnson Street to the boulevard acquired the nickname "East Dixie" in 1923. When Hollywood began, the only auto road south was the Dixie Highway, which came through Dania east of the Florida East Coast railroad tracks, then made an angle turn west to cross the tracks to the north of Sheridan Street. Young's wide boulevard was designed to lure drivers off the main route, the Dixie, and into the city. However, after 18th Avenue was installed and laid with rock, drivers began to stay on it heading south because it was the straight route to the Circle. The January 15, 1923 *Hollywood Reporter* indicated that as this was probably inevitable, 18th Avenue would become the East Dixie, the other main road through the heart of Hollywood.

By 1924 18th Avenue had developed into a bustling commercial route, especially around Garfield and Buchanan Streets, with shops to service travelers, including a grocery and dry cleaner, and a profusion of cabins and cottage courts. Most of the shops and cabins were demolished in the 1926 hurricane.

In 1930, the federal government continued to extend U.S. Route 1 south, deciding to run it along 18th Avenue and around the ten-acre Harding Circle. The work of widening and repaving 18th Avenue down to the Dade County line continued through most of 1931, not without controversy. While this made road sense, it entirely changed J.W. Young's original plan for his city. He anticipated that travelers would arrive on the original Dixie or the train, both of which ran between the circles, then turn either east or west to discover the broad boulevard with its circle parks and imposing resort hotels. Putting the major north–south route around the Circle, creating traffic snarls, was not Young's original intention.

18th Avenue at Garfield Street.

Here stood the imposing Brandon's Hippodrome Theatre with its semicircular façade. Before they built a church, the Lutherans met here. The building was demolished in the 1926 hurricane. 26 san. See Garfield Street.

101 North and South 18th Avenue.

Hollywood Hotel, Park View Hotel, Town House. This hotel was under construction in 1922 as soon as Circle Park, which it overlooked, was laid out. Hollywood Boulevard was only paved from the Dixie Highway to the hotel, but almost immediately it began attracting visitors who were eager to see the land that would become the new city. The hotel could hold one hundred guests, on the American plan. The first major building designed by Rubush & Hunter that Young would build, in general it follows the California mission style adapted for resort hotels in California just a decade or so earlier. In the May 1922 *Reporter*, it was described as Spanish Renaissance facing the Circle and with "Moorish effects" (probably including the dome) on the side toward the sea. When Young planned the Hollywood Hills Inn in 1925, this hotel was renamed the Park View. In 1947, the owner renamed it the Town House. Although the site seems ideal for a hotel, Young's building was demolished and unimaginatively replaced by a grocery and drugstore complex.

200 North 18th Avenue.

Utilities Building. The land Young purchased had an excellent supply of underground water. The April 1922 *Reporter* explained that the title Hollywood Land and Water Company referred to drinking water as there were seven deep wells in block 43 alone. In fact, it went on, Hollywood's drinking water was so wholesome that the

Hollywood Company contemplated bottling it for sale to Miami. This building no longer exists.

312 North 18th Avenue.
Southern Bell Telephone & Telegraph Company building, late 1920s. No longer extant.

330 North 18th Avenue.
Hollywood Chamber of Commerce building, 1941. As early as 1922, the city's first civic organization, Chamber of Commerce of Hollywood-by-the-Sea, Florida, was begun. W. Ward Kington was named first president. Though very active in the 1920s and 1930s, the chamber did not have a home. In 1941, citizens decided they should present the city in a good-looking building; the city gave the land, and about $8,000 in building funds was raised from private citizens. The design of the white building combined a red tile roof with a neoclassical pediment, columns and doorway. When the land was taken back by the city, the building was torn down and the chamber moved farther north on the Federal.

1340 North 18th Avenue.
Billy Boye building, shared by Boye Bottled Gas and Billy Boye Ice Cream, 1940. The building, which dates to *circa* 1925, is still extant.

1420 North Federal Highway.
Hollywood Church of Christ in 1940.

1800 North Federal Highway.
Scott's Drive-In. With the move of South Broward High School from Dania to Hollywood, nearby Scott's Drive-In became the favored hangout. A true 1950s drive-in, Scott's provided waitresses who came to the car and attached a tray to the driver's-side door. No photos of Scott's have been located. The building is still extant, under another name.

1901 North Federal Highway.
South Broward High School. Designed by Bayard Lukens, it was built in 1948-1949 in the international style. Greatly enlarged since.

18th Court
In 1940, 18th Court extended from Johnson Street to Hayes Street.

930 North 18th Court.
Home of Olaf Owra in 1924. Owra was contractor for several of J.W. Young's buildings, including Young's home, the Golf and Country Club, the foundation for

the Beach Hotel, and later the City Hall. Owra later moved to Grant Street. House not extant.

936 North 18th Court.

Home of Michael and Mabel Chrest in 1924. Chrest was manager of the Young Company's popular Tangerine Tea Room on the Broadwalk at Johnson Street until it was demolished in the 1926 hurricane. About 1930, he opened Chrest's on Ocean Drive, which was a bar after Prohibition ended. It was especially popular with the naval officers in training at the Hollywood Beach Hotel during World War II. No longer extant.

19th Avenue

Originally 19th Avenue was 3rd Avenue. It extends to city limits north to south.

1512 North 19th Avenue.

Home of James and Gertrude Newman, 1924. He was a lecturer-salesman for the Hollywood Land and Water Company, then went into real estate. Their first home at this address was a cabin they built in 1923. Newman reconstructed one of his sales pitches for Virginia TenEick's *History of Hollywood (1920 to 1950)*. House no longer extant.

19th Avenue between Hollywood Boulevard and Harrison Street.

Hollywood's first post office, demolished in the 1926 hurricane. 26 san.

20th Avenue

Originally 20th Avenue was 2nd Avenue. It extends to city limits north to south.

107 North 20th Avenue.

Christian Scientists opened a Reading Room here in 1925.

125 North 20th Avenue.

Tyler Building, constructed 1925–26. The Masonic Hall was upstairs until its members built a lodge at 19th Avenue and McKinley Street in the 1940s.

205–07 20th Avenue.

The Rotary Club had quarters here in the late 1920s.

304 North 20th Avenue.

Built as a dormitory in 1924 for hotel help by J.W. Young, this site was designed by Rubush & Hunter. Very shortly, housing for visitors became urgent and this became

the Casa Blanca Hotel for paying visitors. Also listed on Polk Street. Still extant and in good condition. 26 san.

20th Avenue near McKinley Street.

Frogs were raised for consumption in ponds here in the 1930s. No longer.

1204 North 20th Avenue.

Mack Lumber Company. Jimmy Mack bought the Hollywood Builders Supply at the close of the Twenties and renamed it Mack Lumber Company. As part of the Young Company, it was first called Southern Mill & Bungalow Company. The entire complex reached to 21st Avenue and stretched south for several blocks, starting from Taft Street. No longer extant.

21st Avenue

Originally 21st Avenue was 1st Avenue. It extends to city limits north to south.

This was the first north–south road built by the Young Company in Hollywood in 1921(the Dixie Highway already existed). It parallels the Florida East Coast Rail Road on the east side of the tracks. Buildings are all even numbers; odd numbers are across the tracks on the Dixie Highway.

During the 1926 hurricane, knee-deep saltwater from the Atlantic Ocean reached as far west as 21st Avenue, finally halted there by the raised railroad track bed.

205–07 North 21st Avenue.

Store built by Charles A. Dagley, 1925. Dagley was a real-estate broker who created several subdivisions along 18th Avenue north toward Dania in 1925-1926. Some of the names for these subdivisions are St. James Park, Chattanooga Park and Hollywood Lawns. In 1943, American Legion Post 92, one of the first civic associations to organize in 1923, raised funds and purchased this building, adding an auditorium and kitchen. Still extant. 26 san.

219 North 21st Avenue.

Hollywood Publishing Company, begun July 1924. To generate news and publicity, the Young Company built its own printing plant. The architect for this handsome building, which was described as Italian Renaissance, has not been discovered, probably either Martin Hampton or Rubush & Hunter. When the Young Company publishing enterprises outgrew this building, the company moved to a larger one on Hollywood Boulevard. When the charter was adopted creating Hollywood as a city on November 28, 1925, a city hall was required. The old publishing building, not occupied at that time, was pressed into service as Hollywood's first City Hall. After the actual City Hall was erected, Hollywood government moved to City Hall Circle at 26th

STREET GUIDE

Avenue. This building has been expanded and used for clubs and restaurants, but the original structure remains and has been recognized as a landmark.

402 North 21ˢᵗ Avenue.

Florida East Coast railway station, completed March 1924. The building was on the east side of the double tracks. Although the FEC tracks passed through Hollywood before the city existed, there wasn't a passenger stop in J.W. Young's new city even after it had developed considerably. Therefore Young made a deal with the railroad: if a railroad stop were added near his broad Boulevard, he would build a station. An agreement was reached, and in his usual fashion, Young went all out. When the station was completed, it was described as the most imposing station south of Jacksonville. The December 1923 *Hollywood Reporter* included a two-page spread of an extended railroad station stretched between the FEC tracks and 21ˢᵗ Avenue from Polk Street to Pierce Street. It had a central tower and arcaded wings, providing shelter the length of the passenger area and creating the epitome of the tropical Spanish look Young had selected. The architect's name has not been discovered; perhaps Martin Hampton received this commission together with that of the country club. The contractor was Louis Bergeron of Miami. What a splendid impression of Hollywood this beautiful station made for generations of passengers arriving from the north! When rail traffic declined, it could have been used for shops and offices. Instead, this impressive piece of Hollywood history was demolished in order to straighten out 21ˢᵗ Avenue. 26 san.

21ˢᵗ Avenue and Taft to Garfield Streets.

Florida East Coast rail siding. Completed in January 1922 and given to the Hollywood Company, this provided switching space for between twelve and fifteen box cars. Rail delivery of construction materials in particular was a great advantage to the new city. Still operating.

801–21 North 21ˢᵗ Avenue.

J.W. Young's Hollywood Builders Supply Company, also called Southern Mill & Bungalow Company, extended along 21ˢᵗ Avenue from where the siding tracks cross 21ˢᵗ from Taft Street and run south several blocks to Garfield Street. This key local industry continued to expand until the Young Company went bankrupt. Jimmy Mack, who had been a bookkeeper for the builders' supply company, bought it and renamed it Mack Lumber Company, which continued into the 1980s. Now gone.

21ˢᵗ Avenue, unidentified address.

FEC railway pump station. Early trains on the FEC lines were pulled by steam engines that required water. In Hollywood, the pump was somewhere between McKinley and Sheridan Streets, probably closer to McKinley. Not extant.

214 South 21ˢᵗ Avenue.

Dixie Plumbing Company. Owned and operated by Earl Waltz and his sons beginning in 1931.

220 South 21ˢᵗ Avenue.

Home of Earl Waltz, plumber, who served on the city commission and was on the city's first planning and zoning board in 1941.

22ⁿᵈ Avenue

In 1940, 22ⁿᵈ Avenue extended from Johnson Street north to city limits.

3500 North 22ⁿᵈ Avenue.

Attucks School, Attucks High School, Attucks Middle School. The first school here was built in 1925 in what was then the city of Liberia, and it was called the Dania-Liberia School. At that time it served for all grades for the black schoolchildren. It was renamed Attucks School, for the Revolutionary War figure from Framingham, Massachusetts. Born to a black slave father and a "Praying Indian" mother, Crispus Attucks left home as a youth. Years later, working in Boston, Massachusetts, he led a group of other local revolutionaries armed only with clubs against the heavily armed British militia. Attucks, who was killed, is considered to have been the first to die for the American Revolution. For most of its existence, Attucks School was in Dania.

23ʳᵈ Avenue

In 1940, 23ʳᵈ Avenue extended from Arthur Street north to city limits.

Along the 23ʳᵈ Avenue line, from about Taylor Street south to about Van Buren Street, farmers were growing turpentine mangoes and avocadoes when J.W. Young bought the property in 1920. Even today some of these trees survive.

2204 North 23ʳᵈ Avenue.

Home of Lester C. and Hazel Boggs by 1929. Boggs was Hollywood's mayor, from 1943 to 1947 and from 1949 to 1953. He was also on the city commission for many years. He was in the septic-tank business, quite necessary as there weren't any city sewers west of the Dixie Highway.

2310 North 23ʳᵈ Avenue.

Boggs Field, named for Mayor Lester C. Boggs.

2810 North 23ʳᵈ Avenue.

St. Andrews Episcopal Church in 1940.

24th Avenue

In 1940, 24th Avenue extended north and south to city limits.

119 North 24th Avenue.

Home of Charles D. Rowe, owner of the Farway Dairy, Inc., by 1940. Not extant.

24th Avenue and Johnson Street.

The old farmhouse, at the corner, was used initially as housing for black workers, 1920–1921, when there was little to no housing in Hollywood. This area in the Little Ranches had been farmed for several decades by people from Dania and Hallandale. Not extant.

709 North 24th Avenue.

The First Pentecostal Church. Mentioned by the later 1920s. Building not extant.

25th Avenue

In 1940, 25th Avenue extended from Johnson Street north to city limits.

26th Avenue

In 1940, 26th Avenue extended north and south to city limits. This is an old north–south trail along the high ground, predating even the Dixie Highway in Hollywood.

26th Avenue at Johnson Street.

Old signpost for the original north–south road between Palm Beach and Miami. The post still existed in the 1920s. The trail was probably used by Seminoles, by members of the U.S. military stationed in Forts Dallas and Lauderdale and by intrepid nineteenth-century travelers on horseback and by coach. Post no longer extant.

27th Avenue

1602 South 27th Avenue.

McNicol Middle School, named for Hollywood's first junior high school teacher Frances "Fannie" McNicol. She and her husband Thomas were vacationing in Fort Lauderdale from St. Louis, Missouri, in 1924 when the Broward County school superintendent put out a search for a teacher for Hollywood. The school was in the Young Company's first sales pavilion at 19th and Harrison Street, with pupils from all over the United States, Cuba and South America. Mrs. McNicol was put in charge of

the junior high school, seventh and eighth grades. The McNicols moved to Hollywood and lived at 1447–49 Madison Street. She continued to teach, and her husband became postmaster from 1928 to 1929.

28th Avenue

In 1940, 28th Avenue extended to city limits north to south.

Many streets in Hollywood ended at 28th Avenue before the 1950s. Initially this was because of the West Marsh, a watery area created by streams that began in what would become the Orange Brook Golf Course. Under J.W. Young, the marshes were regularized by having a canal dug, now the C-10. In 1926, the Seaboard Air Line Railway ran its single-track, north–south railroad along what would be about 29thAvenue.

28th Avenue at Hollywood Boulevard.
The boulevard crosses the C-10 Canal and the railroad.

28th Avenue at Johnson Street.
From here, a bridge crosses the C-10 Canal and the street crosses the railroad.

28th Avenue at Taft Street.
From here, a bridge crosses the C-10 Canal and the street crosses the railroad.

28th Avenue at Sheridan Street.
From here, a bridge crosses the C-10 Canal and the street crosses the railroad.

1110 South 28th Avenue.
The Wardrop family, who lived here, kept a cow from 1943 until World War II ended. Mr. Wardrop was a dairyman in Cuba before coming to Hollywood.

58th Avenue

58th Avenue was not part of early Hollywood.

4220 North 58th Avenue.
Home of John and Guilda Bryan, built about 1914. This is considered to be one of the oldest standing wood-frame houses in Broward County. Its two stories were constructed of Dade County pine in a Carolina style. The site was an island, or hammock, at one time, before land around Davie was drained, and the house is still surrounded by live oaks. The house still stands, and is still a private residence. **Not open to the public**.

Broadwalk

In 1940, the Broadwalk extended to city limits north to south.

The "Broad Walk" was the first paved passage on Hollywood beach, begun in March 1923, at Johnson Street. By winter, the walk reached south for one mile; visitors could park at Johnson just off the bridge and walk along, admiring the pristine sand and the Atlantic Ocean.

The Broadwalk became a boardwalk after the hurricane of 1926 tore up the pink cement. The 1935 hurricane blew away the wood boards, which were replaced by black-top.

Broadwalk south of Johnson Street.

The Hollywood Beach Casino—with its Olympic-size saltwater pool with two wading pools and up to one hundred cabanas—was designed by Martin L. Hampton and built in 1925. Under Mollie Grimshaw in the 1930s and 1940s, nearly every child in Hollywood learned to swim in this spectacular pool. Only the bravest dove off "Third," the board at the top of the tower. Demolished 1970s.

Broadwalk at Harrison Street.

Shops and apartments were built in late 1924 for Mr. and Mrs. W.B. Symmes, designed by Martin L. Hampton. Destroyed in 1926 hurricane.

712 South Broadwalk.

Home of Harry and Ruth Simms, designed by Henry Hohauser to resemble a grand yacht, 1938. Still extant.

Broadwalk, near Connecticut Street.

Third and last sales pavilion of the Hollywood Land and Water Company, built 1925. It was blown into North Lake by the 1926 hurricane, but the recreation area there is still sometimes called "the pavilions" or "the ovens." The latter refers to the midcentury grills installed for public cookouts.

Dixie Highway

Dixie Highway was sometimes called the West Dixie in the 1920s.

The original north–south road, from Indianapolis to Miami, built through the efforts of Carl Fisher to bring visitors by car to his developments on Miami Beach. It passed through Broward County in 1915. In Hollywood, the Dixie runs along the west side of the Florida East Coast railroad tracks. (The street on the east side is 21st Avenue.)

151

Dixie Highway and Hollywood Boulevard.
Where the city of Hollywood, Florida began.

Dixie Highway and Hollywood Boulevard, southwest corner.
Curtis Block, 1923, where James Breeding opened a drugstore. Building demolished in 1926 hurricane.

Dixie Highway and Hollywood Boulevard, southwest corner.
Valhalla nightclub, built in the mid-1930s and reputed to be a gambling establishment. Demolished 2005.

110–14 South Dixie Highway.
Seybert court and offices. 26 san. Not extant.

120 South Dixie Highway.
Home of D.L. and Gracewood Seybert. 26 san. Not extant.

Dixie Highway and Van Buren Street.
Home of W. Ward and Minnie Kington, built in December 1923, a two-story, concrete showplace costing $10,000. Kington was a "retired coal and oil operator of extensive means" from Kentucky who bought forty-one Hollywood lots to develop and erected the Kington Building just east across the tracks at the southeast corner of 21st Avenue and the boulevard. He and his wife rapidly became leaders in various fledgling civic organizations, including the Woman's Club and the Chamber of Commerce. Following the 1926 hurricane, their substantial home served as a temporary ward for the injured. After her husband's death, Minnie Kington became Mrs. Bellamy. In later years the still-handsome home became a funeral parlor. Demolished 2005 for condominiums.

240 South Dixie Highway.
Filling station, offers "Vulcanizing," a method of repairing rubber auto tires. 26 san. Not extant.

440 South Dixie Highway.
Home of Ralph B. Springer, owner of a transportation company and mayor of Hollywood, 1938–41. House not extant.

700 South Dixie Highway.
Italian American Civic Club, 1950.

Dixie Highway and Moffat Street, to Washington Street.
Hollywood Airport or Hollywood Airpark, 1941 to 1952. See Moffat Street.

Dixie Highway at Polk Street.
Hollywood Place, cul-de-sac opposite Florida East Coast railway station, with garage for 120 cars, a dry cleaner and the Hotel Dixie. 26 san. Not extant.

402 North Dixie Highway, corner of Fillmore Street.
Filling station. 26 san. Not extant.

424 North Dixie Highway at Collins Court.
Accurate Garage owned by Jane Short. 26 san.

Dixie Highway at Johnson Street.
Dowdy Field, established in 1933. In the depths of the Depression, Earl Dowdy, who was manager of the Piggly-Wiggly grocery store, asked the city to help raise community spirits by creating a playing field on city property at Johnson Street and the Dixie Highway. The city not only built the field, they also named it for Dowdy. It soon became the home field for local teams, with a small grandstand for spectators. The Baltimore (Maryland) Orioles held spring training at Dowdy Field before World War II and from 1946 to 1948.

Dixie Highway at Johnson Street, corner.
National Guard Armory, begun 1953. Built for Company C, 211th Infantry on a corner of Dowdy Field. The first troops from here went off to the Korean War. Still extant.

Florida East Coast Rail Road (FEC)
The Florida East Coast Rail Road opened southeast Florida for development. Henry Flagler built the system in stages in the later nineteenth century. By 1894 the tracks had reached West Palm Beach (a city created by the railroad); in February 1896 the tracks had reached Fort Lauderdale; and in April 1896 through service began for passengers to Miami. Rail travel thus passed through the future city of Hollywood at that time. J.W. Young convinced the FEC to include a passenger stop in Hollywood by building a handsome station beside the tracks a few blocks from Hollywood Boulevard in 1924. Currently the double tracks are used for freight service only.

Interstate 95
Interstate highway 95 came through Hollywood in 1976, paralleling the Seaboard railway rather than slicing through the heart of downtown.

Ocean Drive, also A1A

The survey for Ocean Drive, the first road on the beach, began with Young Company surveyor Tony Mickelson running lines on the uninhabited barrier island early in 1922. Road construction began at Johnson Street in July 1924, heading south. The road reached the new bridge at the end of the boulevard in 1925, thereby opening the beach to vehicle travel. In 1940, Ocean Drive was extended north and south to the city limits. When the state created coastal route A1A, Ocean Drive became part of that road system. Address numbers on Ocean Drive run north from the Hollywood Beach Hotel and also south.

101 North and South Ocean Drive.

Hollywood Beach Hotel. From the first moment in 1920 that J.W. Young drew his plans for Hollywood by-the-Sea, he must have intended to have a major hotel at this very site for it is due east, straight down the hundred-foot-wide boulevard, from the initial turnoff at the Dixie Highway. To reach the proposed site of this focal point of his city, Young had swamps drained, land created, roads built over sand and a bridge installed—a process that took five years and cost millions. Rubush & Hunter were commissioned to design the Beach Hotel and had drawings made by February 1925. This grand resort, modeled after the Virginia Hotel in Long Beach, California, had rooms for five hundred, a ballroom, an ornate dining room as well as sumptuous lobbies. Much of the design was the work of Philip A. Weisenburgh from Indiana, who as the architectural firm's master of ornamentation, was responsible for office and design supervision of all Rubush & Hunter's Florida commissions. At last in the spring of 1925, construction vehicles and materials could reach the site, and work began. Foundations for the huge structure on the sandy beach island were laid by Olaf Owra. Superintendent of construction was Clyde Reed from Reading, Pennsylvania. Work on the hotel went on twenty-four hours a day for six months, under lights at night, in order to have the luxury hotel open by January 1926. Tents were erected on the sand to the northwest of the construction site to house the workers (not Tent City—see Washington Street). When the grand Hollywood Beach Hotel opened, it rivaled the beach resorts built by Henry Flagler in the previous century.

Before the hotel could have a second winter season, the September 1926 hurricane went directly over and through the resort, piling sand in the lobby as the ocean raced through the building, reaching up to the second floor. But the hotel was so well built it withstood the storm's attack, and after massive cleanup, it opened for its next season. Young had to relinquish his magnum opus with all his other properties in the late 1920s, but it retained its glamour status under the new owners. Owned by Albert and Edwin Rosenthal, the Hollywood Beach Hotel was the major employer for the city throughout the Depression.

In 1942, the U.S. Navy came to Hollywood. In December, the navy established an Officer Indoctrination and Training School at the Beach Hotel and the trainees moved in with no changes made to the elegant hotel. Future navy officers were surprised to have elevator "girls" in sailor suits and maid service in their rooms. Moreover, after classes they were free to swim or to go into town where many had wives living. Marine guards were stationed at the entrance to the hotel, as well as on the bridge, requiring anyone going or coming to show credentials. Men and women who were not in the armed forces were called into action at the hotel as World War II plane spotters stationed in Rubush & Hunter's open towers, the highest elevation on the beach, where they spent the night watching the sea and skies, reporting anything at all to the coast guard. Another group patrolled the shore at night on foot.

Following the war, the Beach Hotel was owned by Ben Tobin and returned to the tourist trade for several decades before being sold to the Florida Bible College in 1971. A major insult was given to the venerable landmark when the off-ramp for the Boulevard bridge was planted in the former garden entrance to the hotel. When the college was sold, the hotel became a time-share resort. Today it is the Ramada Inn Hollywood Beach Hotel and offers condominiums and hotel rooms. The hotel owners hope to restore some of the public areas to their former grandeur.

203 North Ocean Drive.

Chrest's Bar, a popular watering place following the repeal of Prohibition. Mike Chrest, owner, had been manager of the Tangerine Tea Room until it was demolished in the 1926 hurricane. When the navy took over the Beach Hotel, the bar became a navy hangout where young men wrote their names and messages all over the walls. Chrest kept these often-poignant messages for years after the war. The bar no longer exists.

2301–02 North Ocean Drive.

Log Cabins, built in the 1930s. No Spanish-mission nor streamline modern architecture for the builder of this beach resort. The log cabins still exist, greatly modified.

1001 South Ocean Drive.

At the south end of the beach, the Beach Trailer Park, extending from the Atlantic Ocean to Ocean Drive at Jefferson Street, was the late 1930s version of a campground that replaced J.W. Young's Tent City. It was advertised as the only trailer park directly on the beach. No longer extant.

3515 South Ocean Drive.

Diplomat Hotel, opened 1958. Though the original Diplomat seems modest by today's standards of humongous beach high-rises, when the resort was built, it was the biggest and most attractive tourist lodging in Hollywood since the 1925 Hollywood

Beach Hotel. In a sense, it was the northern outpost of Miami Beach resort hotels that had sprung up since the World War II. Architect Norman Giller particularly liked the building, with its hyperparabolic porte cochère. In the early twenty-first century, this building was demolished and replaced by more expansive structures.

3800 South Ocean Drive.

Tuscany Motel. Just over the line from Miami-Dade County, this motel was said to be the meeting place for Meyer Lansky, who lived in Miami Beach, and his racketeer colleagues in the 1950s when gambling was illegal.

Park Road

Park Road was not included in the 1940 directory.

Early maps of Hollywood show Park Road (at about Thirty-first Avenue) crossing Hollywood Boulevard from about Washington to Johnson Streets, without any roads planned between Park Road and 28th Avenue in that area. In the early 1920s, this was a watery landscape called the West Marsh. J.W. Young began draining the area that would become the golf course but not the area to the north of the boulevard (28th to Park Road and Hollywood Boulevard to Johnson). Perhaps he intended that it would remain a parklike natural setting.

3300 North Park Road.

Topeekeegee Yugnee Park. Dedicated December 1971. This 145-acre park was created on the former 300-acre Ben Butler Dairy Farm, which included a rock quarry that had filled with fresh water. Turning the 30-acre lake into a swimming and boating recreational area was a bow to actuality for local kids who had been sneaking in to swim there for years. Of course, the present lake at T-Y Park has been made much safer than the old rock pit.

Seaboard Air Line Railway

The second railroad line to come through Hollywood was the Seaboard Air Line Railway. The track and rails were brought down from West Palm Beach in 1926. In Hollywood, the rails paralleled a nonexistent 30th Avenue, nonexistent because the area between 28th Avenue and Park Road (31st Avenue) was wetlands, called the West Marsh. The Seaboard station house was designed by the architectural firm of Harvey and Clarke, who designed all the Seaboard stations from West Palm Beach to Homestead. The station was constructed in 1926 by the railway. When the first passenger train passed through Hollywood in January 1927, there was nothing much to see to the north or south but jack pines. There were a few houses and chicken farms at 28th Avenue, and to the west down the boulevard at 40th Avenue stood the empty Hollywood Hills Hotel.

Not much changed in the area for the next twenty-five years other than Riverside Military Academy and the navy occupying the hotel. The lonely little station was a poor cousin to the glamorous, expansive Florida East Coast station well to the east. As fate would have it, the station built by J.W. Young for the FEC was demolished, while the more modest Seaboard building has been placed on the National Register of Historic Places and is being restored. With Tony Campos as the guiding force, the original freight room is being developed as the Hollywood Railroad Station Museum-the Dorothy Walker Bush Museum, under the auspices of the Big Pine and Sawgrass Model Railroad Association, the City of Hollywood, the Florida Department of Transportation, Tri-Rail and Amtrak. The rest of the complex is still in service as Hollywood Station serving Amtrak and Tri-Rail.

State Road 7, Route 441

In 1927, State Road 7, now Route 441, opened at about 60th Avenue, which was not part of Hollywood. For decades, the chief use of the rough, narrow, two-lane road was as a sorely needed truck route. In 1940, State Road 7 extended north and south from the Hollywood city limits. Locals called it 7th Avenue.

March 1924. Seminole Okalee Indian Village. Dania Reservation, 481 acres, was established for the independent tribe on both sides of Stirling Road at future State Road 7. Annie Jumper Tommie and her family were the first to move there. Hollywood then ended at Sheridan Street; today Hollywood surrounds the Seminole reservation lands, now known as the Hollywood Reservation.

Conlon development. Well to the west of J.W. Young's land, in what would only later become Hollywood, another developer, R.L. Conlon purchased land and laid out streets. Conlon's property on the west side of what later became State Road 7 extended from Pembroke Road to Hollywood Boulevard; on the east side from Pembroke Road to Johnson Street. As did Young's, Conlon's fortunes failed with the Depression and that area remained barely inhabited until after World War II.

Dairies. West beyond State Road 7, large tracts of unincorporated land were filling with dairy farms in the 1930s. Listed in the 1937 business directory are Biscayne Farms Dairy, E.A. Cowdery, proprietor, Johnson Street, Hollywood Pines; Farway Dairy, West Pembroke Road, J.J. Woitesek and C.D. Rowe, proprietors; Goolsby's Dairy, West Bendle Road, R.G., E.W. and Cecil Goolsby, proprietors; Hollywood Hills Dairy, West Hollywood Boulevard, B. Gustafson, Peterson, proprietors; Johnson's Dairy, West Pembroke Road, Ray Johnson, proprietor; McArthur Dairy, Johnson Street, one-half mile west of 7th Avenue (State Route 7), B.B. McArthur, proprietor; Perry Dairy, West Pembroke Road, L. and H. Perry, proprietors; Wachtstetter's Dairy, Route

1, Hollywood, Guy Wachtstetter, proprietor; and Waldrep's Dairy, West Bendle Road, W.P. Waldrep, proprietor. Locals who knew the dairymen were sometimes invited out to ride cow ponies over the empty cow pastures from Sheridan Street to Washington, in what is now the 6000 block.

Gunnery range, 1943–1944.
Empty land to the south and west of SR 7 was used as a gunnery range by the navy during World War II.

State Road 7 and Grant Street, 1940s.
Before Hollywood bus service reached State Road 7, residents there did not find it easy to get into downtown Hollywood. In the 1940s, for entertainment, benches were set up along the sidewalk at State Road 7 and Grant Street, where movies were shown on an outdoor screen on weekend evenings.

State Road 7 and Johnson Street.
Locals hunted bear and panthers in this area as late as 1950 in the mostly undeveloped land around the dairies.

State Road 7 off Stirling Road.
In 2004, the Seminole tribe established the Hard Rock Casino and Resort on their reservation (surrounded by Hollywood, but not part of the city).

Surf Road

In 1940, Surf Road extended north and south from the Hollywood city limits. Sometimes mistaken for an alley, Surf Road is a legitimate street.

Surf Road and Washington Street.
Tent City was built here in the fall of 1925 before the Hollywood Beach Hotel was completed, as the city desperately needed lodgings for tourists. The rental units were not exactly tents, but cabins with canvas roofs, floors, rooms, kitchens and baths. There was also a communal lounge area and cafeteria. J.W. Young copied the Tent City concept from a new idea that was already popular on California beaches, including the Catalina Islands, where tent cities were laid out in streets with stores, cafeterias and the like. Each tent was equipped with running water and electric lights, but no cooking need be done. Individual tents varied from two to four rooms or more. Young planned to start with accommodations for one hundred families, but expand to house several thousand people as a permanent feature. (In some photos, the tents shown are all canvas. These were tent housing for the Beach Hotel workers.) Tent City, also called Beach City, was highly successful, even for

individuals who had been settled in Hollywood long enough to list Tent City as their address in the directory. Needless to say, all the tent housing was blown away in the 1926 hurricane, never to be rebuilt.

712 North Surf Road at Georgia Street.

The Harry and Ruth Simms house, also listed at 712 South Broadwalk, was designed by Henry Hohauser to resemble a grand yacht. Hohauser was a Miami architect notable for his inventiveness in designing streamline Moderne buildings in the thirties. In a 1933 article about the Simms house, Hohauser offered to build others in Hollywood. Further study on Hohauser in Hollywood would be welcome. This delightful house is still extant.

Surf Road and Garfield Street.

In 1933, the city erected the paddleball courts, now a city landmark. There are six courts plus three shuffleboard courts.

East and West Routes and Landmarks

Adams Street
In 1940, Adams Street ran from the beach to west city limits

1500 Adams Street.

Home of founder J.W. Young's youngest son William (1913–1956) and his wife Marion "Babe" Whatley. Bill and Babe were married May 15, 1937, in Hollywood. Before their wedding, each lived at home—Bill at 1055 Hollywood Boulevard and Babe at the Trianon Hotel, which her mother owned at 1959 Monroe Street. The couple built their Adams Street house in 1938–39. For years afterward, it was the last house on the south side of Adams Street and there were tomato fields to the east down to the water. Bill served in World War II and was elected a justice of the peace on his return. He is buried in Arlington National Cemetery. For many years, Babe was the nurse at the Hollywood Clinic, 139 North Seventeenth Avenue. The landmark house is still extant.

1521 Adams Street.

Home of Paul F. Colbert, for whom Colbert School was named. Colbert served as principal of Hollywood Central, West Hollywood, Hallandale and Dania Elementary Schools, and South Broward and Hollywood Hills High Schools in the 1940s and 1950s. He was also the assistant and associate superintendent of schools for the Broward school district in the 1960s. 26 san. Still extant.

1533 Adams Street.

Home of the Bayard Lukens family, designed by Lukens in 1946. An architect trained at Pennsylvania State College, Lukens was one of those instrumental in bringing the streamline Moderne look to Hollywood (today often erroneously called art deco) beginning in the 1930s. The May 3, 1940 *Hollywood Reporter* describes his work as buildings with "simple straight lines, a trim shiny appearance, clean white finish designed in direct contrast to bright-colored shutters, ideal for a tropical setting." Lukens's buildings can be identified throughout Hollywood.

1535 Adams Street.

Earlier home of architect Bayard C. Lukens, who designed it in 1927-1928 after the family lost their first house in the 1926 hurricane.

Adams between 17th and 16th Avenues.

The January 1923 *Hollywood Reporter* says builder R.M. Ducharme of New York is building homes on seventeen lots in the Central section.

1612–14 Adams Street.

Home of the Reverend Thomas H. Sprague, who was the pastor of the First Baptist Church, 17th and Monroe, at its founding in 1925. Sprague had worked as a Young Company salesman before. 26 san. Still extant.

1633–35 Adams Street.

Residence of James and Clauriese Mann, *circa* 1938–1941. He owned the Hollywood Art Gallery, 1900 Hollywood Boulevard. 26 san. Still extant.

1719 Adams Street.

Built by C.W. Zimmer in February 1924, as a bungalow of hollow tile and stucco with a solar water heater. He was editor and publisher of the *American Poultry Journal*. 26 san. Still extant.

1947 Adams Street.

Home of Louis and Sarah Sokolow Brown. He was born in Brest, Poland, in 1886 and came to the United States to escape pogroms in 1907. Louis worked as a store clerk in Jacksonville from 1910 to 1913 and moved to Dania in 1913 where he began his first store. He married Sarah Sokolow in 1915. They opened Brown's at 2024 Hollywood Boulevard *circa* 1924. With the Phil Adlers, the Browns were probably the first Jewish families to settle in Hollywood. 26 san. Only the rear building remains.

1956 Adams Street.

Villa-Arms Apartments. Rene Ann Young and her grandmother Jessie Young were living here about 1949 when Rene Ann married Craig McNair. Built as the Clara in 1924–25. Still extant.

2430 Adams Street.

Home of Royal Scott, who was elected to the city commission in the first municipal election, July 1927. Still extant.

2445 Adams Street.

Home of J.W. Robinson who was elected to the city commission in the first municipal election, July 1927. Still extant.

Other Adams Street addresses indicated on the June 1926 Sanborn map are 1513, 1517, 1521, 1612, 1630, 1636, 1644, 1648, 1734, 1821, 1825, 1838, 1925, 1939, 1945, 2019 and 2033.

Airports

Fogg Field. Named for Fort Lauderdale pilot Merle Fogg, who was killed in 1928, the airport was created from the former South Side Golf Course and dedicated May 1929. In October 1942, the U.S. Navy bought the seldom-used airstrip and built a naval air station, which was deactivated in October 1946. Still on site is the navy's Link Trainer Building, a museum.

The Fort Lauderdale-Hollywood International Airport entrance is off U.S. Route 1.

Hollywood Airport or Hollywood Airpark. *See Moffat Street.*

Arizona Street

In 1940, Arizona Street ran from the Broadwalk to Ocean Drive.

300 Arizona Street.
Residence of Dr. Elbert McLaury in 1940-1941.

309 Arizona Street.
Cavanaugh Apartments, 1925. One of the earliest buildings on Hollywood Beach, this was the residence of some navy officers' families during World War II. 26 san. Still extant.

317 Arizona Street.
The house was moved in September 1932 from 2606 Washington Street by C.B. Smith for Chandler Parsons. The home was bought from August Skoglund. Parsons, who was commodore of the Hollywood Yacht Club, enlarged the original pink stucco house into a property of modern style, according to the *Hollywood Herald.* Upon Parsons's death in 1939, the Hollywood docks were dedicated in his honor.

Arthur Street

In 1940, Arthur Street ran from the beach to the west city limit.

310 Arthur Street.
Carlson Apartments, home of Anne and Ray Carlson from the 1930s to the 1950s. He was a contractor.

Atlanta Street

Initially Atlanta Street was Liberia Street in 1924. In 1940, it ran from North 22nd Avenue west to city limits.

2207 Atlanta Street.

In 1940-1941, this was the home of Mamie Taylor, dressmaker.

2215 Atlanta Street.

In 1940-1941, this was the home of David Pratt. The house number may have changed to 2239, listed as the home of D. and Prudence Pratt, built *circa* 1924 and one of the earliest houses in Liberia.

Boulevard
See Hollywood Boulevard.

Buchanan Street
In 1940, Buchanan Street ran from the beach to the Florida East Coast Railroad (21st Avenue).

329 Buchanan Street.

The first two homes on the beach were built by the J.L. Franks from Buffalo, New York, in February 1924 and by the Daniel Russos in March 1924. J.L. Frank's two-story stucco house was "three blocks south of the proposed casino," a site not definitely identified although there is a 1924 photograph of the building under construction in the *Hollywood Reporter*. Based on this information and the 1926 Sanborn map, this appears to be the address. In the mid-1930s, the site became the Pine Tree Apartments. Still extant.

1700–02 Buchanan Street.

St. John's Episcopal Church, the second oldest church building in Hollywood, was built in 1925. Still extant.

1715 Buchanan Street.

Home of Ralph and Lena Young, 1924 California-bungalow style. No relation to the city founder, Ralph Young designed the golf courses at the Hollywood Golf and Country Club (1924) and the first nine holes at the future Orange Brook Golf Course (1934). After his death, in 1938, the Orange Brook Golf and Country Club named a championship trophy in his memory. The house is still extant.

1735 (or 1742) Buchanan Street.

St. John's Evangelical Lutheran Church was built in 1931 by the congregation that was organized in 1926. Before the church was erected, services were held in Brandon's Hippodrome Theatre on 18th Avenue. After the theater was demolished in the 1926 hurricane, services were held in Dania Community Hall. The congregation moved to a larger building in west Hollywood in 1957.

Buchanan and Garfield Streets.

By 1924, 18th Avenue had developed into a bustling commercial route, especially around this intersection.

Buchanan Street and 21st Avenue.

Hollywood Electric Light & Power, 1922. Replaced by Florida Power & Light in 1925.

Buchanan Street near 21st Avenue.

J.F. and E.S. Beebe built an ice plant here in 1923. In those years before electric refrigerators were generally in use, ice for ice boxes was crucial to subtropical Hollywood, and this was a thriving business. Foot-square cubes of ice were delivered door to door by the ice man. If you wanted some ice for your pitcher of tea, bits were chipped off the block with an ice pick. In 1926, the Pure Ice Company bought the Beebes' business and moved to 2200 Jackson Street. 26 san. Gone.

Central Section

This was a square mile bounded by the present-day Dixie Highway on the west, Johnson Street on the north, 14th Avenue on the east and Washington Street on the south—J.W. Young's first land purchase for his future city in July 1920.

The Indiana building contractor Harry K. Bastian built most of the first houses in Central Hollywood, starting several at once in 1922 (possibly late 1921). Some were built on spec for buyers who wanted their lot complete with a house. In February, the Bastian company hired John Brown to keep an eye on the fifteen houses already under construction.

Chaminade Drive

Chaminade Drive was not extant until the 1980s.

500 East Chaminade Drive.

Chaminade Madonna High School, 1988. Chaminade High School for Boys at 500 East Chaminade Drive was under construction in December 1960. It was named for Blessed William Joseph Chaminade of Bordeaux, France. In 1988, it combined with Madonna School for Girls, founded in 1960 by the Sisters of Notre Dame. In 2005 some of the movie *Hoot*, based on the children's book by Carl Hiaasen, was filmed here.

Circle

Also called Circle Park, Central Park, Harding Circle and Young Circle, the circle is located on the axis of Hollywood Boulevard and 18th Avenue. This was the

center, and the centerpiece, of J.W. Young's planned city. As a follower of City Beautiful ideals, Young understood the value of open spaces, parks and vistas in enhancing the beauty, value and hygiene of an urban environment.

Hollywood Boulevard and 18th Avenue.

The first of the three circle parks along Hollywood Boulevard to be built—and in 1921, the first large piece of land to be surveyed—this 10-acre park was intended by J.W. Young to be the centerpiece of his city. He dedicated Circle Park, as he first called it, to the people of Hollywood. In 1924, he named it for former President Warren Harding, who visited the city. In 1931, the Hollywood City Commission formally dedicated it as a park, banning commercial enterprises. Following Young's death, it was renamed for the city founder, Joseph W. Young Circle.

South side, 1922–1923.

Temporary bunkhouse for workers. Burned in 1923.

Southwest quadrant facing the Great Southern Hotel.

First municipal band shell, 1929. Gone.

Southeast quadrant.

Amphitheater designed by architect Kenneth Spry. Demolished 2004.

Southeast façade of amphitheater.

All-Wars Memorial and perpetual flame, dedicated November 11, 1951, honoring the veterans of all U.S. wars. Demolished 2004.

West side, facing Hollywood Boulevard.

Bust of Joseph W. Young, 1882–1934, founder of Hollywood; by Joseph Baumgarten, sculptor. The bronze bust was erected by the Hollywood City Commission in 1951. Text on the wall enclosing the pedestal reads: "His vision and courage created this City."

Cleveland Street

In 1940, Cleveland Street ran from the beach to the west city limits.

1708 Cleveland Street.

Home of Harry and Ida Pringle. Harry was Hollywood's third and fifth mayor, elected in the first municipal election in 1927 and again in 1931. Home no longer extant.

Between Cleveland and McKinley, just east of 18ᵗʰ Avenue.

Home of Lulu and Walter W. Altman in 1922. Altman was a water-pump engineer for the Florida East Coast steam engines, working the pump at about McKinley at the tracks. See McKinley Street.

1804–06 Cleveland Street.

Commercial storefront built before 1926 and relatively unchanged. At one time was Billy Boye's, who offered ice cream and bottled gas. 26 san. Still extant.

1811 Cleveland Street.

Home of Blanche and Henry Mann, from 1926. Henry Mann was owner-operator of Arcade Cleaners at 2039 Hollywood Boulevard (later at 2025 Tyler Street, for 20 years). Henry served as commander of Hollywood American Legion Post and president of local Kiwanis. Blanche was the bookkeeper for J.W. Young in 1926. Beginning 1933, she worked for the city for more than thirty years, as auditor, treasurer and city clerk. 26 san. Their house is extant.

Collins Court

In 1940, Collins Court ran from 416 North 21ˢᵗ Avenue west to about 22ⁿᵈ Avenue.

Possibly named by Dr. Randall Collins, who built the Accurate Garage and was involved in other Hollywood construction.

Collins Court and Dixie Highway.

Accurate Garage, auto repair shop of Jane Short, was on the south corner by 1925. The south side of the court was lined with seven identical buildings; the north side lined with seven disparate buildings, and the end of U is called "Pine Crest," possibly tourist cabins. All on 1926 Sanborn map.

Connecticut Street

In 1940, Connecticut Street ran from the Broadwalk to Ocean Drive.

Connecticut Street area, at the shore.

In 1942 or 1943, a small black empty submarine (U-boat) beached near the ovens around Garfield and Connecticut Streets. Police would not let anyone near the U-boat, and the navy or coast guard speedily removed it without comment.

Between Garfield and Connecticut Streets, on the beach.

The third and last Young Company sales pavilion, 1925. The building was blown away in the 1926 hurricane; locals continued to refer to the area as "the pavilions."

Dewey Street

In 1940, Dewey Street ran from 14th Avenue to the Seaboard Air Line Railway (30th Avenue).

Named for a navy man. About 1924, J.W. Young acquired more land along the south border of his property, and as the presidential street names began with Washington and moved north, names were needed for the new streets in south Hollywood. The engineers suggested Dickey, Mickelson, Attaway, McCarrell and names of others who had been instrumental in Hollywood's development, but Young demurred. Tony Mickelson, a navy man from World War I, then suggested admirals, which is how the streets from Dewey to Moffat were named. (Another version of the story is that Young recommended the engineers' names, but in any case Mickelson chose the navy men.)

1849–53 Dewey Street.

Phyllis Apartments. In the 1930s, Guy and Forest Wachtstetter lived there, owned the apartments and named them for their daughter Phyllis. They also owned Wachtstetter Dairies. The apartment building is still extant.

Dewey Street between 19th and 18th Avenues.

Jack Young rented a place here in 1924 (houses then were not numbered).

1940 Dewey Street.

Home of Earl and Clara Dowdy by 1928. In 1933, at the depths of the Depression, Earl asked the city to build a playing field on its property on the Dixie Highway and Johnson Street to boost morale. Dowdy Field was named for him in 1934. Home no longer extant.

1954 Dewey Street.

Home of Joe T. Hall, mayor of Hollywood in 1942. In 1933, he was living at 1500 Harrison. The Dewey Street house is still extant.

2034 Dewey Street.

Mrs. J.W. Young lived here when she was honored as a pioneer mother by the Apartment & Hotel Association in May 1953.

Fillmore Street

Fillmore is sometimes spelled Filmore. In 1940, it ran from the beach to the west city limits.

1221 Fillmore Street.

In 1940, home of Raymond E. Dilg, president of Hollywood Federal Bank.

1800 Fillmore Street.

Olive Apartments, 1924. Designed by Rubush & Hunter and owned by Paul R. John, who was on the first city commission and served as the second mayor. The building is still extant.

1916 Fillmore Street.

Home of Raymond and Jessie Orr, mid-1920s. Raymond worked with the dredges that created North and South Lakes and the Lakes section from 1923 to 1925.

1933 Fillmore Street.

Mid-1920s home of Yeoman Keen, an electrical contractor.

Fillmore Street between 19th and 20th Avenues.

Home of J. Rogers Gore, 1924, director of the Hollywood Publishing Company of the Hollywood Land and Water Company and editor of the *Hollywood News*. House addresses were not numbered in 1924. Possibly he lived in the Alva Hotel at 1945 Fillmore, built in 1924.

2123 Fillmore Street.

Home of Edgar and Jeanetta Nash, plumber and teacher, by 1929.

2140 Fillmore Street.

Home of Jake and Jane Watson. He was a dredge captain in the mid-1920s.

2233 Fillmore Street.

Home of Woodrow Malphurs in 1940. He was a Hollywood police officer.

Fillmore Street and 24th Avenue.

Hollywood Tabernacle, Mary E. Johnson, pastor. Established in the late 1920s. No longer there.

2739 Fillmore Street.

Home of Thomas Barr. The last building out west on Fillmore in 1940.

Flagler Street

Flagler Street was not listed in the 1940 Hollywood directory.

Flagler Street and 58th Avenue.

Built by R.L. Conlon, 1920s. His development was not part of Hollywood at the time. Gone.

6100 Flagler Street.

Built by R.L. Conlon, 1920s. His development was not part of Hollywood at the time. House is still extant.

Fletcher Street

In 1940, Fletcher Street ran from 17th Avenue to the Seaboard Air Line Railway (30th Avenue).

1717 Fletcher Street.

Home of William and Estah Michel, from the mid-1920s. The couple owned Michel Paint and Electric Company, 1925 Hollywood Boulevard. No longer extant.

Forrest Street

In 1940, Forrest Street ran from 22nd Avenue to west city limits.

Forrest Street near 18th Avenue.

Office of S.H. Kiser, general building contractor, in 1925-1926. Probably in what is now Dania, which had joined Hollywood in 1925.

2207–52 Forrest Street.

Baptist Church of the New Jerusalem, 1939.

2215 Forrest Street.

Home of John B. Brown, 1940 (possibly since 1924).

Funston Street

In 1940, Funston Street ran from 14th Avenue to the Seaboard Air Line Railway (30th Avenue).

1640 Funston Street.

Home of Dr. O.A. Bingham, 1940. Still extant.

Funston Street at 18th Avenue.

New Elks Lodge, built 1949. Building gone; lodge moved elsewhere.

Garfield Street

In 1940, Garfield Street ran from the beach to the west city limits.

Between Garfield and Connecticut Streets, on the beach.

Third and last Young Company sales pavilion, 1925. It was blown away in the 1926 hurricane; locals continued to refer to the area as "the pavilions."

Garfield Street and Broadwalk.

"The ovens," covered picnic area with cookout ovens. Begun in 1930s. Now Broadwalk Beach Community Center.

Garfield Street and Surf Road.

In 1933, the city erected the paddleball courts, now a city landmark. There are six courts plus three shuffleboard courts. Still extant.

Garfield Street area, at the shore.

In 1942 or 1943, a small black empty submarine (U-boat) beached near the ovens around Garfield and Connecticut Streets. Police would not let anyone near the U-boat, and the navy or coast guard speedily removed it without comment.

340 Garfield Street.

Home of the Valentine Martin family, designed by Bayard Lukens in 1934 as a Cape Cod cottage. Still extant.

18th Avenue at Garfield Street.

Floodwaters from the 1926 hurricane landed a barge here from the Inland Waterway on September 19.

Garfield Street and 18th Avenue.

The imposing Brandon's Hippodrome Theatre, with its semicircular façade, is known from posthurricane photographs. The 1926 Sanborn map indicates that it held seventeen hundred. Lutherans met in the Hippodrome before the 1926 storm. 26 san.

Less than a block from the Hippodrome is the Garfield Theatre, with capacity of seven hundred and fifty. Shops here included a grocery, dry cleaner ("Walter Bono Cleans Hats"), the Yamato Inn at McKinley Street (Hollywood's first Asian restaurant?) and the Greenwood Inn at Sheridan Street. 26 san. All demolished in 1926 hurricane.

Between Garfield and Arthur Streets, west of 18th Avenue.

Garfield Court, nine cabins. 26 san. Presumably destroyed in 1926 hurricane.

2001 Garfield Street.

The Young Company's Southern Mill & Bungalow Company was an extensive lumberyard and millworks that filled the blocks between Garfield and Taft Streets and 20th to 21st Avenues. It was also named Hollywood Builders Supply Company. In 1928 or 1929, Jimmy Mack bought it and renamed it Mack Lumber Company. The office was at 1204 North 20th Avenue at Garfield Street. No longer extant.

2540 Garfield Street.

Septic tank plant. Demolished in 1926 hurricane.

Georgia Street

In 1940, Georgia Street ran from the Broadwalk to Ocean Drive.

314 Georgia Street.

Home of Murrill Lillard in 1940. He owned several beach properties.

315 Georgia Street.

Marine Villa, home of Gladys Simms in 1940. Still extant.

Grant Street

In 1940, Grant Street ran from the beach to the west city limits.

1907 Grant Street.

Home of Doc and Della Aspy, built in 1923. Doc worked for the city. Their mission-style house is still extant.

Grant Street near 20th Avenue.

Home of James and Pearl Barton, 1924. They were from Calgary, Canada; he was a fingerprint expert. Houses were not numbered in 1924. House not extant.

1951 Grant Street.

James A. Lewis built here upon arriving in the city in 1924. A firm believer in the two-party system, Lewis had been in politics in Pennsylvania, where he had been nominated by both parties. He had a mercantile business from 1891 before retiring in 1922. He was elected to be Hollywood's seventh mayor in 1933 and was in office when city founder J.W. Young returned home only to die. Lewis represented the city at the funeral. Home now gone.

2045 Grant Street.

Home of building contractor Olaf Owra, *circa* 1935. Owra also owned 1845 Rodman and 930 North Eighteenth Court. Owra was contractor for J.W. Young's

house, the Hollywood Golf and Country Club and the first City Hall on its circle, among other sites. House not extant.

Grant Street at 24th Avenue.
First Pentecostal Church, 1930s.

Grant Street and State Road 7.
Benches were set up on sidewalk here and movies shown outdoors, 1940s.

Greene Street (originally Macon Street)
In 1940, Greene Street ran from 22nd Avenue to west city limits.

2243 Greene Street.
Home of Wilfred Brown, 1940.

Harding Street
In 1940, Harding Street ran from the beach to the west city limits.

2023 Harding Street.
Probably designed by architect Kenneth Spry, 1950–1960. Some of Spry's houses may be identified by the distinct midcentury modern design: the two sides of the slanted roof not meeting but joined by a clerestory window under the higher side. (Technically, this is called a shed roof.) Spry also used new textures on the wall surfaces, as he did here, using native oolite. A further study of Spry's work would be welcome.

Harrison Street
In 1940, Harrison Street ran from beach to Florida East Coast Rail Road (21st Avenue).

Harrison Street and Broadwalk.
Site of "Mexican style" adobe building that Martin L. Hampton designed for Mr. and Mrs. W.B. Symmes, 1923–24. It was built about 1925, then demolished by the 1926 hurricane.

725 Harrison Street.
Home of Edwin Rosenthal in 1940, owner of the Hollywood Beach Hotel and the Golf and Country Club. House extant.

858 Harrison Street.
Home of .G.M. and Nellie Stratton from 1925-1926. J.W. Young bought the land west of 30th Avenue from Stratton, who had farmed in what would become

Hollywood Hills. This house was clearly a showplace for the newly created Lakes section. House extant.

1116 Harrison Street.

Home of Vincent Howard, built 1925–26. House extant.

1145 Harrison Street.

Home of Margaret and Merrill H. Nevin from 1927 or 1928. Merrill was on the 1924 committee to establish the city charter. Previously, the couple lived on Monroe Street near his parents, D.C. and Florence Nevin, in 1923 and 1924, before moving to Jefferson Street, then here. The house, still extant, is beautifully maintained.

1146 Harrison Street.

Home of Jake Lansky by 1946. Modern style, probably designed by Bayard Lukens. Still extant.

1151 Harrison Street.

Home of Arthur Enos, 1940s. Another example of Bayard Lukens's "tropical modern" architecture. Enos owned the Hollywood Theatre (later Ritz Theatre) on Hollywood Boulevard.

1301 Harrison Street.

Designed by Cedric Start in Moderne, or tropical modern, style. Home of Charles Bates, 1940. House extant.

1350 Harrison Street.

A second Methodist congregation built the Temple Methodist Episcopal Church in 1925, an imposing structure in the classical Renaissance style. Due to some damage in 1926 and loss of congregation during the Depression, the building stood empty until after World War II. It was one of several empty "ruins" with falling plaster, spooky shadows and hollow echoes that attracted inquisitive local girls to poke about inside. The building has been restored as a well-kept private home.

1407 Harrison Street.

Home of Billy Sims, architect, *circa* 1930, who also designed the Hollywood Kennel Club. A fine example of art Moderne. Still extant.

1421 Harrison Street.

Home of Annie Nicholls, *circa* 1940. Another example of art Moderne, this home was illustrated in the November 19, 1941 *Hollywood Sun.* Still extant.

1455 Harrison Street.

The expansive, Spanish-eclectic mansion of Hollywood Land and Water Company Vice President F.O. Van Deren in 1925-1926. Van Deren had lived in the Hollywood Hotel in 1924 and on Harrison by 1925. Plaque incorrectly lists C.W. Sammons— general sales manager, Miami division of the Hollywood Land and Water Company— as owner, but Sammons's house was on the boulevard. Still extant.

1519 Harrison Street.

A "porch house" designed by architect Igor Boris Polevitzky who was famous for his Birdcage House of 1950, constructed chiefly of screened-in extensions of the house that integrated the outdoors with the interior and allowed for breezes in the era before air-conditioning. Hollywood's single-story "porch house" has his updated version of the front porch, with walls tilting outward, a model of midcentury modern. Under restoration in 2005.

1532 Harrison Street.

In 1928, the Christian Scientists built a church here, a small white building with Doric columns across the porch. As the congregation grew, they built a larger First Church of Christ, Scientist next to the original building, which became the Sunday school. In 1959, the Sunday school became the property of the Hollywood Garden Club, which moved the building to 3001 Hollywood Boulevard. It is now the quarters of the Big Pine and Sawgrass Model Railroad Association.

1606–18 Harrison Street.

There were nine buildings here in 1925. 26 san.

1631 Harrison Street.

The house probably dates from 1930s. In 1940, it was owned by Harry Newman and was the home of Katherine and Robert L. Haymaker. Haymaker was mayor of Hollywood in 1947 when, on September 17, a Category 4 hurricane tore up the beach with thirty-foot waves and 118-mile-per-hour winds. A second, very wet hurricane hit October 11, 1947, causing widespread flooding, which led to the state's biggest flood up to that time. Broward County was most affected. House still extant.

1650 Harrison Street.

Hollywood Land and Water Company sales manager J.M. Kagey and wife Eva built "a handsome home on Harrison, for $35,000 in the domestic Spanish style" (September 1924 *Hollywood Reporter*). At one time a funeral home, the building is now the Hollywood Art and Culture Center.

1732–50 Harrison Street.

Circle Building. Mrs. Duling's Dining Room and two private schools were there in 1940. This 1920s building is still extant.

1744 Harrison Street.

Office of Cedric Start, architect. 1940

1818 Harrison Street.

McWilliams Ice Cream operated here in the 1940s. Not extant.

1855 Harrison Street.

Mach Building. 1930s building with unusual Art Deco detailing on pilasters.

Harrison Street at 19th Avenue.

Site of the first Hollywood Land and Water Company sales pavilion, 1922. In 1921, even before the first hotel was completed, the Young Company had a sales force operating in an open pavilion on the future Harrison Street. There weren't any other buildings then. By 1924, the pavilion was used as the temporary Hollywood Public School; close to one hundred pupils in all grades were taught in the open pavilion while Hollywood Central School was under construction. Fannie McNicol began the first junior high here. Like Hollywood schools today, pupils came from all over the United States, and Central and South America. The frame structure was probably destroyed in the 1926 hurricane.

Harrison Street, northwest corner of 19th Avenue.

First post office, 1923. Destroyed in 1926 hurricane.

Harrison Street, southeast corner of 19th Avenue.

Men's store operated by Floyd J. Sweet (with poker, roulette and a horse tote in the rear). In the 1940s, as a teenager, Marion Obenauf carried track results to her brother-in-law's haberdashery and wrote it on the tote board. This was only one of numerous shops in downtown Hollywood in the 1930s and 1940s that had slot machines and other gambling activities. At the time, gambling was not illegal. Shop not extant.

1904 Harrison Street.

Floyd L. Wray's Flamingo Groves fruit sales and shipping, 1940. Building still extant.

1916 Harrison Street.

Office of Kenneth J. Spry, architect, by 1940. Building still extant.

1946 Harrison Street.
 Banks Furniture Co., 1940

Harrison Street and 20th Avenue.
 Harrison Building, 1925. Helen Hart's first tutoring school was here beginning in 1930 until she built her own school on Hollywood Boulevard. The Harrison Building is still extant.

2021–31 Harrison Street.
 This building stood alone on the 2000 block of Harrison Street on the 1926 Sanborn map without a number. In 1931, Jack Dresnick opened Hollywood Furniture Company here. Then numbered 2020, the building was the only one on that block of Harrison Street. Dresnick's father had owned the building before. The Dresnicks lived in the former Kington Building at 2032 Hollywood Boulevard where they operated Jack's for many years. In 2005, the Harrison Street building became the Holocaust Documentation and Education Center.

Hayes Street
In 1940, Hayes Street ran from beach to the west city limits.

330 Hayes Street.
 The Breakers. Mission-style. 26 san. Still extant.

Hayes Street just off 20th Avenue.
 Buttridge Lumber Co. This was just opposite the much larger property of the Young Company's Southern Mill & Bungalow/Hollywood Builders Supply Company. 26 san. Probably gone in the 1926 hurricane.

1905 Hayes Street.
 Home of barber Thomas Rilenge from the 1920s. 26 san. The house has been remodeled.

Hollywood Hills Section
Hollywood Hills originally ran from the C-10 Canal/30th Avenue line to about 56th Avenue, and to the north and south city limits.
 J.W. Young bought this property, which was farm land, from G.M. Stratton and, in 1925, opened the Hollywood Hills Section for sales. Young envisioned this area to be as highly desirable as the Lakes section, with amenities such as golf, tennis and horse riding. Young began a golf course in 1926 and built the Hollywood Hills Inn. Engineers from the Hollywood Land and Water Company platted the lots, then the Young Company hired the Highway Construction Company of

Cleveland, Ohio, to build streets. Work was halted following the 1926 hurricane. Eventually the Cleveland Company—which changed names several times before becoming Hollywood, Inc.,—would acquire Hollywood Hills but would not develop it before1959. Hollywood children of the 1940s recall riding bicycles along sidewalks hidden under thick palmetto growth—there were no roads, no houses, just sidewalks, as if civilization had come and gone in the area from 30th to 60th Avenues. Except for Riverside Military Academy, the Hollywood Hills section was nearly uninhabited. In 1959, Hollywood, Inc., began to complete the development of Hollywood Hills, opening the First Section for sales in April 1959; six hundred homesites were sold.

Hollywood Boulevard
In 1940, the boulevard ran from Ocean Drive to the west city limits.

This is the north–south dividing line for numbering addresses on the avenues. Clearing to build the boulevard began November 1921 at the Dixie Highway. The boulevard was Hollywood's second paved road. (The Dixie was paved in 1915.) At one hundred feet wide, Hollywood Boulevard was considered Florida's widest boulevard for a time.

Hollywood Boulevard and the Broadwalk; also 101 North Ocean Drive.
Hollywood Beach Hotel. See Ocean Drive.

Boulevard at the Inland Waterway (or the Florida East Coast Canal).
Boulevard Bridge was begun in the summer of 1924 by the Donnell-Zane Company of New York, which was hired by J.W. Young. The cost was $110,000. Described as a "jack-knife bridge," with the two sides lifting to allow boats to pass through. When work completed spring 1925, the bridge was sixty-two feet wide with ten-foot walks on either side. This was the first real bridge in Hollywood to cross the canal, and it was the only bridge to the beach in Hollywood until the Sheridan Street bridge was constructed.

Boulevard, from 17th Avenue east.
Under water and tidal, this area was called the East Marsh by Young Company engineers. In March 1923 Hollywood Boulevard ended at 17th Avenue when dredging began in the East Marsh to create two artificial lakes, North and South Lakes. The fill was used to provide a causeway between them for the boulevard extension to the Inland Waterway. The March 1924 *Hollywood Reporter* quoted chief engineer Frank Dickey as saying it would take between six and eight months to complete the lakes. Then time would have to be allowed for the water to drain and the land to settle. "By this time next year [1925]," said Dickey, "it is hoped that Hollywood Boulevard will be paved through to the ocean and that building will be possible."

840 Hollywood Boulevard.
Built 1925–26, home of Dr. Robert R. Harriss in 1945.

909 Hollywood Boulevard.
Home of C. Warren Sammons, general sales manager for the Hollywood Land and Water Company. According to available directories he and wife Wealthy were on Monroe Street in 1924 and on Hollywood Boulevard in 1927. House is gone.

940–42 Hollywood Boulevard.
Home of Mrs. Georgia Baldwin, 1934. Fine example of streamline Moderne-style architecture. Still extant.

1014 Hollywood Boulevard.
Boulevard Apartments, 1925–26 City Attorney T. D. Ellis Jr. fled from his apartment here the morning of the 1926 hurricane, when the storm surge—which had swept across the barrier island—was advancing up Hollywood Boulevard. Water had reached a depth of several feet in the apartments when residents decided to evacuate. Ellis saw the Johnson Street barge and managed to climb aboard and ride out the hurricane. When the storm abated, the barge was wedged between buildings on 16th Avenue between the Hollywood Boulevard and Tyler Street. The barge was the city-owned "bridge" from the Johnson Street canal crossing. Years later, when the hurricane tragedy dimmed and people could think of it in a lighter vein, Ellis filed a salvage claim against the city for the value of the barge, claiming that it had been abandoned at sea when he found it and brought it to land. The adjudicator found in favor of Mr. Ellis. (*Hollywood Herald,* June 20, 1952.)

In 1928, Marguerite May Walter, Young's secretary since 1919, lived in the Boulevard Apartments, which were owned by Dr. and Mrs. Arthur Connor in 1931. No longer extant.

1055 Hollywood Boulevard.
In July 1925, Rubush & Hunter drew plans for a baronial twenty-three-room Spanish-eclectic mansion for J.W. and Jessie Young and their sons. Philip A. Weisenburgh, the architectural firm's master of ornamentation, was responsible for the design. Olaf Owra was the contractor. The house was said to have cost $30,000. From the open pergola on the roof, Young could see his entire city as it grew. The two younger sons were married here, Tonce in 1927 and Bill in 1937. On February 27, 1934, Hollywood's founder, Joseph W. Young died here. Jessie Young sold the house after World War II. Since 2004, it has been beautifully restored. **This private home is not open to the public.**

Boulevard and 11th Avenue.
Undeveloped property owned by Frank Costello, who never lived in the city. Liens were placed on his property in April 1953 while Costello was in federal prison.

1352 Hollywood Boulevard.
Home of C.R. and Grace Gilliland, 1928. C.R. was the manager of the Young Company's Hollywood Boat and Transportation division. House demolished, but service building at rear remains.

Boulevard and 14th Avenue.
Meyer-Kiser Corporation offices, 1925. Developers built homes in this area from designs by Rubush & Hunter.

1504–06 Hollywood Boulevard.
Home of Anna Berner, 1926.

1515 Hollywood Boulevard.
Helen Hart established a tutoring school in 1930 that continued for several decades, first at 20th and Harrison, then in 1940 in her own building here, which was designed by Bayard Lukens. The building is still extant, though no longer a school.

1555 Hollywood Boulevard.
One of Bayard Lukens's masterpieces of tropical-modern architecture, 1930s. Owned by Thomas McAuliffe in 1940. Still beautifully maintained.

Hollywood Boulevard at 16th Avenue, south side.
Site of second Young Company sales pavilion, 1923. It was two-stories high, with a view of the Atlantic Ocean out over the East Marsh, which was being drained to create the two lakes. Also known as the Hollywood Lecture Hall. Probably destroyed in the 1926 hurricane.

16th Avenue between Hollywood Boulevard and Tyler Street.
Where the Johnson Street barge bridge was halted by buildings as it was swept inland on flood waters in the September 17, 1926, hurricane.

1600 Hollywood Boulevard.
First Presbyterian Church; the original building was erected in late 1926 or early 1927. The present church was built in 1948 and designed by Cedric Start, architect.

1612–17 Hollywood Boulevard.
Architect D. Anderson Dickey designed an apartment building for Martin Wohl here in 1935.

1625 Hollywood Boulevard.
Home of Jesse G. Wellons in 1940.

Hollywood Boulevard at 18th Avenue.
Hollywood Hotel, built 1923, the first hotel built by J.W. Young and later called the Park View Hotel, then the Town House. Demolished. See 18th Avenue.

Hollywood Boulevard at 18th Avenue.
Young Circle. See Circle.

Hollywood Boulevard Downtown, Even Numbers on South Side Between 1800 and 2100

1800 Hollywood Boulevard.
Great Southern Hotel. Designed by Martin L. Hampton for J.W. Young in 1924. With one hundred rooms, including a ballroom, the hotel cost Young more than a half-million dollars. This defining landmark of downtown Hollywood is to be demolished in 2005.

1900 Hollywood Boulevard.
Hollywood Art Gallery. Auction house of James Mann, 1940s–1950s.

1902 Hollywood Boulevard.
Lillian's ladies' wear. Owned by Lillian and Dave Stine, 1930s.

1908 Hollywood Boulevard.
Half Moon Art Gallery, 1940s–1950s.

1912 Hollywood Boulevard.
Flamingo Groves fruit shippers, 1931

1914 Hollywood Boulevard.
Adler's Inc. Hollywood's first ladies-wear store, built by Phil Adler and his sisters Hattie Adler and Victoria Landman in 1925. 26 san. By 1940, it was Merhige Gowns.

1926 Hollywood Boulevard.
Morse Arcade, three stories, built in 1923. The Hollywood Public Library began here in 1927 under the auspices of the American Association of University

Women and the Woman's Club. Currently connected to the Ramada Inn (entrance on Harrison Street), the three floors of the arcade were beautifully restored in 2004 and now closely resemble 1925 photos.

1930 Hollywood Boulevard.

Wellons and McGowan at 1930 Hollywood Boulevard were granted a license for slots in November 1935. Breeding's Liquor Store was here in 1940.

1934 Hollywood Boulevard.

J.W. Young's publishing enterprises, including the *Hollywood Daily News*, moved here in 1925. Architect of the original uncertain. In 1940, The Toggery Shop men's wear was on the ground floor. In 2004, restoration to remove the 1970s metal façade and reveal the original early 1920s splendor was funded by Aron and Zahava Halpern at a cost of between $400,000 and $500,000.

1936–38 Hollywood Boulevard.

Central Arcade. The two stories were built in 1923 by Harry Bastian's Bastian Supply and Construction Company of Indianapolis, Indiana, and purchased by realtor Mark J. Tully. Beginning in the 1930s, the offices of dentists C. Victor Bussey and Arthur W. Kellner (one of Hollywood's mayors) were in Central Arcade. Others in the building included Dr. Ralph Bailey, Dr. O.A. Bingham, Dr. Jess Cohn and Dr. Maxwell Hartman. Karlberg Studio, photographer, was also here in 1940. 26 san., as arcade.

1946½ Hollywood Boulevard.

Office of Roe Fulkerson, optometrist, civic leader in the 1930s through 1950s. Fulkerson was a leader in Kiwanis and founder of *Kiwanis, International* magazine. In 1935, he was elected to the Florida House of Representatives and in the 1940s to the Hollywood City Commission.

2000 Hollywood Boulevard (southwest corner at 20th Avenue).

Hollywood Land and Water Company First Administration Building, 1923. Gone in the 1926 hurricane.

2022 Hollywood Boulevard.

Melina's. Began in November 1934 with children's wear. Still owned by the same family.

2016–18 Hollywood Boulevard.

Florida Theatre built 1939 as the latest in streamline Moderne neon with plush seats, subdued lighting and air-conditioning—nearly the only place in town.

Children younger than age twelve paid twelve cents. All the first-run movies were shown here, with programs changing two or three times weekly. Now a parking lot.

2024 Hollywood Boulevard.
Brown's Department Store, 1924. A branch of Sokolow's in Dania, operated by Lewis Brown and then his son Earl I. Brown. 26 san.

2032–42 Hollywood Boulevard.
Kington Building, southeast corner of 21st Avenue and the boulevard, built 1923 by W. Ward Kington, whose 1923 mansion was just opposite across the Florida East Coast railroad tracks. It was a Rubush & Hunter design with a Renaissance simplicity constructed before J.W. Young settled on the Spanish-mission style, with stores at street level and large apartments on the second floor. Some of those living in the Kington Building in 1924 and 1925 were dredge operator C. Austin Boyd and wife Helen, Aletha Knight, Dagmar Larsen and Mary Carlson, manager. Jack Dresnick operated Jack's on the ground floor beginning 1931, and for a time, his family lived in an apartment above, as did tailor Sol Cohn's family. In 1933, it became the Broward Building. In the 1940s the popular dance studio of Billy and Ruth Ambrose was here. The façade of this landmark building is unchanged from the original design.

Hollywood Boulevard Downtown, Odd Numbers on North Side Between 1800 and 2100

1909 Hollywood Boulevard.
Rainbo Grill, 1930. Still extant and being restored by owner Jim Durphy, 2005.

1911 Hollywood Boulevard.
Late in 1923, a large, two-story building at 1911 Hollywood Boulevard became the Hollywood Furniture Company. In 1940, it was the A&P grocery store; upstairs was Sportland Bowling Alleys. 26 san.

1921 Hollywood Boulevard.
Hollywood Theatre, owned by Arthur Enos, built by contractor Thomas McCarrell Sr. in 1923. Before they built their own churches, the Catholics and the Presbyterians held services here. Young Company photographer Yale Studios had offices upstairs in the 1920s. In 1935, this became the Ritz Theatre. In the 1940s, the Ritz was the place to go for cowboy western movies. For between ten and twenty-five cents, kids could see a double feature and cartoons. Popcorn tossed by the kids in the balcony was a hazard for the kids below. 26 san. Not extant.

A Guide to Historic Hollywood

1925–27 Hollywood Boulevard.

The Kagey Building, built in 1923 by J.M. Kagey, sales manager for the Hollywood Land and Water Company.

1949 Hollywood Boulevard (northeast corner of 20ᵗʰ Avenue).

Hollywood Land & Water Company's Second Administration Building, designed by Martin L. Hampton in 1924 to provide more spacious quarters for the company. J. W. Young had the central office on the second floor. Following the 1926 hurricane the building served as morgue. In 1934, the Piggly-Wiggly grocery chain moved its store here from Twentieth Avenue. The building was demolished and the site is now Anniversary Park.

2001 Hollywood Boulevard.

Hollywood State Bank, February 1924. Rubush & Hunter's last commission from Young, this imposing structure replaced a smaller building. Another masterful design by Philip Weisenburgh, the south and east façades had five round arches springing from intricately carved, full-round Corinthian columns, which stood before two-story decorative balconies. Under the slightly overhanging tile roof was a central cartouche. Following the 1926 hurricane, plans were altered to eliminate a penthouse; even so, the structure was fitting statement of strength and solidity for a bank that never closed during the Depression. Later it became the First National Bank of Hollywood. The U.S. post office was on the ground floor in the 1940s and 1950s. Today the façade has been remodeled.

2009 Hollywood Boulevard.

David's Place, magazines and sundries in front; pool and slots in the back in the 1930s when gambling was legal.

2019–25 Hollywood Boulevard.

Kriekhaus building, built by Danian W.C. Kriekhaus in 1923 at a cost of $15,000 with its oolite limestone-covered arcade. Now gone.

2033–47 Hollywood Boulevard.

The first building in Hollywood erected by J.W. Young's Hollywood Land and Water Company on the first street corner. It was built as the single-story company garage in October 1922 and designed by his architects Rubush & Hunter with California-mission details. In 1923, Young sold the building and it became the Ingram Arcade. A second story was added at some time later. Now a recognized Hollywood landmark, it is well-maintained by owner Robert McCarthy. 26 san.

Hollywood Boulevard West of the Dixie Highway and Florida East Coast Rail Road Tracks

Hollywood Boulevard and the Dixie Highway.
Hollywood began here May 1, 1921, when Hollywood Land and Water Company surveyor Tony Mickelson established lines to begin construction of the one-hundred-foot-wide Hollywood Boulevard for about five blocks east and west of this spot.

Hollywood Boulevard and Dixie Highway, southwest corner.
Curtis Block, where James Breeding opened a drugstore. The building was seriously damaged in 1926 hurricane. It was replaced in the late 1930s by Valhalla, a nightclub reputed to be a gambling establishment. Demolished 2005.

Hollywood Boulevard at about 22nd Avenue.
John Murray of New York built a five-room bungalow for his family here in 1924 and started a chicken farm beginning with forty chickens. Not extant.

2200–06 Hollywood Boulevard.
Cobbler and stores. 26 san. Not extant.

2208–14 Hollywood Boulevard.
Stores. 26 san. Dixie Sheet Metal & Roofing Works, 1929.

2209–15 Hollywood Boulevard.
Cree Court, six buildings. 26 san. Home of Jack Wells, landscape gardener, 1929. Not extant.

2216–22 Hollywood Boulevard.
Stores. 26 san.

2217–23 Hollywood Boulevard.
Stores. 26 san. Not extant.

2233 Hollywood Boulevard.
The Moose built a new lodge here in 1949. The lodge has since moved to Taylor Street.

2224–30 Hollywood Boulevard.
Zimmer Court, six buildings. 26 san. Not extant.

2300 Hollywood Boulevard.
Hollywood Bible Chapel, founded by the Conlons in the 1930s. Still operating.

2308–14 Hollywood Boulevard.
Six buildings. 26 san.

2309–15 Hollywood Boulevard.
Three buildings. Home of Samuel and Jennie Hennick in 1924. Samuel was a hoisting engineer. 26 san. Not extant.

2317–23 Hollywood Boulevard.
Four buildings. Sylvester and Laura Carpenter lived at 2317 Hollywood Boulevard in 1924. 26 san. Not extant.

Hollywood Boulevard at 24th Avenue.
Home of Anna and Burpee Mikel whose son William Mikel born May 1923 was one of the first two children born in Hollywood. His cousin Altman Lee Aderholdt was born June 21, 1921. House no longer extant.

2450 Hollywood Boulevard.
Chandler Hotel, 1924. Now gone.

Hollywood Boulevard from 21st to 26th Avenues
Paved with sidewalks, August 1923.

2600 Hollywood Boulevard.
City Hall Circle. Originally a pineapple field, the second ornamental circle was surveyed in 1924 by A. Louis Platt, who became Tony Mickelson's chief of party for the Little Ranches. In 1928, City Hall was erected on it. Demolished and replaced by present City Hall.

Hollywood Boulevard (address unknown).
Still farther west was McCutcheon & Peck's Tourist Camp. Not extant.

2910 Hollywood Boulevard.
Stratford's Bar, 1944. One of the oldest in Hollywood, it is still operating.

Hollywood Boulevard at about 28th to 30th Avenues.
Crossed a swampy riverbed that J.W. Young's engineers called the West Marsh that extended from about Pembroke Road to Johnson Street. See C-10 Canal.

STREET GUIDE

3001 Hollywood Boulevard.

Hollywood Station. A second railroad began operating through Hollywood when the Seaboard Air Line Railroad was run from Palm Beach to Miami along the edge of the West Marsh. A station stop was established at 30ᵗʰ Avenue and the boulevard in 1926 where it stands today. The first passenger train to stop here was the Orange Blossom Special on January 8, 1927, carrying Dorothy Walker Bush, mother and grandmother of the Presidents Bush. The station was placed on the National Register of Historic Places in 2005 and was dedicated the Dorothy Walker Bush Museum of railroad memorabilia in 2005. It is still a working station, as Amtrak and Tri-Rail use these tracks today.

3000 Hollywood Boulevard.

This small white building with its Doric columns was built in 1928 as the First Church of Christ, Scientist, at 1532 Harrison Street. As the congregation grew, they built a larger church and used this as their Sunday school. In 1959, the Hollywood Garden Club acquired the building and moved it to this location. With the decline of the garden club, the building has become part of the D.W. Bush Museum (see 3001 Hollywood Boulevard).

Under Hollywood Boulevard flows the C-10 Canal.

The canal begins at the Orange Brook Golf Course and eventually flows into the Dania Cut-off Canal. The C-10 Canal was dug at the expense of J.W. Young to drain land for the golf course he planned in Hollywood Hills, 1926.

3101 Hollywood Boulevard.

Stan Goldman Park. Named after Stanley Goldman, city commissioner for eight years, who died in office of a heart attack February 16, 1986. An environmentalist, Goldman worked to have a park established at this site.

3200 Hollywood Boulevard.

Orange Brook Golf Course, originally the Municipal Golf Course when it was established by city ordinance in July 1934 when locals wanted a public golf course. The city didn't have the funds to build one but donated the land; money for development would have to be raised. In August 1934, Floyd Wray, C.C. Freeman, Dr. Arthur Kellner, R.B. Walker and C.R. Gilliland formed the unpaid Golf Commission. As clearing began, the original nine holes designed by Ralph Young in 1926 for Hollywood Land and Water's Hollywood Hills Section were discovered by A.J. Ewing, golf course architect, who thought 80 percent of the original course could be saved. Another discovery was the remnants of an orange grove. The course is built on the site of the former Stratton farm.

Through the efforts of these volunteers, the course and a temporary clubhouse opened with a flourish October 18, 1934, as the Municipal Golf Course, an immediate success. The *Hollywood Herald* noted that this had been a community project. Seventy-four hotel and apartment owners pledged more than $1,000 to support it. The opening day was a legal city holiday. A handsome building by Bayard Lukens in the latest Moderne design, praised as "a very magnificent and modernistic building," soon replaced the temporary clubhouse. The Hollywood Open in the 1930s here attracted golf greats Sam Snead, Ben Hogan, Byron Nelson, Louise Suggs, Marlene and Alice Bauer, and Babe Didrikson Zaharias. Still operating.

3251 Hollywood Boulevard.

Hollywood Mall, *circa* 1960. The first enclosed, climate-controlled shopping center in Hollywood. Shoppers greatly enjoyed strolling here with their children, free from automobile traffic, where they could walk or sit down while avoiding blistering sun and sudden downpours. Sadly, this sense of safety was shaken when seven-year-old Adam Walsh, son of *America's Most Wanted* host John Walsh, was kidnapped from here and killed in 1981. Mall still extant.

Hollywood Boulevard between Thirty-fourth and 35th Avenues.

Young Company rock pit, dug in 1921 for rock to build Hollywood Boulevard. Now filled in for the tennis courts at David Park. Tennis ace Chris Evert occasionally played here as a child.

Hollywood Boulevard at 34th Avenue.

Municipal Water Works Plant established here 1938.

4000 Hollywood Boulevard.

The third and culminating circle on Young's grand plan. Engineer Sam Whitehead laid out the Hollywood Hills section with its several crescent drives beginning in January 1924. Mirroring the Beach Hotel at the eastern end of the boulevard, the Hollywood Hills Inn on this circle created a pleasing vista to draw visitors west. Designed by Rubush & Hunter, it was grand and well appointed. Completed in the summer of 1925, the site was occupied as the Hills Inn only for the 1925–1926 winter season and was left empty after the 1926 hurricane. The city acquired the property in 1930.

From 1932 through the 1950s, this was the winter quarters of Riverside Military Academy of Gainesville, Georgia, which purchased the property from the city and brought the area to life. Each winter, the academy brought six hundred cadets, nearly one hundred faculty members and their families to Hollywood.

During World War II, Riverside Military Academy relinquished the buildings to the U.S. Navy for the Naval Air Gunners Training School, replacing cadets with sailors, Navy WAVES (Women Accepted for Volunteer Emergency Service) and marines. Meanwhile, men and women who were not in the armed forces became plane spotters stationed in high places. This included the open towers of Riverside Military Academy, previously inhabited by bats and owls. Spotters spent the nights watching the skies and reporting anything at all to the coast guard. The Riverside Military Academy returned after the war.

The building was demolished in the 1970s, and the circle renamed Presidential Circle. The startlingly modern glass and blue neon Presidential Building that now occupies it is in keeping with Young's City Beautiful concept, serving as a visual magnet to draw the eye to west Hollywood.

Hollywood Boulevard and Hills, or Riverside, Circle, southwest quadrant.

Homes of Clyde and Amy Elliott and Virginia Elliott Lathrop, later TenEick, 1930s. The two Spanish-mission-style houses from 1925 were demolished about 2001.

Hollywood Boulevard about 58th Street.

Minnie Pearl's Restaurant owned by Grand Ole Opry Star in the 1950s. Not extant.

Hollywood Boulevard and State Road 7.

The boulevard was extended to State Road 7 when this north–south road was opened in 1927. The boulevard was again extended from State Road 7 to U.S. Route 27 in May 1953.

West Hollywood Boulevard.

Hollywood Hills Dairy, B. Gustafson, Peterson, proprietors. Thus listed in 1937 directory, this is one of some fifteen dairies established in the unincorporated land west of State Road 7 in the 1930s.

6501 Hollywood Boulevard.

McArthur High School, opened in 1956 in portables on land donated by James Neville McArthur of the McArthur Dairy family. In 1958, McArthur donated another ten acres and a permanent structure was erected at a cost of $1.2 million. Seminole Indians from the Hollywood Reservation began to join Hollywood children in this school. The original buildings were replaced in 2005 by the present handsome campus, for $27 million.

Hood Street (originally Henry Street)

In 1940, Hood Street was extended from Twenty-second Avenue west to city limits.

2212 Hood Street.
Home of James Cheek in 1940.

2218 Hood Street.
Home of the Reverend Charles P. Powell in 1940.

2220 Hood Street.
Home of Anthony Black in 1940.

2223 Hood Street.
Home of Charles B. Thomas in 1940.

2227 Hood Street.
Home of John Doan in 1940.
2240 Hood Street.
Home of Alonzo Moore in 1940.

2345 Hood Street.
Home of Mittie Johnson in 1940.

Indiana Street

In 1940, Indiana Street extended from Broadwalk west to Ocean Drive on beach.

312 Indiana Street.
Neff Apartments, 1926. Not extant.

324 Indiana Street.
Built in March 1924 by the Daniel Russo family, this was the second home to be built on the newly opened beach. Originally a limestone oolite bungalow, it was enlarged by Russo to an apartment house. Here Dr. Harrison Walker established and operated Hollywood's first hospital, called the Gulfstream Hospital, until the Depression caused him to close the hospital in 1929. In 1940, it was the Gulf Stream Hotel. It is still an apartment building. 26 san.

Jackson Street

In 1940, Jackson Street extended from the beach west to city limits.

STREET GUIDE

1457 Jackson Street.

Home of architect Cedric Start, built in 1939 soon after his arrival in Hollywood in 1935. Olaf Owra was contractor. The home was written up in the January 1942 issue of *Better Homes & Gardens*. Start, a graduate of Columbia University, designed hundreds of homes; some forty churches, including the First Presbyterian Church; Memorial Hospital; and the *Hollywood Sun-Tattler* building. A more complete cataloguing of his work in Hollywood would be welcome. His home is still extant.

1515 Jackson Street.

Home of John Causey, who worked for the ice company at 2200 Jackson. Still extant.

1637 Jackson Street.

Spanish-eclectic home of Charles and Mary TenEick, 1925–1926. Charles was the city engineer in 1929 and later served as postmaster. Mary Nunez TenEick was a botanist who published *Garden Club Manual Checklist of Plant Material for South Florida* in 1935, which listed 4,200 plants (reprinted in 1950 as *The Florida Plant Checklist*). 26 san. The house was remodeled and is still extant.

1657 Jackson Street.

Home of J. Everett Sauls, plasterer, whose talented son Jackie Sauls became a professional dancer with his own dance studio on Twenty-first Avenue in the 1950s.

1724–40 Jackson Street.

Seminole Place, twelve cottages. 26 san. Not extant.

1808 Jackson Street.

Among the first to live in Central Hollywood were William H. and Bertie Fields of Kentucky, who moved into a Jackson Street eight-room, two-story concrete house with a veranda and porte cochère, according to the January 1923 *Hollywood Reporter*. Now gone.

1818 Jackson Street.

The Wellinger Apartments were the home of young marrieds Jimmy and Mary Mack, as well as Virginia Elliott and Harold Lathrop in 1929. Mack bought the Southern Mill & Bungalow Company in receivership in 1929 and renamed it Mack Lumber Company. Harold Lathrop had arrived in Hollywood as driver of one of Young's White buses, then worked for the ice company. His wife Virginia, later TenEick, wrote the *History of Hollywood 1920 to 1950*. Building still extant.

1833 Jackson Street.

Home of Ruth L. Burgoon, second-grade teacher to most Hollywood children at Hollywood Central School in the 1930s and 1940s. She sometimes entertained the class with her talking doll, which spoke and sang by means of a phonograph record inside its body. 26 san. House is still extant.

1836 Jackson Street.

Home of Clarence Williams, Hollywood's mayor in 1941. Florence Gassler, a nurse and Hollywood Pioneer, also lived here. 26 san. The house is still extant.

1857 Jackson Street.

Maryland Apartments. The building served as a temporary hospital following the 1926 hurricane. Still extant.

1860 Jackson Street. (Also numbered 1856.)

Home of Frank Burton, June 1922. The Youngs' oldest son, Jack, and Mickie (Mildred Albright), who were married in February 1925, lived here for a time and their daughter Rene Ann was born here. This house is no longer extant.

1908–11 Jackson Street.

This was the site of the elegant Villa Hermosa apartment-hotel built by J.W. Young's close friends Edythe and Ed Whitson in the fall of 1925. After the 1926 hurricane, the Whitsons housed two hundred refugees and fed an additional three hundred every day, including workers from the Red Cross and National Guard. Not extant.

1917 Jackson Street.

Home of Paul John in 1922-1923. John then sold it to Mark J. Tully in 1923. Paul John was Hollywood's second mayor. The house later belonged to Jack and Mary Burton; Mrs. Burton taught third grade at Hollywood Central School in the 1940s. House now gone.

1941 Jackson Street.

Home of Frank Dickey and wife Orpha from 1924. This house should become a designated landmark as few people other than J.W. Young were as important to the development and growth of Hollywood as Frank Dickey. As chief engineer of the Hollywood Land and Water Company, Dickey oversaw the platting and surveying of the original lots, streets and lakes. He worked closely with Charles H. Windham to construct Port Everglades Harbor. He served three terms as a Broward County commissioner, and from 1935 to the 1940s, he was Hollywood city manager. Orpha

Gallup Dickey was also a civic leader; she was the first president of the Hollywood Woman's Club in 1922. 26 san. This historic home still stands.

1946 Jackson Street.
 Home of Dr. Harrison A. Walker, 1925. Dr. Walker began as a resident physician in the Hollywood Beach Hotel, then established Hollywood's first hospital, Gulfstream Hospital at 324 Indiana Street on the beach. 26 san. House still extant.

1957–59 Jackson Street.
 Poinsettia Hotel, later Royal Palm Hotel, built 1924. Still extant.

2145 Jackson Street.
 Cherokee Court, four buildings. Now gone. 26 san.

2200–04 Jackson Street.
 Pure Ice Company, or Purity Ice & Cold Storage Corporation in 1925, City Ice and Fuel plant by 1940. This was an important industry as ice boxes were far more common than electric refrigerators in the 1920s and 1930s. The building still stands. 26 san.

Others on Jackson without a specific address:
Oliver and Mae Behymer, "e Jackson" (probably for east Jackson Street) listed in the 1924–25 county directory. Oliver was editor and chief writer for J.W. Young's news magazines, *The Hollywood Reporter* and *South* from 1921 to 1927.
 Frank Witt, office manager in 1924 for the Hollywood Land and Water Company, lived on the north side of Jackson Street, according to the 1925 directory.

Jefferson Street
In 1940, Jefferson Street extended from the beach to city limits.
 Jefferson Street is the south border of the 1922 Little Ranches section established in 1922. This section, bounded by the Dixie Highway, Jefferson Street, 26th Avenue and Johnson Street has half-acre lots.

Jefferson Street on the beach.
 Beach Trailer Park, extending from the ocean to South Ocean Drive (number 1001), the 1930s equivalent to Tent City. Advertised as the only trailer park directly on the beach. Not extant.

1311 Jefferson Street.
 Home of Phil "The Stick" Kovolick, listed on the Florida Sheriff's list of the one hundred top gangsters in Florida in 1959. He was apparently the driver, bodyguard

and bagman for the Lanskys. Friends of Kovolick recall that there was heavy security on the windows of the house. Occasionally they would find Meyer Lansky playing cards with Phil; both men were very nice to the visitors. However, Phil apparently ran up against his own bosses and ended up in a rock pit in a cement barrel, or so the story goes. His beautiful home is extant.

Jefferson Street, address not located.

According to a 1924 *Hollywood Reporter*, Margaret and Merrill H. Nevin were "landscaping their new home on Jefferson Street after selling their house at 1616 Monroe to Dr. James Hartley." A few years later they moved to 1145 Harrison Street.

Block between 15ᵗʰ and 16ᵗʰ Avenues.

Jefferson Park, a block set aside for children's recreation, 1923. Children from Hollywood Central School marched there in the 1940s and 1950s for Physical Education. 26 san. Still extant.

1544 Jefferson Street.

Durie Apartments, 1926. C.R. Gilliland lived here in 1929. Still extant.

1700 Jefferson Street.

Jefferson Apartments, 1924–1925. Jack and Mildred Young lived here in 1929. Still extant.

1737 Jefferson Street.

California-bungalow-style home of Dr. Bruce Butler in 1925 when he moved his practice to Hollywood. His profile appeared in the June 29, 1934 *Hollywood Herald*. House still extant.

1740–42 Jefferson Street.

Home of Charles and Mary Zinkil. Their son William would be Hollywood's mayor in 1955–57 and 1959–66, then would be elected a state representative and state senator. Mission-style home still extant.

1809 Jefferson Street.

Home of Floyd and Jane Wray in 1924. Not extant.

Jefferson Street between 18ᵗʰ and 19ᵗʰ Avenues.

William Jennings and Ira Guthrie were both on Jefferson in 1924, before the houses were numbered. Ira Guthrie was secretary-treasurer of Hollywood Land and Water Company. Jennings was director of the landscape department. Mrs. Caesar LaMonaca is also listed here in 1924. Exact location not located.

Street Guide

2000 Jefferson Street.
> Casa El Jeanne Apartments, 1924–25. Still extant.

Johnson Street

In 1940, Johnson Street extended from the beach west to the city limits.

Johnson Street from about 17th Avenue to the Dixie Highway was the north border of the future city of Hollywood in 1920 when J.W. Young bought his initial land purchase from Dania farmer Stephen Alsobrook. At that time, the road was an unpaved cart and truck track. The first area to be laid out with sidewalks and rock-covered streets was between the Dixie Highway and about 18th Avenue, and Washington Street to Johnson Street in 1922. By December 1922, Johnson Street was graded and paved from the Dixie Highway to the Canal.

Johnson Street at the canal. (Then called the Florida East Coast Canal.)
> By February 1922, a seventy-foot barge bridge had been set up across the seventy-foot wide canal to allow foot passage to the empty, uninhabited beach. During the 1926 hurricane, this barge was carried inland by the raging flood until it was halted by buildings at 16th Avenue between the boulevard and Tyler Street. The bridge was not replaced and Johnson Street ceased to be a beach crossing. The area is now in S.S. Holland Park, which was named for the energetic leader of Hollywood's highly successful War Bond and War Stamp drives during World War II.

Johnson Street on the beach.
> With trucks now able to reach the beach island, the pink concrete Broadwalk was begun at Johnson Street in March 1923.

Johnson Street and Broadwalk.
> Theatre Under the Stars, a band shell, was built 1924–25 by the Young Company. It has been replaced.

Johnson Street at the Broadwalk, northwest corner.
> Tangerine Tea Room, built by the Young Company, 1924. Mike Chrest was manager of the highly popular restaurant, with ballroom dancing. It was destroyed in the 1926 hurricane.

Johnson Street on the beach.
> Lined with shops 1924. None extant.

Johnson Street.
> Ocean Drive, the first road on the beach, was begun at Johnson Street in July 1924, heading south.

Johnson Street, north border of Hollywood Golf Course.

J.W. Young purchased this land in 1922 from former Dania Mayor John Mullikin. Some forty acres had previously been planted with tomatoes, as had most of Dania, right down to the north side of Johnson Street.

Johnson Street, between 16th and 17th Avenues.

A frame bungalow marketed in the Young Company salesmen's books, 1924–25. Still extant.

1724 Johnson Street.

Home of William and Helen Eitler, built 1923. William was vice president and treasurer of Hollywood Construction & Finance, a Young Company.

1727 Johnson Street.

Home of Henry Palmer in 1940. Hollywood is a treasure-trove of small classic Moderne houses; this is a notable example. It is fairly geometric, with a flat roof, trim applied sparingly as horizontal bands, smooth stucco exterior and a round porthole window next to the entry.

1941–49 Johnson Street.

Home of Zaidee Hildebrand, 1926. In 1940, her address was 1549 Johnson Street.

2027 Johnson Street.

Meekins Cement Block. 1924. An important industry in early Hollywood, headed by Cliff Meekins. Buildings now gone.

Johnson to Jefferson Streets and Dixie Highway west to 26th Avenue.

J.W. Young planned this area for his half-acre lots in the Little Ranches section.

Johnson Street and the Dixie Highway.

Dowdy Field. In late 1933, Earl "Pop" Dowdy, manager of a local softball team, asked the city to build a softball field. The commissioners and Mayor James A. Lewis agreed, and donated city land to create Dowdy Field, dedicated in the spring 1934. This quickly became the home field for local teams, with a small grandstand for spectators. The Baltimore (Maryland) Orioles held spring training at Dowdy Field before World War II and from 1946 to 1948. South Broward High School teams also played here. Still in use.

STREET GUIDE

Johnson Street and the Dixie Highway, southeast corner.

National Guard Armory, begun in 1953 for Company C, 211th Infantry. The first troops from here went off to the Korean War. Still extant.

Johnson Street, one block west of the Dixie Highway.

Higby Photo Co., 1926. Source of many 1920 photos of Hollywood.

2113 Johnson Street.

Adlers Court, seventeen cabins (probably owned by Sol Adler) 26 san. Now the site of the National Guard Armory.

2201–09 Johnson Street.

Green Light Inn, one large and four smaller buildings shown on 1926 Sanborn map. Gone.

Johnson Street, two blocks west of Dixie.

H. Churchill & Sons painters, 1926.

2229 Johnson Street.

West Side Club, begun in the 1930s. The building is on the 1926 Sanborn map.

Johnson Street and 24th Avenue.

Here stood a farmhouse in 1920 that was used initially as housing for J.W. Young's black workers, 1922–1923. Possibly on 26 san. Not extant.

2414 Johnson Street.

Dixie Sash and Door, three buildings *circa* 1923. 26 san.

2451 Johnson Street.

House apparently designed by Kenneth Spry as one of a group of homes here. The homes may be identified by the distinct midcentury design, where the two sides of the slanted roof do not meet but are joined by a clerestory window under the higher side. (Technically, this is called a shed roof.) Spry also used new textures on the wall surfaces, including native oolite, as on a house on Harding Street. A further study of Spry's work would be welcome.

2455 Johnson Street.

House apparently designed by Kenneth Spry, midcentury.

2501 Johnson Street.

House apparently designed by Kenneth Spry, midcentury.

2511 Johnson Street.
House apparently designed by Kenneth Spry, midcentury.

2539 Johnson Street.
House apparently designed by Kenneth Spry, midcentury.

Johnson Street and 26ᵗʰ Avenue.
According to author Virginia TenEick, in the 1920s, there was an old signpost here for the earlier north–south route. Not extant.

2727 Johnson Street.
Nine-hole Sunset Golf Course opened in 1952. Still extant.

Johnson Street at about 29ᵗʰ Avenue.
Bridge over the C-10 Canal. The canal created by J.W. Young, *circa* 1924 from the West Marsh to drain land for golf course, now Orange Brook Golf Course.

Johnson Street at 35ᵗʰ Avenue.
Hendrick Hudson apartments, 1924–1925. Memorial Hospital was built on this site.

Johnson Street and 35ᵗʰ Avenue.
Memorial Hospital, Hollywood's second hospital, begun in 1952 with 100 beds. The original building was designed by architect Cedric Start. The hospital complex has been greatly expanded. In 2002, the hospital was named a regional care center with 684 beds. The section named Joe DiMaggio Children's Hospital, founded in 1992, now has 144 beds.

Johnson Street, one-half mile west of 7ᵗʰ Avenue (State Road 7).
McArthur Dairy, B.B. McArthur, proprietor. Also listed in the 1937 directory is the Biscayne Farms Dairy, E.A. Cowdery, proprietor, at Johnson Street and Hollywood Pines. James McArthur gave some of his family's dairy acreage at Hollywood Boulevard for a school, which was named for them, McArthur.

Johnson Street to Sheridan Street and farther west.
The northwest section of Hollywood was inundated during the state's biggest flood following the 1947 hurricanes. Some 7.5 million acres were under water in places for months afterward. Broward County was most affected.

Johnson Street and State Road 7.
Locals were hunting bear and panthers here as late as 1950 in the mostly undeveloped land around the dairies.

Lakes section

This section of Hollywood was begun in 1923 and the land area was drained by 1925.

It was originally called the East Marsh by Young's engineers. Although the elevation of 18th Avenue was ten feet, from 14th Avenue east the land was pretty much under water when J.W. Young bought the property, according to Tony Mickelson, who surveyed the area. In his original design, Young had planned to dig and dredge out two keyhole-shaped lakes, using the bottom muck to fill the surrounding areas. Dredges began work on the two artificial lakes by January 1923, and by March 1923, Hollywood Land and Water Company began offering lots for sale in the future Lakes section (still mostly under water) on either side of Hollywood Boulevard. (The boulevard did not as yet exist just west of the canal.) Lake-bottom rock was used to pave streets in this section and on the beach.

An aerial photo of April 1924 that shows the Lakes area in the distance suggests that the marsh had receded at least to 13th Avenue. Neither lake is completely formed as yet, and there is an island in North Lake. Raised land for the boulevard causeway can be distinguished. The Lakes section was sufficiently drained in 1925 so that lots had begun to appear.

The Meyer-Kiser Corporation commissioned Rubush & Hunter to design prestigious homes for the Lakes. The architects provided about twenty designs in tile, stucco and cast stone, often asymmetrical with a tower at one side, with moon gates, triple Palladian windows, balconies and urns. George E.T. Wells and G. Lloyd Preacher & Co. of 124 East Flagler Street in Miami were associate architects for these Lakes houses. The original Lakes section—which comprised the area from Johnson Street to Washington Street and from 14th Avenue to the Intracoastal Waterway—has been greatly expanded today.

Lee Street

Lee Street extended from the beach west to the city limits in 1940.

321 Lee Street.

General Lee Apartments. Gone

2301 Lee Street.

The 1940 home of Lester C. Boggs, who owned the septic-tank business. He was Hollywood's mayor from 1943 to 1947 and from 1949 to 1953. He also served on the city commission.

2344 Lee Street.

Home of Lawrence and Katherine Lubinski by 1925. Their daughter Florence (later Gassler), a nurse, was working in Jacksonville when the 1926 hurricane hit Hollywood. She volunteered with the Red Cross and took a train south, but could only view the devastation from the train window as the train would not stop in Hollywood. She managed to return by bus and found her parents safe. She then worked three days nonstop aiding survivors. After moving to Hollywood, she treated patients from the Beach Hotel and as far north as Pompano in the 1930s and 1940s.

Liberia

In the 1940–41 street directory, this area referred to as a "colored section west of N. 22nd av and north of Sheridan."

In 1923, J.W. Young built this separate city as a new town for African Americans after he discovered that Florida's segregation laws did not permit non-whites to live in the cities. Young purchased forty square blocks on the main road (Dixie Highway) between Dania and Hollywood. His plan included a circle park, with a half-circle intended for a hotel, similar to Hollywood's circle. The Young Company donated land for schools, churches and parks and built four frame houses by 1924. The first residents were Tom Hannibal and family. As in Hollywood, development of Liberia stopped after the 1926 hurricane and Young's eventual loss of finances. The area is now partly in Hollywood and partly in Dania.

The area suffered a loss of fifty-five homes in the November 8, 1935 hurricane. Hollywood's American Legion post and the Red Cross helped rebuild the homes.

Liberia Street.

The 1924 county directory lists twenty families living on Liberia Street. Most likely this was the initial road laid out in Liberia, now Atlanta Street.

Liberia, perhaps on Liberia Street. Exact location not specified.

A dormitory built by J.W. Young for black workers was designed by his oldest son, Jack, according to the September 1924 *Hollywood Reporter*. Probably not extant.

Dunbar Park, between 23rd and 24th Avenues.

Vestiges of the circle park planned for Liberia by J.W. Young may be noticed in the curved street here.

Lincoln Street

In 1940, Lincoln Street extended from beach west to city limits.

Lincoln Street, Central section in 1922, had begun to experience a building boom of Spanish- and Florida-style homes

815 Lincoln Street.
See 815 North North Lake Drive.

Lincoln Street and 20th Avenue.
Florida Power & Light occupied a city block in 1925. 26 san.

2144 Lincoln Street.
Lincoln Hotel. This was originally the Turner Apartment House, built in September 1923 by Fred Turner, with J.F. Weidow of Orlando as contractor. As the first hotel in the Little Ranches, it was "thoroughly modern in every detail, having [a] private bath" with each of the fifty rooms. Among the occupants in 1924 and 1925 were William Cowles, chief engineer of dredges for the Hollywood Land and Water Company, and Samuel Whitehead, civil engineer who was surveying Hollywood Hills. It is now the Lincoln Manor. 26 san.

Lincoln Street between 23rd and 24th Avenues.
The playground at Lincoln Park was begun in 1948.

Little Ranches

In 1921, the Little Ranches section extended from the Dixie Highway west to 26th Avenue, and from Jefferson to Johnson Streets.

With the Central, or downtown, section, the Little Ranches was the first area of Hollywood to be developed; survey work began in 1922 by Tony Mickelson. Located just west of the Florida East Coast railroad tracks and the main north–south road (the Dixie Highway), this is the highest area in the city (fourteen feet above sea level), dry and not prone to floods. The half-acre lots in the Little Ranches are larger than elsewhere in the city. In 1924, A. Louis Platt became Mickelson's chief of party for Little Ranches, laying out the second ornamental circle at the boulevard and 26th Avenue, City Hall Circle. Because of the larger lots, alleys were not included in the Little Ranches.

Following World War II, home development began to move west in the Little Ranches as far as 28th Avenue. Before that homes in Little Ranches were widely scattered and enjoyed unimpeded views out over the landscape. Empty lots were covered with wild flowering periwinkles and lantana (and sandspurs). Under the low-growing plant life lived rabbits, field mice, bobwhite

quail, meadowlarks, various snakes—mostly harmless—and an occasional gopher tortoise.

Madison Street

In 1940, Madison Street extended from the beach west to the city limits.

347–49 Madison Street.

Southwinds Apartments. Built on the beach in 1926, as J.W. Young was building the luxurious Beach Hotel, the U-shaped building was based on the California-mission design. It later became the Hollywood Beach Apartments. It also faces Monroe Street. Still extant.

1333–37 Madison Street.

South Lake Apartments, 1925. The date indicates that the land had drained sufficiently to build on by 1925. Building currently empty.

Madison Street.

The January 15, 1923 *Hollywood Reporter* lists a number of developers, including Frank Thompson, "capitalist from Connecticut" and owner of twenty lots in the Central section and the beach. Thompson was building nine houses around Madison Street. Thompson and his family drove from Connecticut to Hollywood in October 1922 in their Stanley Steamer. Their exact address on Madison is uncertain.

Madison Street.

J.F. Martin of Sandusky, Ohio, was also "building bungalows on Madison and rental bungalows in the Little Ranches," according to the January 15, 1923 *Hollywood Reporter.*

1447–49 Madison Street.

Home of Thomas and Fannie (Frances) McNicol (sometimes spelled McNichol). Fannie McNicol, for whom McNicol Middle School is named, was Hollywood's first junior high school teacher. In 1924–25, she taught in Hollywood's first school building; this was the converted open pavilion that had been the Young Company's first sales pavilion, at 19th Avenue and Harrison Street. Thomas McNicol was postmaster from 1928 to 1929. The 1924 wood frame cottage still stands.

1605–07 Madison Street.

Home of T.N. Tinsley, 1925. 26 san. Still extant.

1608 Madison Street.

Built in 1922 by California architect Homer Messick, as a "double California bungalow." In September 1923, a room in this house became Hollywood's first school,

with Miss Gertrude Brammer teaching six pupils. By fall of 1924, the school had moved to 19th and Harrison Street (see 1447–49 Madison Street) and the house was owned by E.E. Wagner, a salesman for the Young Company who won two Stearns-Knight touring cars. Wagner added the stone wall. 26 san. This landmark house still stands.

1639 Madison Street.
Garfield-Tubbs Apartments, 1924–1925. In 1929 Harry and Beatrice Kaplan, Brown's Department Store manager, lived here. Also living here were Joe T. and Lillian Hall; he would be elected Hollywood's mayor, 1942–43.

1643 Madison Street.
1923. Home of Larry O. and May Casey. An attorney, he was J.W. Young's legal counsel and was on the committee to create a city charter for Hollywood. With T.D. Ellis, Casey wrote the city charter. In 1940, this was the home of Mr. and Mrs. John Rozelle. She taught fourth grade at Hollywood Central School in the 1940s. The house still stands.

1653–57 Madison Street.
Home of C.F. Brodbeck, a vice president of Young's Homeseekers Realty Company, 1925–26. The house still stands.

1652–56 Madison Street.
Vista del Colegio Apartments, 1924–1925. Built in the form of a western adobe ranch. The name means "View of the School," referring to Hollywood Central School. Still extant.

Madison between 17th and 18th Avenues.
Hollywood Central School, begun 1924. See Monroe Street.

1812–18 Madison Street.
June and William Pyne, 1923. William was assistant director of publicity for Hollywood Land and Water Company. June was Hollywood's first policewoman. Gone.

1813 Madison Street.
Home of Marcella and T.D. Dave Ellis from 1927. An attorney, Dave Ellis was co-author of the city charter in 1925. He later served as city attorney for Hollywood and for Dania. The house still stands.

1832 Madison Street.
The 1923 home of C.C. and Sarah Freeman; he was on the city Charter Committee in 1925. Gone.

Madison between 18th and 19th Avenues.

Home of O.E. Behymer, the editor-author of the Young Company's *Hollywood Reporter*, 1925–1926. Exact location uncertain.

1901 Madison Street.

Home of Charles E. and Emma Roden from Toronto, Canada, who are considered to be the first residents to buy a house in Hollywood. Their house was built by the Harry K. Bastian Company from a design by Rubush & Hunter; the Rodens moved in March 1922. Before houses in Hollywood were numbered, some were given names. The Rodens called theirs "Hollywood Villa." Following the 1926 hurricane, notice was given out that all Canadians who were destitute should see Mr. and Mrs. George E. Roden, for the Toronto *Star* was offering relief through the Fort Lauderdale Canadians. This landmark house was torn down in 1964.

2412 Madison Street.

Home of Enart Banks, who owned Hollywood Furniture Company, 1924. House still extant.

2525 Madison Street.

Home of H.C. Hanson, *circa* 1930, called "Tropical Gardens." Hansen was a nurseryman. The cottage originally had a limestone oolite facing and an oolite archway at the entrance. It still exists, somewhat modified.

2626 Madison Street.

Home of Phillip A. Thompson, chief of police in 1947.

2838 Madison Street.

Home of T.W. and Emmie Hunnicutt. He was an ice delivery man. This address was at the far reaches of the Little Ranches in 1929, overlooking the West Marsh.

Mayo Street

In 1940, Mayo Street extended from south 17th Avenue west to the Seaboard Air Line Railway.

6103 Mayo Street.

As part of R.L. Conlon's development in the 1920s, this was Oak Bay Drive. Home still extant.

6131 Mayo Street.

Also part of R.L. Conlon's 1920s development. Home still extant.

McKinley Street

In 1940, McKinley Street extended from beach west to city limits.

McKinley Street and 17th Avenue.

 Home of Tarboux W. Kirkland, poultry farmer, 1924–1925.

Between McKinley and Cleveland just east of 18th Avenue.

 Home of Lulu and Walter W. Altman, 1921 or earlier. Altman was water-pump engineer for the Florida East Coast steam engines, working the pump at about McKinley at the tracks. This may have been the June 21, 1921 birthplace of their grandchild Altman Lee Aderholdt, if daughter Cora Belle and her husband Alvin Lee Aderholt lived with them. Exact sites of house and pump not located.

McKinley Street between 1707 and 1818.

 There is a profusion of houses or cabins indicated in this area on the June 1926 Sanborn map. Probably many were demolished in the September 1926 hurricane.

McKinley and 18th Avenue (then referred to as the East Dixie).

 The Yamato Inn sign reads American-Oriental (perhaps Hollywood's first Asian restaurant?). September 1926 photos suggest it was destroyed in the hurricane. 26 san.

1930 McKinley Street.

 Whitehouse Gardens, 1924–1925. Eight cabins in a U-shape at the back of the lot. 26 san. Gone, perhaps in the 1926 hurricane.

1933–35 McKinley Street.

 Navajo Court, 1924, which had twelve cabins. Gone, perhaps in the 1926 hurricane. 26 san.

McKinley Street between 19th and 20th Avenues.

 "Hollywood Hospital" is indicated on the June 1926 Sanborn map and in the 1926 county directory. The hospital was advertised in the summer of 1926 under Frank Rich, superintendent, and Mrs. T.D. Hague, superintendent of nurses. Nothing more was heard about it after the hurricane, and there is no record that this building was ever used as a hospital. Possibly still extant.

McKinley Street at 19th Avenue, northeast corner.

 The Masonic Lodge was begun in the 1930s and completed after World War II. A two-story center for the Masons, Eastern Star, Rainbow Girls and DeMolay. The

Roe Fulkerson Masonic Lodge has moved to State Road 7, and the building is now a church.

20th Avenue near McKinley.

Frog ponds where frogs were raised for consumption in the 1930s. Not extant.

Meade Street (originally Tuskegee Street)

Meade Street is part of a later addition to Hollywood.

2400 Meade Street.

The Mary M. Bethune Elementary School was named for the founder of the Daytona Normal and Industrial Institute for Negro Girls, later Bethune-Cookman College.

Moffat Street

In 1940, Moffat Street extended from 17th Avenue west to the Seaboard Air Line Railway.

Moffat Street to Washington Street and Dixie Highway.

Hollywood Airport or Hollywood Airpark. A private air field begun July 7, 1941 on unimproved property and promptly renamed MacArthur Field after the attack on Pearl Harbor, Hawaii. Throughout the war, it was one of a tiny number of airfields open to private aircraft. After the war, in 1945, new owners renamed it Hollywood Airpark. It remained active until July 1952 when burgeoning building development around it made it seem hazardous. The owners closed the airfield and subdivided the property, which is now residential.

Monroe Street

In 1940, Monroe Street extended from beach west to city limits.

322 Monroe Street.

Built on the beach in 1926, as Young was building the luxurious Beach Hotel, the U-shaped Southwinds was based on the California-mission design. It later became the Hollywood Beach Apartments. It also faces Madison Street. Still extant.

337 Monroe Street.

Designed by architect D. Anderson Dickey and built in 1936 by Benjamin Kramer, a liquor-store owner from New Jersey. The house, which somewhat resembles a chalet, was carefully restored in the 1990s by Sal Pellettiere and is still extant.

1248 Monroe Street.

Home of racketeer Vincent "Jimmy Blue Eyes" Alo. He came to Florida in 1936 to work with Julian "Potatoes" Kaufman at the Plantation, a well-known betting and gaming parlor in Hallandale. Alo had been a close friend of Meyer Lansky since 1929 when each was in the bootlegging business in New York. Like Lansky, Alo kept his operations in Hollywood, where his family lived, very quiet, although he did own part of the Hollywood Yacht Club on North Lake, another gambling establishment in the 1940s. Alo placed a large A on the street side of his house in the 1940s. The house is still extant, although without the A.

1333 Monroe Street.

Home of Guy and Forest Wachtstetter in 1940. He owned one of the dairies to the west of State Road 7. Earlier the Wachtstetters, lived in and owned the Phyllis Apartments at 1849–53 Dewey Street. Home still extant.

1334 Monroe Street.

The city directory lists a Jack Lonsky here in 1940. This may be Jake Lansky who owned a Harrison Street house after World War II.

1435 Monroe Street.

Home of Earl and Pauline Watkins in 1940.

1505 Monroe Street.

Home of Earl and Pauline Watkins in 1929; then the home of Paul Robinson. The 1925 house originally belonged to William Cozens. The design is the style of a California/Spanish colonial mission. Pauline Watkins taught history and social studies at Hollywood Central School and South Broward High School in the 1940s and 1950s. Watkins School in Pembroke Park was named for this popular Hollywood teacher. Robinson owned both Ritz and Florida Theatres. The house is still extant.

1615 Monroe Street.

Floyd and Jane Bush Wray moved here from Jefferson Street after 1926 with her mother Ida Bush. "Tourists" lived here in 1940. The Wrays came to Hollywood in 1925 and began organizing Flamingo Groves in Davie the following year, with the intention of cultivating the Lue Gim Gong orange, a summer-maturing fruit. The Wrays' partners were Clarence Hammerstein and Frank Stirling. By the 1930s, they were creating a botanical garden of tropical and exotic trees and shrubs on the Everglades hammock Jane Wray had selected. As producers and shippers of citrus fruits with stands on the boulevard and elsewhere in Hollywood, the Wrays were

among those who kept Hollywood alive during the Depression. Their home has been beautifully restored by Ken and Peggi Nelson.

1616 Monroe Street.

Margaret and Merrill H. Nevin moved to from here to Jefferson Street after selling their 1924 house to Dr. James Hartley and his wife Clara. 26 san.. House still extant.

1620 Monroe Street.

Home of Orlando and Flora Forbes, April 1924. Orlando was a field sales manager for the Hollywood Land and Water Company. He is credited with buying the first lot in the future city, at the Indiana State Fair. 26 san. House still extant.

1624 Monroe Street.

Home of Edwin and Edythe Whitson from April 1924. Ed was manger of the official resale department of Hollywood Land and Water Company; Edythe also worked in sales for Young. The Whitsons built the elegant Villa Hermosa and other apartments. 26 san. House still extant.

1616, 1620 and 1624 Monroe Street.

Examples of the owner's preference for a solid California-craftsman-style bungalow, 1924. All are still extant.

1700 Monroe Street.

Hollywood Central School opened in March 1925, an elegant structure built to designs by Rubush & Hunter in the Spanish style, or more accurately, California mission. The first Central School building, enlarged in 1926–27 occupied the city block between Madison and Monroe Streets and 18th and 17th Avenues. The land had been given for this purpose by city founder Young. The yellow-ochre stucco building with red tile roof and tile floors had open porticos on the east and west, and an auditorium that was used for many civic events for several decades. A 1938 city brochure describes the school, then as accredited through Junior High and the tenth grade, as thoroughly modern, with twenty-four classrooms, a large auditorium, a school clinic and an excellent cafeteria serving wholesome warm meals under the management of the Hollywood PTA.

The original building was demolished after a fire.

1701 Monroe Street.

First Baptist Church. The original sanctuary, built in 1925, resembled an early Christian basilica, with an elaborate churrigueresque west portal as the only ornamentation. The original building, which may have been a Rubush & Hunter design, has been changed and expanded.

1841 Monroe Street.

Home of Thomas McCarrell, 1925, builder of the Hollywood Theatre on Hollywood Boulevard. 26 san.

Monroe Street (address unknown).

Spanish-bungalow home of Warren and Wealthy Sammons in November 1922. No address located. By 1925, they had moved to Hollywood Boulevard. Sammons was general sales manager of Hollywood Land and Water Company with J.W. Young.

Monroe Street in Block 80.

Gilmore & Gilmore, contractors from Leesburg, Florida, bought five lots on Monroe in June 1922, where the firm planned to build houses. Addresses not located.

1855–57 Monroe Street.

First Hollywood home of Clyde and Amy Elliott and their daughter Virginia, who would later write the history of Hollywood as Virginia TenEick. The house was built in 1922 in the heart of historic Hollywood; the Elliotts settled there in 1923 after it had been enlarged. As there were no street numbers then, they called their address "Spanish Village." Elliott, probably at J.W. Young's urging, took a number of aerial photos of the city in 1924. In the 1930s, the Elliotts moved to Hollywood Hills, at Fortieth and Circle Drive. Clyde Elliott took part in numerous civic activities. Among them, he was on the committee to create the Hollywood city charter; he was also vice mayor. Vivacious and outgoing, Virginia Elliott entertained at parties by playing the accordion; she was also a hardworking reporter for the *Miami Herald*. This historic house still stands.

1945 and 1949 Monroe Street.

Homes built by contractor E.A. Van Atten in 1923 for Miss Hattie Adler at 1949 in a modified Adobe-mission style and for her brother Phil Adler and his wife Minnie at 1947 in the California-bungalow style. With their sister Victoria Landman, they owned Adler's ladies' wear store at 1914 Hollywood Boulevard. The store opened in 1924. The Adlers may well have been the first Jewish permanent residents of Hollywood. As there was no temple in early Hollywood, Phil Adler continued as a member of the Reformed Jewish Temple of Indianapolis, Indiana. His sisters were founding members of the First Church of Christ, Scientist in Hollywood. These homes, which were pictured in the January 1924 *Hollywood Reporter,* still stand.

1955–57 Monroe Street.

Trianon Hotel, 1924, built for the Whatley sisters from Chicago. The Whatleys would eventually become linked to the Youngs when Marion "Babe" Whatley, daughter of the hotel owner/manager Helen Whatley, married Billy Young in 1937. Still extant.

2409–15 Monroe Street.

Laundries are indicated here on the June 1926 Sanborn map.

2614 Monroe Street.

Miss Elizabeth Dellone lived here in 1940. She moved with her four adopted children to North Lake Drive about 1945. House no longer extant.

New York Street

In 1940, New York Street extended from the Broadwalk west to Ocean Drive.

310 New York Street.

Something of a mystery, this limestone oolite rock house is said to have been built in 1922, but it does not appear on the June 1926 Sanborn map. In 1940, Elizabeth R. Schultz lived there; she was manager of the Cavanaugh Apartments nearby. Legend has it that at one time a bookie owned the New York Street home and had installed dozens of phone lines to take bets. Still extant.

320 New York Street.

The New Yorker Apartments, owned by Richard Gensel in 1940. Classic 1930s Moderne design. Still extant.

North Lake Drive

North Lake Drive is not mentioned in 1940 directory.

815 North North Lake Drive.

Built by William Cozens, 1925–26 and first numbered 815 Lincoln Street. A handsome Spanish-Moorish stucco home with ornamental tiles, arches and fountains, it was built in lonely splendor on the north side of brand-new North Lake. Still very isolated in the 1940s and 1950s, the house was owned by Miss Elizabeth Dellone and her four adopted children who kept a horse there. The children and their friends took turns riding through the Australian pines and mangroves surrounding the house. Except for the Dellone house, the north side of North Lake was undeveloped and uninhabited (by people) through the 1940s. The Camp Fire Girls held a council nearby between North Lake and the canal in the 1940s. After paved North Lake Drive ended, the girls and their dismayed parents had to pick their way over dried mud riddled with land crab holes to sit at the ragged edge of the canal and slap mosquitoes and sand gnats. That was camping out in old Hollywood.

Oregon Street

In 1940, Oregon Street extended from the Broadwalk to Ocean Drive.

316 Oregon Street.

Home of Edwin Rosenthal in 1940. Rosenthal and his brother Albert had purchased the Hollywood Beach Hotel, the Golf and Country Club and the Park View Hotel in the early 1930s. (In 1933, Edwin lived on Harrison Street.) The house, which dates back to the mid-1920s, still stands.

Pembroke Road

This is the south border and dividing line between Hollywood and Hallandale. In 1922, the Young Company rock quarry was off Pembroke Road in the Hills section. Now in Hallandale, it still exists.

West Pembroke Road.

Several dairies were established in the unincorporated land west of State Road 7. Listed in the 1937 directory are: Farway Dairy, J.J. Woitesek and C.D. Rowe, proprietors; Johnson's Dairy, West Pembroke Road, Ray Johnson, proprietor; and Perry Dairy, West Pembroke Road, L. and H. Perry, proprietors.

Pierce Street

In 1940, Pierce Street extended from beach west to city limits.

1805 Pierce Street.

The Catholic Church of the Little Flower, a handsome permanent location for the church, which was begun in 1941. Previously the Catholics had occupied a wood frame structure at 19th Avenue and Van Buren Street. Before that, in 1925, they met in the Hollywood Theatre on Hollywood Boulevard. The original church has been expanded and a school was added.

Pierce Street and 20th Avenue.

Hollywood Land and Water Company power station; became Florida Power & Light Power Station in 1925.

2021 Pierce Street.

Chelsea Apartments, the O'Sullivan rooming house. The twelve-unit building was designed by architect Jack Davidon in spring 1924 for Miss Mary O'Sullivan. The building still stands.

2224 Pierce Street.

Owned by Riley and Nora Walters, who purchased the first lot to be cleared in Little Ranches (Dixie Highway west to 26th Avenue, and Jefferson to Johnson) in 1922. Riley worked for the water company for many years.

2240–46 Pierce Street.

Everglade Court, 1924, a group of cabins that continued up to Lincoln Street. 26 san. Not extant.

2314 Pierce Street.

Victor Court, 1924, a group of cabins. 26 san. Not extant.

2416 Pierce Street.

Cement block manufacturing. 26 san. Not extant.

2501 Pierce Street.

Advertised in the February 18, 1949 *Sun-Tattler* following the widespread floods of 1947: "House for sale, high and dry, no land crabs."

2600–06 Pierce Street.

Choctaw Court, twenty-one houses, reaching to Fillmore Street; Pine Crest, eight houses or cabins. Not extant. 26 san.

Plunkett Street

In 1940, Plunkett Street extended from 14th Avenue west to the Seaboard Air Line Railway.

2700 Plunkett Street.

Home of Mattie and George M. Beerbower, built in 1925 in what was then vast empty hinterlands. This handsome, well-constructed bungalow still stands.

2701 Plunkett Street.

Colbert Elementary School, begun in 1949. Colbert was the second elementary school built in Hollywood, nearly twenty-five years after the first, Hollywood Central. The need for a new school reflected the growing postwar baby boom. The new school was named for Paul F. Colbert, a highly respected former principal of Hollywood Central School, who later became assistant and then associate superintendent of Broward County schools.

Polk Street

In 1940, Polk Street extended from beach west to city limits.

201 Polk Street.

Surf Hotel, 1930s. Ella Jo Stollberg, later Wilcox, Hollywood's first female attorney, lived there in 1940. Hotel no longer extant.

STREET GUIDE

320 Polk Street.

Built for Dr. Arthur Blanchard Connor and his first wife Lillian in 1933. Dr. Connor was an eye-ear-nose-throat specialist who served in France in World War I. In 1925, he signed up for one of J.W. Young's ten-day, all-expense excursions from Chicago, Illinois, to Hollywood, which Connor said became a $40,000 vacation (reflecting on the properties he had bought since). He and Mrs. Connor returned in 1926 and again in 1928. The Connors also owned the Ocean View Apartments (formerly Murrelle in 1928). In 1929, they bought the Mayrose Apartments and the Boulevard Apartments in 1931. Both apartments are now gone. During World War II, Dr. Connor was called to Jackson Memorial Hospital to perform surgery to reconstruct faces of men who were burned when the Germans attacked shipping in the Gulf Stream just offshore. Dr. Connor received a presidential commendation from President Franklin D. Roosevelt for this work. This stunning house of tropical-modern design may be considered a landmark in relation to its first owner, who said during the worst of the Depression that he "never lost faith in this part of Florida."

700 Polk Street.

Hollywood Yacht Basin in North Lake. One of J.W. Young's many planned amenities for Hollywood, it was finally developed in 1952-1953, although never to the extent that Young had hoped. North Lake is simply too shallow for later-twentieth-century yachts. According to Jimmy Alo, the Hollywood Yacht Club was one of the meeting places of organized illegal gaming in the 1950s.

1329 Polk Street.

Home of Mr. and Mrs. Roger Barthlemy (the home is sometimes listed as 1401 Polk, which would be in the golf course). This stunning two-story, streamline Modern design, *circa* 1936, almost has a European 1930s look. The architect has not been identified. Barthlemy, who was French, joined the Free French movement in England at the beginning of World War II and remained there, working with Charles de Gaulle throughout the war. House still extant.

1442 Polk Street.

A wonderful example of international art Moderne at its most cubic, the house was designed by Bayard Lukens in 1939. In 1940, it was occupied by Samuel Flash. During World War II, it was owned by Major Herbert Bayette (later a general) who served with Dwight D. Eisenhower and was a personal friend. Mamie Eisenhower stayed here for a time during the war. The present owners have the original blueprints for the house, which is still extant.

1520 Polk Street.

Designed by Bayard Lukens in 1935 for Vera and Clarence Hammerstein. This is a fine example of Lukens's Florida look, with variegated tile roof and a smooth curving wall at the front entrance. White stucco walls were set off by horizontal trim in another color. His interiors are beautifully detailed, with moldings, trim over and around doors, and fireplaces with heatolators (vents with decorative metal screens along the sides of the fireplace), and use of decorative Cuban and Spanish tiles. The Hammersteins, who had been living in Miami, moved to Hollywood in 1928 where they lived at 813 Tyler Street with her parents, Mr. and Mrs. Jacob Rust. Next they moved to 1536–38 Polk Street and, during the Depression when lots were auctioned off for tax certificates, the couple acquired eleven lots on Polk Street, including the three lots on which they built. With the Floyd Wrays and Frank Stirling, the Hammersteins founded Flamingo Groves in Davie in January 1927; Ham Hammerstein was vice president of marketing. From the 1930s to the 1950s, Ham and Vera traveled throughout the world seeking exotic plants; Ham made a special study of mango culture. At his death Ham left this house to the City of Hollywood in memory of his wife Vera. Ham made his decision after having seen the Taj Mahal, which an Indian shah had built for his wife. The house is cared for by the Hollywood Historical Society and is **open to the public one Sunday each month (except during the summer). Call the Historical Society for specifics, 954.923.5590.**

1538 Polk Street.

Dentist Byron Pell and wife Mildred lived here in 1926 before moving to Van Buren Street (see Van Buren Street). John and Lucile McDonough lived here in the 1930s before moving to Funston Street. John was an executive with Florida Power & Light. While living on Polk Street, his daughters had a pet owl. 26 san. Still extant.

1556 Polk Street.

Virginia Lee Apartments, 1922. Still extant.

1628 Polk Street.

Home of William L. Adams, chief of police then Hollywood's sixth and eighth mayor, 1931–33 and 1934–35. Adams came to Hollywood in 1921 and joined J.W. Young's enterprises. From Pennsylvania, Adams had a degree from Boston College. After graduating, he joined the army and took part in the Spanish-American War, the Boxer campaign and World War I. In 1911, he wrote a book, *Exploits of a Soldier Abroad and Afloat*, for which he received personal commendation from President Theodore Roosevelt. Before World War I, he served in the Pennsylvania legislature. Following the war, he came to Florida.

Street Guide

Polk and 17th Avenue.

Hollywood Golf and Country Club. At the end of 1922, J.W. Young opened the first nine holes of his golf course on land that he bought from the former mayor of Dania, John Mullikin. Some forty acres had previously been planted to tomatoes. The golf course was designed by a friend of J.W. Young—Ralph Young from Indianapolis, Indiana—and laid out and landscaped by Charles Olsen, a horticulturist from Rochester, New York. A year later, the course was expanded to eighteen holes. J.W. Young hired the Miami architect who had just designed a country club for George Merrick, Martin L. Hampton, to design his country club. Hampton's design for the Hollywood Golf and Country Club appeared in several pages of the November 1923 *Hollywood Reporter*. Sited at the northeast corner of Seventeenth Avenue and Polk Street, it had a slightly off-center tower at the entrance and two wings set at an angle on either side of an open patio. The long east side closing the triangle faced the links. The central patio sported the renowned glass-brick dance floor set over multicolored lights. All the rooms, the lounge, the men's and ladies' locker rooms as well as the dining room were Spanish baronial in décor, with wood beams and oriental carpets. The men's area even had a "soda fountain" (this was Prohibition). The December 1923 *Reporter* has a photo of the country club nearing completion under contractor Olaf Owra. This splendid building was subjected to a garish neon sign when, from 1929 to 1931, it was leased to Al Capone, who used it as a gambling casino. Then in 1943, the navy leased the Hollywood Beach Hotel, which included the country club. This beautiful, historic building was torn down and replaced by an empty corner of the golf course.

1656 Polk Street.

Flora Apartment Hotel. J.S. Matson commissioned architect Martin L. Hampton to design the Flora directly opposite the country club. It opened in May 1924 and is still in operation.

Between Polk and Taylor Streets on 18th Avenue.

The first water plant in Hollywood was here, completed February 1922. Eighteenth Avenue was not a major road at that time. Not extant.

A park behind the waterworks is mentioned 1925 city advertising brochures. Not extant.

1824 Polk Street.

Hollywood Public Library, which had been operating in makeshift quarters, was given a beautiful building, designed in a gracious classical style. All white, with a modernized classical pediment over the entrance and two pilasters at either side, it was completed in 1942. Not extant.

1845 Polk Street.

Shuffleboard courts, established here on city property in 1939 as another means to attract tourists, still the city's chief source of income. These were more elaborate than those at the beach (at Garfield Street), and the Shuffleboard Club was very active here for years. Not extant.

1855 Polk Street.

The Rec. Originally this was Firemen's Community Hall, built in the 1930s. During World War II, it served as the Victory Canning Center and other war effort purposes. In 1944, the city created a recreation center for local teenagers; named The Rec, it began in the Great Southern Hotel dining room while Firemen's Hall was being adapted. For the rest of the 1940s and the 1950s, high-school students had a club of their own, with tables and chairs, ping-pong tables, a dance floor, a juke box and a soft-drink machine. It was open afternoons and weekend evenings, with a manager-hostess at the door. While white kids of all social levels were welcome, unfortunately because of state segregation laws, black children were unable to join them. The building was a simple, white one-story structure resembling a dance hall, which it was. No longer extant.

1901 Polk Street.

Site of Hollywood's first fire station, built in 1923. It was replaced in the 1930s by a much larger station.

2001 Polk Street.

Originally Office Help Apartments built by J.W. Young as a dormitory in September 1925, designed by Rubush & Hunter. Shortly this became the Casa Blanca Hotel for paying visitors to the city. Still extant.

2028 Polk Street.

Jewish Community Center, 1940s. Religious services were held here in Temple Sinai before the temple at Eighteenth Avenue and Van Buren Street was built in 1952.

Polk Street and original Dixie Highway.

A cul-de-sac called Hollywood Place is indicated opposite the splendid railroad station, with a garage for 120 cars, a dry cleaner and the Hotel Dixie. 26 san. None of these exist, or are even remembered, today.

2115 and 2131 Polk Street.

Home of Bennett L. and Mildred David, substantial CBS buildings where they would raise eight children, several of whom became prominent in the city. In May

1953, Jessie Faye Young and Mildred David were honored as Pioneer Mothers by the Apartment & Hotel Association. Mildred David was mother of speaker-designate of the State House of Representatives, Ted David, and current City Commissioner B.L. David Jr. Her other six children were Sam, Bob, Claude, Bill, Shirley and Sarah. She and her husband had come from Georgia in the early 1920s. B.L., as he was known, was also a city commissioner, vice mayor in 1934 and postmaster from 1939 to 1941. He had owned and operated David's Place on Hollywood Boulevard (after his death, it was sold to Albert and Roger Peterson, who retained the name). The houses still stand, though obscured by commercial buildings. 26 san.

2200 Polk Street.
Home of John and Jennie Duell by 1929. In the 1930s, John rolled his manual lawn mower down to Young Circle and mowed it by hand for the city. Not extant.

2201–07 Polk Street.
Fitzgerald Court. Established in 1924 by R.M. Ducharme and consisting of six small frame houses, then purchased by Catherine Fitzgerald, another Whatley sister. Two of the houses, now in rather poor condition, still stand. 26 san.

2216–22 Polk Street.
Home and store of Caesar D'Isepo from the late 1920s. A jeweler, D'Isepo had Bayard Lukens design his home in the mid-1930s. The store is gone; the house may remain but has been altered. 26 san.

2246 Polk Street.
Home of John and Udita Bagatti by 1929. This frame cottage still stands. 26 san.

2300–06 Polk Street.
Pennsylvania Court. Owned and operated by Mr. and Mrs. George Hambrecht, from the 1930s. The Hambrechts lived in the two-story stucco house on the west side of the entrance; the other frame rental houses still stand and are occupied.

2301–07 Polk Street.
Land purchased by A.C. Tony Mickelson in August 1922, after his survey team cleared it. That winter, he built a frame cottage on the northwest corner. The cottage was blown off its foundation in the 1926 hurricane, killing one occupant (Tony was elsewhere). After he married Lamora Gleason in 1927, they moved to Old Forge, New York, where Tony continued to work for J.W. Young, surveying lots for Hollywood-in-the-Hills. After Young's death, the couple returned to Hollywood, and in 1935 built a frame Cape Cod cottage on the southeast corner of the acre. Lamora's parents, Evelyn

and Dexter Gleason, followed shortly and built a similar house on the northeast corner. In 1938 with land to spare, they built a three-sided row of classrooms on the west half of the lot and named it the Outdoor School. Tony worked in the engineering department of the city, while Lamora developed the school, of which she was headmistress. Hers was the only accredited private school in Hollywood and taught hundreds of local and visiting children; at its peak, the school had one hundred pupils and ten teachers annually. Fondly remembered by many was the first-grade teacher, Evelyn Gleason, whose daughter had pressed her into service. Parents begged her to stay on until she could teach their baby in first grade. She finally retired at age eighty. Tony served as Hollywood city manager from 1947 to 1949, in time to deal with mopping up the city after two wet hurricanes. When he and Lamora were ready to retire, Tony sold the property to the Giacin family, who built the pleasant apartment building there today. The two enormous sapodilla trees were planted by Tony in the 1940s.

2323 Polk Street.

Home of Captain William and Ida Swabey, built about 1925. Bill was a World War I army veteran, given to blowing taps on his bugle. The Swabeys raised chickens throughout World War II. It was a treat for the little girl next door, who happens to be the author, to collect the eggs. The oolite limestone house still stands. 26 san.

2326 Polk Street.

Home of Earl and Fern Groff in 1925. Earl was a steam-shovel operator. Not extant.

2720 Polk Street.

Home of Frederik and Bonnie Watts in 1929. House still extant.

Port Everglades

At the end of 1924, J.W. Young took another momentous step, possibly even more far-reaching than creating a city. In the name of Hollywood Harbor Development Company, he purchased 1,440 acres from John F. Warwick around Lake Mabel (or Bay Mabel). The land included submerged and mangrove-covered land, north of Dania and south of Fort Lauderdale. Here Young envisioned a deep-water harbor that would serve U.S. cities along the Atlantic coast, with shipping eventually reaching down to South America. The mangrove thickets along Lake Mabel's swampy shore were cleared in only one month by thirty-five French Canadian lumberjacks, hired by company engineer John Gleason, whose Vermont family had been logging for two centuries. When the job was done, most of the men returned home.

Young's Tropical Dredging & Construction Company began operations at Lake Mabel by May 1925. Young, ever the promoter, had hired General George W. Goethals

as consulting engineer following his world-renowned construction of the Panama Canal that was completed in 1914. However, the general did not suit, and in November, Young brought an old acquaintance from Long Beach, California, Colonel Charles H. Windham, to oversee the development of Port Everglades Harbor. Windham, then city manager of Long Beach, had been the visionary behind the development of the harbor of that city. Working closely with him was Frank Dickey. Port Everglades opened February 22, 1928. Costs of development were shared between Hollywood and Fort Lauderdale; the two cities still share the port. In 1930, the federal government took over operations at Port Everglades with its single slip. Today it is a major port serving cargo and cruise lines, just as Young had envisioned.

Raleigh Street

In 1940, Raleigh Street extended from 22nd Avenue west to the city limits.

2210 Raleigh Street.
Home of Solomon T. Harrison in 1940.

2217 Raleigh Street.
Home of George Maddox in 1940.

2220 Raleigh Street.
Home of Henry Matthews in 1940.

2234 Raleigh Street.
Home of Turner Evans in 1940.

2245 Raleigh Street.
Mount Pleasant Methodist Church, 1930s.

2317 Raleigh Street.
Home of Clarence Clayton in 1940.

2318 Raleigh Street.
Home of William Knowles in 1940.

2327 Raleigh Street.
AME Church, 1940.

2335 Raleigh Street.
Home of Lawrence Mann in 1940.

Rodman Street

In 1940, Rodman Street extended from 14th Avenue west to the Seaboard Air Line Railway.

1733 Rodman Street.

Home of Olaf Owra in 1941. Owra, a contractor, built the Hollywood Golf and Country Club, the foundation for the Hollywood Beach Hotel, Young's home at 1055 Hollywood Boulevard, the 1927 City Hall building and numerous other buildings. Born in Norway, Owra came to Hollywood in the early 1920s.

1820 Rodman Street.

Home of Charlotte and Arthur Kellner. Dr. Kellner came to Hollywood in 1925 and established his dental practice, then brought his bride Charlotte. His dental office was in the Central Arcade. He was active in almost every phase of public life in Hollywood and served for many years on the Florida State Dental Board. He was elected mayor of Hollywood during the Depression, 1935–1938, and helped to guide the city out of its worst years. After decades of public service, he received the Chamber of Commerce Community Service Award. Charlotte Kellner was a talented artist. Their home is no longer extant.

1845 Rodman Street.
Home of Olaf Owra before 1940. See 1733 Rodman Street.
1921 Rodman Street.
Home of Dr. and Mrs. Kellner in 1934. See 1820 Rodman Street.

Roosevelt Street

In 1940, Roosevelt Street extended from the beach west to the city limits.

1721 Roosevelt Street.
Home of Carlton Montayne in the 1940s. He wrote for the *Hollywood Tattler.*

1731–37 Roosevelt Street.

Home of Valentine Martin in the 1930s. Martin worked for a number of newspapers, beginning with the *Hollywood News* in 1929 and working up to chief of the South Broward bureau of the *Fort Lauderdale News.* In 1935, he and his family moved to Garfield Street on the beach. Both houses are still extant.

Scott Street

In 1940, Scott Street extended from the beach west to the city limits.

1819 Scott Street.
Coral rock (native oolite), mission-style bungalow, 1920s. Still extant.

Sheridan Street
In 1940, Sheridan Street extended from the beach west to the city limits, and was the city's north border for much of its length until the 1950s.

Sheridan Street and Ocean Drive, approximately.
Duck Lake. A small natural lake in the area east of Ocean Drive and north of Sheridan Street, where J.W. Young planned to build an imposing home. Architects drew plans for it on an entire block to be built on the beach. Instead Young began his home at 1055 Hollywood Boulevard in 1925. This was a fortunate decision, for Duck Lake "blew away" in the 1926 hurricane, which completely filled it with sand. North Beach Park now covers the site of Duck Lake.

Sheridan Street and the Intracoastal Waterway.
Sheridan Street Bridge. Dedicated July 4, 1962, this is Hollywood's second bridge to the beach island.

751 and 1200 Sheridan Street.
West Lake Park. An astonishing 1,500 acres of coastal wetlands, mangrove forest and a natural lake all once owned by J.W. Young, who bought the land around West Lake as he was buying land around Dania and up to his holdings at Lake Mabel (now Port Everglades). On maps, the shores of this natural lake were platted, but not developed by Hollywood Land and Water Company. By 1930, the area had been acquired by Hollywood, Inc., but the company did not make any effort to develop it before 1960. By the 1970s, ecologists realized that this unique area of untouched coastal property in South Florida was akin to a national treasure. Within its boundaries are approximately 123 bird species, including 20 that are rare or endangered; 10 animal species; 80 forms of plant life; and 86 species of fish. Many of the fish start their lives in West Lake mangroves before swimming out into the Atlantic. Nevertheless, the owners had every right to develop and build on the property. But activists in the 1970s spoke out. Friends of West Lake was formed; its members were joined by community leaders; environmentalists; naturalists, including Marjorie Stoneman Douglas; and determined legislators from the City of Hollywood and Broward County in the effort to purchase and preserve this property. By 1985, a total of $20 million had been raised and the property was purchased from Hollywood, Inc., and became a Broward County park. Within the park is the Anne Kolb Nature Center Complex with a visitors center, exhibit hall and lecture hall. It was named

for Broward County Commissioner Kolb (1932–1981), a former journalist, who was instrumental in the creation of West Lake Park.

Sheridan Street and 18th Avenue.
Early settlers living in the future Hollywood in 1920 were the Ben Jones family and the Ed Hensen family, both in the undeveloped area that would become Sheridan Street and 18th Avenue. Exact locations unknown.

Sheridan Street at 18th Avenue.
Greenwood Inn. Located on the 1926 Sanborn map. Possibly in Dania originally. Not extant.

2044 Sheridan Street.
First headquarters of J.W. Young's Hollywood Land and Water Company, purchased as a log cabin from Stephen Alsobrook. The Young Company added rooms, wings and gables, and then painted the building red in 1921, so it was called "The Red House" and "The House of Seven Gables." Young Company sales and engineering departments began work here. Several members of the survey crew lived here at first, when there weren't any other buildings in the undeveloped city, as did Ward Keller, carpenter, and Charles "Dad" June, who managed the house. The house was sold to Mr. and Mrs. George Storer in November 1923 and given the Sheridan address. It was torn down in the fall of 1964 to widen the road.

Sheridan Street at Park Road.
Topeekeegee Yugnee Park or T-Y Park. Dedicated in 1971. Sheridan Street had previously stopped at about 29th Avenue. See Park Road.

Simms Street (originally Chicago Street)
In 1940, Simms Street extended from North 22nd Avenue west to city limits.

2217 Simms Street.
Home of Joseph Evans in 1940.

2218 Simms Street.
Home of Ezekiel Edwards in 1940.

2228 Simms Street.
Home of Ernest Saunders in 1940. This California-bungalow-style, single-story building was also the Free House of Prayer & Faith. Still extant.

2241 Simms Street.
Home of Thomas Sawyer in 1940.

2242 Simms Street.
Home of Jesse Jackson in 1940.

2302 Simms Street.
Home of Samuel C. Rolle in 1940.

South Lake Drive
South Lake Drive is not listed in 1940 directory.

903 North South Lake Drive.
Loch Laury, home of Dr. and Mrs. Elbert McLaury. Extant.

1001 South South Lake Drive.
Home of Raymond E. and Billie Dilg, 1950s. Ray Dilg, originally from Connecticut, made his way to Miami before 1920 and worked for Carl Fisher. Dilg then went into banking; he joined the First Hollywood Bank in 1931 and was named president in 1934. As early as 1934, he was speaking out for conservation of the Everglades. The house was designed and built about 1950.

Stirling Road
Stirling Road was not part of Hollywood before 1953.

Stirling Road at State Road 7.
Bordered on both sides by the Seminole reservation, which began in March 1924 as the Dania Reservation.

Stirling Road.
Palumbo's Golf Course opened in May 1953 exclusively for Negroes.

5400 Stirling Road.
Hollywood Hills High School. A member of the first graduating class in 1960 was Bonnie Wilpon, who was named the first "Top Teen." In 1999, she published *The Postcard History of Hollywood Florida.*

Taft Street
In 1940, Taft Street extended from beach west to city limits.

1940 Taft Street.

Home of bridge tender Julian Eddy and wife Ada in 1926. The bridge over the canal at Hollywood Boulevard had just been completed in 1925. House not extant.

2637 Taft Street.

Home of Frank Carbo, who made the Florida sheriff's list of the one hundred top gangsters in Florida in 1959.

Taft Street at 36th Avenue.

Hollywood Hills School on Longfellow Circle, designed by architect Thomas D. McLaughlin, plans dated February 2, 1926. It was completed in October 1926 for children of Hills residents, who did not materialize as homebuyers retreated after the September 1926 hurricane. The handsome building stood empty for a time. When Riverside Military Academy took over the Hollywood Hills Hotel in 1931, the academy also rented the Hills school as extra classrooms. During World War II, men and women on the home front became plane spotters stationed in high places. This included the open towers of Hollywood Hills School, previously inhabited by bats and owls. Spotters spent the night watching the skies and reporting anything at all to the coast guard. Following World War II, with the growth of the dairy industry to the west, there were enough children living in the area to reopen Hollywood Hills School. In spite of protests from many Hollywood residents, the building was demolished December 26, 1974.

Taylor Street
In 1940, Taylor Street extended from beach west to city limits.

Between Taylor and Polk on 18th Avenue.

Young Company water plant completed February 1922. Clarence Moody was superintendent.

1949 Taylor Street.

Home of Clarence Moody in 1924. A native Floridian, Moody was an engineer with the Miami Electric Light and Power Company in 1922 when J.W. Young asked him to come to Hollywood to develop Young's electric plant and water systems. He wrote that "J.W. with his big eyes and supersalesmanship had me with his company in about ten minutes." In 1925, when Young wanted to upgrade Hollywood's telephone service, Moody purchased the Broward Utilities Corporation, built the telephone building two blocks north of Circle Park and created the entire phone system. He organized the Hollywood Fire Department and worked closely with those developing Port Everglades. When the Young organization disintegrated in the later 1920s, Moody went into the dredging business. He was elected fourth mayor of Hollywood for the

1928–1929 term. Moody's wife, Lily Osment, came to Miami from Cuba in 1916 to go to school. She may well have been Hollywood's first Cuban resident. In September 1926, Clarence Moody and Tony Mickelson, both navy veterans of World War I, with John Gleason and Bill Osment tried to weather the hurricane in Moody's house, only to watch all but the southeast bedroom wall disintegrate. The men survived, but the house did not.

2233–39 Taylor Street.
Laura Place, a north–south street, was lined with identical cottages. 26 san. No longer extant.

2308 Taylor Street.
Peerless Laundry is indicated here on the June 1926 Sanborn map.

Taylor to Van Buren Streets, along 23rd Avenue.
Groves of avocadoes and mangos grew here when J.W. Young purchased the land in 1920.

2404–10 Taylor Street.
Dunham's Grocery, built in 1925, has been in continuous operation ever since. 26 san.

2432 Taylor Street.
LaBelle Villas, home of Katherine and Leo LaBelle who built the villas in 1937-1938. They were designed by Lee LaBelle's father Edward, an architect. Soon after moving to Hollywood from Chicago, Illinois, Katherine became the first-grade teacher for the Outdoor School. Later Mrs. LaBelle entered the public school system, teaching math at Hollywood Central School and eventually becoming principal of Nova Elementary when it was established in the 1960s. The Villas are still in operation.

2460 Taylor Street.
Home of Charles Barney and Annie Smith in 1929. Described as a "hauling contractor" in the 1929 directory, C.B. was best known for moving houses from one part of Hollywood to another in the 1930s. So many houses were empty then, people would buy a lot in the neighborhood they preferred, then have C.B. bring them one of the sturdy 1920s houses.

2847 Taylor Street.
Home of E.M. Gertz, poultry raiser, in 1929. Taylor Street dead-ended here, as did all the other streets between Hollywood Boulevard and Johnson Street, as this

was where West Marsh began. House no longer extant; site now occupied by the Moose Lodge.

Tyler Street

In 1940, Tyler Street extended from beach west to Florida East Coast Rail Road tracks and 21st Avenue.

319 Tyler Street.

Ocean Spray Apartments, 1930s. An exceptional example of the streamline Moderne vocabulary with its cubic form and strong horizontal and vertical lines of trim. The architect is yet to be identified. Still extant.

Tyler Street, from 17th Avenue east.

The Meyer-Kiser Corporation began building homes on Tyler at Seventeenth in September 1924 and working east. By 1925, the Lakes section was sufficiently drained and lots had begun to appear east of 14th Avenue; the Meyer-Kiser Corporation opened offices at 14th Avenue and Hollywood Boulevard in 1925. Meyer-Kiser had commissioned Rubush & Hunter to design a variety of prestigious homes for properties there. The architects provided about twenty designs in tile, stucco and cast stone, often asymmetrical with a tower at one side and with moon gates, triple Palladian windows, balconies and urns. George E.T. Wells and G. Lloyd Preacher & Co. of 124 East Flagler Street in Miami were associate architects for these Lakes houses. S.H. Kiser had an address at Forrest Street near 18th Avenue.

711 Tyler Street.

Home of Benjamin Eisen by 1940. The house probably dates to 1925 or 1926. At one time, Eisen was a financial officer for Gulfstream race track.

740 Tyler Street.

Home of Benjamin Kaufman by 1940.

813–17 Tyler Street.

Fountain Court Apartments. First home of Clarence and Vera Hammerstein when they moved from Miami with her parents Jacob and Mary Rust in 1928.

1011 Tyler Street.

Address listed by the Florida sheriffs for Charles Frederick Teemer, who was considered to be one of the one hundred top gangsters in Florida in 1959.

STREET GUIDE

1025 Tyler Street.

Home of stone contractor Eric Skoglund, 1925–1926. During the hurricane of 1926, a barge from the Inland Waterway was carried inland by the tidal surge until it lodged against this house. Not extant.

1227 Tyler Street.

Home of James and June Breeding by 1929. Trained as a pharmacist, James owned Breeding's Drug Stores; his first store in 1925 was in the Curtis Building, which was severely damaged in the 1926 hurricane. Breeding's remained in business at several locations throughout the twentieth century.

1240 Tyler Street.

Home of Edward C. Zimmerman by 1940. An unusual pueblo-adobe-style home, distinguished by the flat roof of the forward block of the house with the protruding ends of the roof beams. Still extant.

1300 Tyler Street.

Home of Benjamine Adler in 1924-1925. Relda Apartments. Also listed as the headquarters of Adler Construction Company owned by Sol Adler. With its corner towers, the building is similar in design to the Great Southern Hotel, but it is not known to have been designed by Martin Hampton. Still extant and well-kept.

1321 Tyler Street.

Home of F.W. Thompson of New York, who designed his home himself and had it built by contractor Peter Brunner in 1933. The home was designed to resemble the California-Mexican adobe ranch described in *Ramona,* a late-nineteenth-century novel of life there that was notable for the author's sympathetic view of Native Americans. Thompson drew his plans from memory of a house in San Diego, California, reputed to be where Ramona was married. The house is U-shaped around an open courtyard and cost an initial $13,000. In the later 1930s, Julian "Potatoes" Kaufman lived here; he owned and operated the Plantation, a busy gambling establishment on Hallandale Boulevard. The house is beautifully maintained.

1421 Tyler Street.

Home of Ollie and Edith Gore, 1926. Ollie was marketing and business manager for Young Company publications in the mid-1920s. This house still stands.

1455 Tyler Street.

Home of Mr. and Mrs. Dave Stine, designed by architect Cedric Start, 1940, as a variation on the international Moderne vocabulary of that period with its balanced geometric forms and spare linear trim. Zinkil Roofing Company carried

out the rounded turret tiled roof. The Stines owned Lillian's dress shop on Hollywood Boulevard. Still beautifully maintained.

1500 Tyler Street.

Home of H. Emerson and Alice Evans. Emerson was general manager of sales, northern division, for Hollywood Land and Water Company in 1924 and 1925. Young required his top salesmen to build showplace homes in the city they were promoting. Evans did his bit—this house was said to have cost $80,000 to build in 1925. It is probably a Rubush & Hunter design, carried out by the Meyer-Kiser Corporation. Still extant.

1525 Tyler Street.

Home of Roe and Ann Fulkerson. The home was designed by Bayard Lukens in his personal style he called tropical modern and built in 1935. Both Fulkersons were well-liked civic and social figures in Hollywood in the 1930s and 1940s. An optometrist, Roe was a leader in Kiwanis and founder of *Kiwanis, International* magazine. In 1935, he was elected to the Florida House of Representatives and in the 1940s to the Hollywood City Commission. Anne, distinguished by wearing her thick blond hair in a crown of braids across her head, was a leader in war work in the 1940s. The house is still extant.

Tyler Street and Hollywood Boulevard, at 16th Avenue.

During the hurricane of 1926, the Johnson Street barge bridge was carried from the Inland Waterway by the tidal surge until it lodged against buildings in this area. This was the barge that carried "passengers," including city attorney T.D. Ellis, as they escaped the storm and floods.

1739 Tyler Street on the Circle.

Mailloux filling station, 1930s and 1940s. Not extant.

Tyler Street at 18th Avenue, the Circle.

Moy's Chinese Restaurant on the Circle, 1935. This distinctive restaurant with its sculpture of Buddha at the entrance was demolished in 2004 for high-rise condominiums.

Tyler Street at 19th Avenue.

City Fire Hall in the 1924 directory.

1928 Tyler Street.

Office of Claus Moberg, distinguished midcentury architect.

Tyler Street and 20th Avenue, southeast corner.

Tyler Building. The Masons and Eastern Star had a lodge on the second floor of the Tyler Building in 1925. The groups began their own building at Nineteenth Avenue and McKinley Street in the late 1930s.

Tyler Street and 20th Avenue, southwest corner.

Florida Building in 1925. Not extant.

2004 Tyler Street.

The *Hollywood Herald* building, by 1940.

2024 Tyler Street.

Sun-Tattler Printing Company by 1940. Building designed by architect Cedric Start. Not extant.

Van Buren Street

In 1940, Van Buren Street extended from the beach to city limit.

By the end of 1922, J.W. Young's paper the *Hollywood Reporter* was pleased to note the building boom was going strong in the central section, with many Spanish- and Florida-style homes, from Washington to Van Buren, and Pierce to Lincoln Streets.

300 Van Buren Street.

Flamingo Court, a 1930s Florida Moderne classic. Still extant and painted flamingo pink.

1211–23 Van Buren Street.

Home of Theodore Raper from the 1930s. Raper was mayor of Hollywood when the nation entered World War II. He immediately enlisted. House still extant.

1620 Van Buren Street.

Home of Dr. Byron and Mildred Pell. The sociable and civic-minded Pells came to Hollywood in 1925, living first on Polk Street before moving to this 1924 California-bungalow-style home in 1935. A dentist, Dr. Pell had his office first in the Hollywood Bank building, then in the Hollywood Clinic on 17th Avenue. He was active in various civic organizations and served as president for some, including the Chamber of Commerce. In 1935, Pell was on the committee that founded the Fiesta Tropicale. The house is still extant. 26 san.

1621 Van Buren Street.

John Herchick, living in an apartment here, had not paid attention when the city cracked down on bookies and, in April 1953, was on trial for illegal bookmaking. Eby Apartments on the 1926 Sanborn map. Still extant.

1727 Van Buren Street.

The 1933 home of R.B. Walker, a highly successful insurance agent and one of those on the Golf Commission in 1934 who put up some of their own money and raised more to help the struggling city build the Municipal Golf Course (now the Orange Brook Golf Course) to attract more visitors. The 1920s house is still extant. 26 san.

1804 Van Buren Street.

First Methodist Church, under construction by March 1924, was a "$30,000 church" from designs by Rubush & Hunter. The original building, which was the first church built in Hollywood, was severely damaged in the 1926 hurricane, partly torn down and rebuilt by 1927. Still extant.

Van Buren Street and 18ᵗʰ Avenue.

The first Jewish house of worship was Temple Beth Sholem, built in 1951-1952. Previously the congregation had met in the Jewish Community Center on Polk Street. There were three hundred at the first seder held there in April 1953. The building no longer exists; the congregations have grown and moved elsewhere.

Van Buren Street and 19ᵗʰ Avenue.

Hollywood Hospital. In 1937, this new hospital was opened, the first hospital in Hollywood since 1929. Still in operation, greatly expanded.

1912 Van Buren Street.

Home of George and Susan Young in 1922, according to the November 1922 *Hollywood Reporter.* George also built Young Apartments, which are said to have been the first apartments in Hollywood (they were destroyed in the 1926 hurricane). No relation to the city founder, George served on the Hollywood Charter Committee in 1924. House no longer extant. 26 san.

1921 Van Buren Street.

Clarence and Lily Moody, having lost their Polk Street house in the 1926 hurricane, moved to this house. After serving the city in several capacities, Moody was elected mayor of Hollywood for 1928–29. House no longer extant.

1929 Van Buren Street.

California-bungalow-style house, selected by D.C. and Florence Nevin for their home in 1922 and beautifully landscaped. The genial Nevin was one of Hollywood Land and Water Company's persuasive lecturers, extolling the virtues of the future city from the several sales pavilions when they were surrounded by bare ground. His comfortable home is the California-craftsman-type bungalow, another architectural style developed in California. 26 san. Not extant.

1937 Van Buren Street.

Home of Charles LaFavre from 1938. He was assistant postmaster. During World War II, he served in the civilian defense organization as a plane spotter. His post was the tower of the Hollywood Beach Hotel, the highest point around. His son Robert, who sometimes joined his father on watch, revisited the tower in 2005—it is now a four-story penthouse. Their own house is now a parking lot.

Van Buren Street at 20th Avenue.

The Catholics established their first Church of the Little Flower in a frame structure here in 1926. Before, they had met in the Hollywood Theatre on Hollywood Boulevard. The congregation later moved to Pierce Street, where building began in 1941. Van Buren and 20th building no longer extant.

2036 Van Buren Street.

Built in August 1924 by the Young Company as a dormitory for the Beach Hotel help, the site's three stories with fifty rooms became the Whitehall Hotel. Still extant. 26 san.

Dixie Highway at Van Buren Street.

Among those mentioned in the December 1923 *Hollywood Reporter* were W. Ward Kington and his wife Minnie who were building a two-story, concrete showplace costing $10,000. See Dixie Highway.

2317–23 Van Buren Street.

Crossley Court, thirteen buildings. Shown on the 1926 Sanborn map.

2700 Van Buren Street.

The Young company trucks and buses were removed from the downtown area to in the underbrush in 1923. This shed is no longer extant.

A large number of buildings on Van Buren Street are shown on the 1926 Sanborn map. Some of these are numbers 1601–03, 1756–58, 1848–50, 1920–22, 1925–27, 1948–50, 2209, 2217–23, 2233, 2240–46, 2301, 2306,

2308–14, 2324, 2325–29, 2401–07 and 2417–23. None of these appear to exist now.

Virginia Street

In 1940, Virginia Street extended from Broadwalk west to Ocean Drive.

330 Virginia Street.

Beach Crest Apartments, 1930s. The apartments were owned by Samuel Baker in 1940 and sported a two-story, art-Moderne design. They were also called the Beach View Apartments. Still extant.

Washington Street

In 1940, Washington Street extended from the beach to the city limits.

Washington Street marks the south border of J.W. Young's initial land purchase for the future city of Hollywood. The rest of the square mile is bordered by the present-day Dixie Highway on the west, Johnson Street on the north, and 14th Avenue on the east.

The first area to be laid out with sidewalks and rock-covered streets was between the Dixie Highway and about 18th Avenue, and Washington Street to Johnson Street.

Washington Street and Surf Road.

Tent City. This tourist housing, built on the beach in the fall of 1925, was based on similar canvas colonies used on California beaches. These were not exactly tents, but cabins—with canvas roofs, floors, rooms, kitchens and baths—that could house hundreds of campers. Provided were all amenities, including a communal lounge area, library and cafeteria. Not surprisingly, Tent City was gone with the wind in the 1926 hurricane.

1601 Washington Street.

Home of Fred and Laura Willis who came to Hollywood in 1925. For many years, Fred was successful in real estate and insurance. But before coming south, Fred had studied medicine and became a pharmacist. Following the 1926 hurricane, as soon as they could move about, the Willises went to inspect the Maryland Hotel at 1857 Jackson Street, which was in Fred's charge, only to discover it was filled with injured people. Calling upon his early training, Fred treated patients all night and into the next day, while Laura cooked meals, until medical rescue could arrive and move the patients to hospitals. Their house still stands. 26 san.

2606 Washington Street.

C.B. Smith moved a house from here to 317 Arizona Street on the beach in 1932. See 317 Arizona Street.

2640 Washington Street.

Hollywood Playhouse, 1953, designed by architect Kenneth Spry. Spry was one of the organizers of Hollywood's Little Theater in 1933. During the war, the amateur theater group disbanded but later reformed and sought a permanent home. The city commission gave the theater the land, with a reverter clause in case the tract was not used for Little Theater purposes. Spry's building was under the sword in 2005 but has been reprieved and is still extant.

Wiley Street

In 1940, Wiley Street extended from 17th Avenue west to the Seaboard Air Line Railway.

1708 Wiley Street.

Home of R.H. Anderson, general superintendent of dredging in 1924. Still extant.

Wiley Street and 20th Avenue.

A 1949 ad for a new house here reads: "Home of the Future Today. Ranch Type-ultra modern. Scientific air-flow ventilation." The latter did not mean air-conditioning, which did not become universal for decades.

Wilson Street

In 1940, Wilson Street extended west from the beach to the city limits.

2022 Wilson Street.

Home of Max and Dagmar Larsen from 1923. Both came to Hollywood almost directly from Denmark. Max was a dredge operator, who helped dredge North and South Lakes, the Intracoastal Canal and Port Everglades. Four of their five children were born in the house. One, Elvera Dolores, may have been the first child born in Hollywood after it was incorporated in 1925—she was born January 5, 1926. During World War II, Max Larsen served in civilian defense as a plane spotter. His post was the tower of the Hollywood Hills Hotel, the highest point around the western part of the city. House no longer extant.

BIBLIOGRAPHY

Books

Akin, Edward N. *Flagler, Rockefeller Partner and Florida Baron*. Gainesville, FL: University Press of Florida, 1991.

Andersen, Kristen. *Port Everglades: A Century of Opportunity*. Port Everglades (Florida) Department of Broward County, 2000.

Baca, Elmo. *Romance of the Mission: Decorating in the Mission Style*. Salt Lake City, UT: Gibbs-Smith Publisher, 1996.

Board, Prudy Taylor. *The History of Dania Beach, Florida: A Century of Pioneer Spirit*. Virginia Beach, VA: The Donning Company Publishers, 2004.

Burke, John. *Rogue's Progress: The Fabulous Adventures of Wilson Mizner*. New York: G.P. Putnam's Sons, 1975.

Cuddy, Don. *Tales of Old Hollywood*. Decatur, IL: Spectator Books, 1977.

Curl, Donald W. *Florida Architecture of Addison Mizner*. New York: Dover Publications Inc., 1992.

Federal Writers' Project of the Work Projects Administration for the State of Florida. *Florida: A Guide to the Southernmost State; American Guide Series*. New York: Oxford University Press, 1939. Republished Scholarly Press Inc., 1978.

Fisher, Jerry M. *The Pacesetter, The Untold Story of Carl G. Fisher*. Fort Bragg, CA: Lost Coast Press, 1998.

Foster, Mark S. *Castles in the Sand: The Life and Times of Carl Graham Fisher*. Gainesville, FL: University Press of Florida, 2000.

Fox, Charles Donald. *The Truth about Florida*. New York: Charles Renard Corporation Publishers, 1925.

Gillis, Susan. *Fort Lauderdale: The Venice of America; The Making of America*. Charleston, SC: Arcadia Publishing, 2004.

Hines, Thomas S. *Burnham of Chicago: Architect and Planner*. Chicago: The University of Chicago Press, 1974.

Jackson, Helen Hunt. *Ramona*. New York: Grosset & Dunlap Publishers, 1912. First published in 1884.

Johnston, Alva. *The Legendary Mizners*. New York: Farrar, Straus & Giroux, 1953.

Jones, Robert T. *Authentic Small Houses of the Twenties: Illustrations and Floor Plans of 254 Characteristic Homes*. New York: Dover Publications Inc., 1987. First published in 1929.

Lacey, Robert. *Little Man Meyer Lansky and the Gangster Life*. Boston: Little, Brown and Company, 1991.

LaRoue, Samuel D. Jr. and Ellen J. Uguccioni. *Coral Gables in Postcards: Scenes from Florida's Yesterday*. Miami: Dade Heritage Trust Inc., 1988.

McAlester, Virginia and Lee McAlester. *A Field Guide to American Houses*. New York: Alfred A. Knopf, 1984.

McIver, Stuart B. *Dreamers, Schemers and Scalawags: The Florida Chronicles*. Vol. 1. Sarasota, FL: Pineapple Press Inc., 1994.

————. *Touched by the Sun: The Florida Chronicles*. Vol. 3 Sarasota: Pineapple Press Inc., 2001.

Messick, Hank. *Lansky*. New York: G.P. Putnam's Sons, 1971.

Nash, Eric P. and Randall C. Robinson Jr. *MiMo: Miami Modern Revealed*. San Francisco: Chronicle Books, 2004.

Oliver, Kitty. *Race and Change in Hollywood Florida: Voices of America*. Charleston, SC: Arcadia Publishing, 2000.

Reeves, F. Blair. FAIA. *A Guide to Florida's Historic Architecture*. Gainesville: University of Florida Press, 1990.

Research Atlantica Inc. *City of Hollywood Comprehensive Historic Preservation Plan, Prepared for City of Hollywood Growth Management Department*. Coral Springs, Florida, 1991.

Roberts, C. Richard. *Images of America Hollywood*. Charleston: Arcadia Publishing, 2002.

Rose, Ernestine Bradford. *The Circle: The Center of Indianapolis*. Indianapolis: Crippin Printing Corporation, 1971.

Sears, Roebuck and Co. *Catalog of Houses, 1926; An Unabridged Reprint*. New York: Dover Publications Inc., 1991.

Shoppell, R.W. *Turn-of-the-Century Houses, Cottages and Villas reprinted from Shoppell 1880–1900*. New York: Dover Publications Inc., 1983.

Smith, Henry Atterbury. *500 Small Houses of the Twenties*. New York: Dover Publications Inc., 1990. First published in 1923.

Stickley, Gustav. *More Craftsman Homes; Floor Plans and Illustrations for 78 Mission Style Dwellings*. New York: Dover Publications Inc., 1982. First published in 1912.

Stockbridge, Frank Parker and John Holliday Perry. *Florida in the Making: With a Foreword by the Governor of Florida* [John W. Martin]. New York: The de Bower Publishing Co., 1926.

BIBLIOGRAPHY

Tebeau, Charlton W. *A History of Florida*. Coral Gables, Florida: University of Miami Press, 1971.

TenEick, Virginia Elliott. *History of Hollywood 1920 to 1950*. Hollywood: City of Hollywood, 1966.

Wilpon, Bonnie. *The Postcard History Series Hollywood Florida*. Charleston: Arcadia Publishing, 1999.

Newspapers and Periodicals

Bolstad, Erika. "Old Hollywood's Magnificent Seven—7 Landmarks from city's golden era now in line for historic designation." Miami *Herald*, January 17, 2000.

Brecher, Elinor J. "Last of the Gentlemen Gangsters—'Jimmy Blue-eyes' Alo." Miami *Herald*, April 8, 2001.

Cuddy, Don. "Hollywood." *Broward Life*. [Copy of clipping in archive file; no publication data known.]

Dunlop, Beth. "Inventing Antiquity: The Art and Craft of Mediterranean Revival Architecture." Florida Theme Issue, *Journal of Decorative and Propaganda Arts 1875–1945* (Miami Beach, Florida: The Wolfsonian-Florida International University and The Wolfson Foundation of Decorative and Propaganda Arts Inc.) 1998: 191–207.

Gaylords' Triangle, "The Public Library of Hollywood-in-Florida." Syracuse, New York: January 1945.

Gerard, John. "City's Street Names Had Involved Origin." *Hollywood Sun-Tattler*, October 31, 1985.

Guthrie, Wayne. "Ringside in Hoosierland. Hollywood Plans Its Anniversary." *Indianapolis News*, October 20, 1965.

———. "Hollywood, Fla., Is a Bit of Indiana." *Indianapolis News*, July 8, 1960.

Hollywood Sun-Tattler, "A Driving Tour of Hollywood's Famous Sites," October 31, 1985.

Jensen, Trevor. "Not-so-ancient Broward sites in running for historical notice." *South Florida Sun-Sentinel*, May 25, 1992.

Kleinberg, Eliot. "The War Offshore: German Submarines in the Waters off of Palm Beach County & Other Parts of Southeast Florida." *Tequesta* 64 (2004): 41.

Knetsch, Joe. "Olof Zetterlund and the Founding of Hallandale: New Documents and Understanding." *Broward Legacy*, Winter–Spring 1994, 22–27.

McIver, Joan. "Joe Young's mighty plan." Miami *Herald*, December 9, 1985.

Mickelson, Joan. "Historic Liberia Turns 80." *The Portico* (Hollywood Historical Society) 4 (2003).

South Broward Tattler, "Simms Building Attractive Nautical Home on Ocean," February 18, 1938. With drawing by Henry Hohauser.

Other

Unless otherwise noted, these references can be accessed through the Hollywood Historical Society.

Beckley, R.J., comp. *The 1926 Florida Hurricane*. Privately published and printed, R.J. Beckley.

Broward County Directory, 1924–1925. Partial copy.

Broward County Historical Commission. "Cultural Heritage Landmarks Map." Fort Lauderdale.

Broward County Public Schools. "School-by-School Information." http://www. browardschools.com. 2005.

Casler, Patricia J. "The Architecture of Rubush and Hunter." Submitted in fulfillment of the requirement for the degree of Master of Science in Historic Preservation, Columbia University, Graduate School of Architecture and Planning, 1985. Private collection.

Classified Business and Professional Directory of Greater Hollywood, Florida, 1926. Partial copy.

Coy, C.L. *Hollywood City Directory*, 1933. Copy.

Downtown Hollywood CRA. "Downtown Hollywood. The Historic Hollywood Business District." http://www.downtownhollywood.com.

East Coast Directory Service. *1937 Directory; Complete Residential and Business Guide*. Copy.

Gleason, John J., ed. *Greater Hollywood City Directory for 1926*. Hollywood by-the-Sea, Florida: Junior Chamber of Commerce, 1926.

Gray, Myrtle Anderson, interviewed by Don Cuddy, August 24, 1976, as part of Greater Hollywood Bicentennial Oral History Project. Transcript is in Hollywood Historical Society archives. Note that "Bicentennial" here refers to the nation's, not Hollywood's.

Hollywood Herald, 1934, 1935.

Hollywood Lakes Section Civic Association. "Hollywood Local Historic Sites and Marker Program." http://www.hollywoodlakes.com.

Hollywood Reporter, February 1922–December 1926. Indianapolis, Indiana: Hollywood Land & Water Company, 912–14 Merchants Bank Building. Private collection.

Kemper, Marlyn. "Florida Master Site File." Historic Broward County Preservation Board. Hollywood site inventory compiled 1984. Copy.

Klepper, O.R. *Guide Book of Hollywood by-the-Sea Florida*. Hollywood: Hollywood Publishing Co., 1927. Copy.

Mickelson, Joan. *Index to Virginia TenEick's History of Hollywood, Florida*. Plantation, Florida: Joan Mickelson, 2004.

Mickelson, Tony (Anton Christopher), interviewed by Don Cuddy, August 10, 1976, as part of Greater Hollywood Bicentennial Oral History Project. Transcript is in Hollywood Historical Society archives. Note that "Bicentennial" here refers to the nation's, not Hollywood's.

BIBLIOGRAPHY

Sanborn Map Company. "Hollywood, Broward County, Florida." New York: Sanborn Map Company, June 1926. Copy in the collection of the Broward County Historical Commission, Fort Lauderdale.

South. Hollywood, FL: Hollywood Land & Water Company, 1926. Private collection.

South Broward County Classified Business Directory: Hollywood, Hallandale, Dania, Davie. 1937. Copy.

Southern Directory Company Publishers. *Miller's Street Directory of Hollywood, Fla.: Giving Names of Householders and Denoting Business Places.* Asheville, NC: Southern Directory Company Publishers, 1940–1941. Copy.

Whitson, Edythe, interviewed by Don Cuddy, September 7, 1976, as part of Greater Hollywood Bicentennial Oral History Project. Transcript is in Hollywood Historical Society archives. Note that "Bicentennial" here refers to the nation's, not Hollywood's.

Yale, Bobby. *Hollywood and the Hurricane.* Hollywood, Florida: *The Hollywood News*, 1926.

For further research on the history of Hollywood, Florida, please contact the author or the Hollywood Historical Society.

1520 Polk Street.

PO Box 222755

Hollywood, FL 33020

954.923.5590

hollywoodFLhistory@juno.com

INDEX

INDEX

INDEX

INDEX

INDEX

ABOUT THE AUTHOR

J oan Mickelson is a Hollywood, Florida, pioneer by birth. Her parents,
Lamora and Tony Mickelson, were among the first residents of the new city;
both worked for J.W. Young's Hollywood Land and Water Company. The author
attended her mother's Outdoor School, then Hollywood Central School and
South Broward High School. She was among the first three Florida public school
graduates to be accepted at Radcliffe College of Harvard University, where she
studied romance languages and history of art. She has a master of arts degree
from the University of Chicago and a doctorate from Harvard, both in art history
with a focus on the period around the turn of the twentieth century. For more
than thirty years, she was a museum curator and then director in art and history
museums. Also a biographer, she has written about various artists and a book on
Hilla Rebay, the founding director of the Guggenheim Museum. Currently, she
is working on the biography of Hollywood's founder, Joseph W. Young.

The author in 1960 in her powder-blue Pan American stewardess uniform. She flew out of
Miami on the Central and South American routes.